THE
COMPLETE
IDIOT'S
GUIDE® TO

MANGA
FANTASY
CREATURES
Illustrated

Matt Forbeck and
Tomoko Taniguchi
for Idea + Design Works, LLC

D1504899

ALPHA

A member of Penguin Group (USA) Inc.

To everyone who loves comics everywhere, no matter what kind you may read. Special thanks to my friends at WildStorm and Idea + Design Works for everything they've done for me over the years, and to my parents for using comics to teach me how to read.

—Matt Forbeck

I really appreciate that I was given the opportunity to work on this book. I enjoyed drawing all of the illustrations myself, and I would be really happy if Americans draw Japanese manga with this book!

—Tomoko Taniguchi

ALPHA BOOKS

Published by the Penguin Group

Penguin Group (USA) Inc., 375 Hudson Street, New York, New York 10014, U.S.A.

Penguin Group (Canada), 10 Alcorn Avenue, Toronto, Ontario, Canada M4V 3B2 (a division of Pearson Penguin Canada Inc.)

Penguin Books Ltd, 80 Strand, London WC2R 0RL, England

Penguin Ireland, 25 St Stephen's Green, Dublin 2, Ireland (a division of Penguin Books Ltd)

Penguin Group (Australia), 250 Camberwell Road, Camberwell, Victoria 3124, Australia (a division of Pearson Australia Group Pty Ltd)

Penguin Books India Pvt Ltd, 11 Community Centre, Panchsheel Park, New Delhi—110 017, India

Penguin Group (NZ), cnr Airborne and Rosedale Roads, Albany, Auckland 1310, New Zealand (a division of Pearson New Zealand Ltd)

Penguin Books (South Africa) (Pty) Ltd, 24 Sturdee Avenue, Rosebank, Johannesburg 2196, South Africa

Penguin Books Ltd, Registered Offices: 80 Strand, London WC2R 0RL, England

THE COMPLETE IDIOT'S GUIDE TO and Design are registered trademarks of Penguin Group (USA) Inc.

International Standard Book Number: 978-1-59257-636-4
Library of Congress Catalog Card Number: 2006938601

09 08 07 8 7 6 5 4 3 2 1

Interpretation of the printing code: The rightmost number of the first series of numbers is the year of the book's printing; the rightmost number of the second series of numbers is the number of the book's printing. For example, a printing code of 07-1 shows that the first printing occurred in 2007.

Printed in the United States of America

Note: This publication contains the opinions and ideas of its authors. It is intended to provide helpful and informative material on the subject matter covered. It is sold with the understanding that the authors and publisher are not engaged in rendering professional services in the book. If the reader requires personal assistance or advice, a competent professional should be consulted.

The authors and publisher specifically disclaim any responsibility for any liability, loss, or risk, personal or otherwise, which is incurred as a consequence, directly or indirectly, of the use and application of any of the contents of this book.

Most Alpha books are available at special quantity discounts for bulk purchases for sales promotions, premiums, fund-raising, or educational use. Special books, or book excerpts, can also be created to fit specific needs.

For details, write: Special Markets, Alpha Books, 375 Hudson Street, New York, NY 10014.

Publisher	**Marie Butler-Knight**
Editorial Director/Acquiring Editor	**Mike Sanders**
Managing Editor	**Billy Fields**
Development Editor	**Ginny Munroe**
Production Editor	**Kayla Dugger**
Copy Editor	**Amy Borrelli**
Cover and Book Designer	**Kurt Owens**
Proofreader	**Aaron Black**

Contents

Part 1: Things That Walk Like Men

1 Humanoids:
Sometimes the Worst
Monsters Look Like Us2

Humans, and the monsters that wish they were.

Samurai 3

Ninja 7

Goblin 10

Beastman 13

2 Undead:
You Can't Kill What's
Already Dead 17

Unliving, undead—they're trouble either way.

Skeleton 18

Zombie 22

Eastern Vampire 25

Western Vampire . . . 28

3 Fairies & Giants:
Big and Small,
Monsters All 32

Big and small, we cover them all.

Dwarf 34

Pixie 38

Troll 41

Giant 44

Part 2: Beasts and Monsters

4 **Animals:**
Common Creatures
Play Their Parts**50**

Beasts of burden and predators on the prowl.

Unicorn 51

Wolf. 55

Bear 58

Lizard. 61

Tiger 64

5 **Demons & Dragons:**
The Worst of the Worst.**68**

The worst kinds of foes in this realm and beyond.

Western Demon 69

Western Dragon 73

Eastern Demon. 76

Eastern Dragon. 79

6 **Elementals:**
Back to Basics.**83**

Back to basics in the worst way, with monsters from each of the five elements.

Earth Elemental 84

Air Elemental 88

Fire Elemental. 91

Water Elemental. . . . 94

Void Elemental 97

7 **In Other Elements:**
By Air or by Sea, They're
Still Monsters to Me**101**

Death from above or below—either way, you're still dead.

Eagle 102

Bee. 106

Shark 109

Squid 112

8 **Out of This World:**
Creatures from Beyond **116**

No hope of stopping illegal aliens like these.

Gray 117

Killer 121

Robot 124

Mecha 127

Part 3: Creating Your Own Creatures

9 **Think Theme: Start with**
the End in Mind **134**

Conceptual, not musical, silly.

Lightning Cat 135

Robodog 139

Night Creature 142

10 **Variations:**
Spice Up Your
Creature's Life **146**

Riff like a rock star.

Riceball 147

Fiery Gorilla 151

Bionic Dragon 154

Zombie Rats 157

Pixie Queen 160

11 Surprises:
Monsters More
Than They Seem **164**

Context is everything—except when it's not.

Vampire Princess. . . 165

Snakeman 169

Monster Book 172

12 Chibi:
Too Darn Cute**176**

Drawing on the infantile side of your brain.

Chibi Samurai 177

Chibi Demon 181

Appendixes

A Glossary186

B Visual Glossary.189

C Further Reading193

D Recommended Websites . . .196

Introduction

Welcome to *The Complete Idiot's Guide to Manga Fantasy Creatures Illustrated.* Despite that being a mouthful of a title, we hope you'll find the contents of this book easy to swallow.

While this is a *Complete Idiot's Guide,* this is not a beginner's course. If you are still searching for the first stepping stone on your path toward manga enlightenment, we suggest starting with *The Complete Idiot's Guide to Drawing Manga Illustrated.* You'll recognize most of the title from this book, except for the "Fantasy Creatures" part.

Fantasy creatures are a staple of many manga tales, particularly those that make it over the Pacific to the United States. It's no surprise that artists like to draw them. They're dramatic, exciting, and packed full of fun.

How to Use This Book

This book is broken down into three large sections. We start with the simpler stuff first and become more adventurous as we move along.

Because you're likely most familiar with drawing the human form, in **Part 1, "Things That Walk Like Men,"** we start with the living. Then we tackle the undead, and from there we size up figures both tiny and titanic.

In **Part 2, "Beasts and Monsters,"** we again start with traditional creatures like everyday animals. Then we rise to the challenge of demons and dragons. After that, we plunge into the various elements of the world and the creatures that call them home. And then we move beyond.

Once you've mastered the classic creatures, it's time to try your hand at your own in **Part 3, "Creating Your Own Creatures."** By way of example, we start by choosing popular themes. Then we riff on those with variations of our own. From there, we get really weird, but we end on a cute note with a nod toward the chibi form.

Extras

Throughout the book, you'll find snappy little sidebars designed to help answer questions and illuminate the world of manga fantasy creatures for you.

Manga-nese Definitions of words that come from the world of manga. Often these are Japanese words, like *ganbatte!,* which means "good luck!"

Chimeric Koans Miscellaneous bits of information that don't seem to fit anywhere else—but which we're sure you'll appreciate. A chimera is a mixed-up monster made up of parts of many animals, and a koan is a Zen riddle. Together they make something even more puzzling than before.

AIIEEE!!! Warnings about things that might go wrong with a particular drawing. Pay careful attention here, or you'll end up saying "AIIEEE!!!," too.

Pearls of Wisdom Bits of knowledge that you'll want to hold on to like the precious things they are.

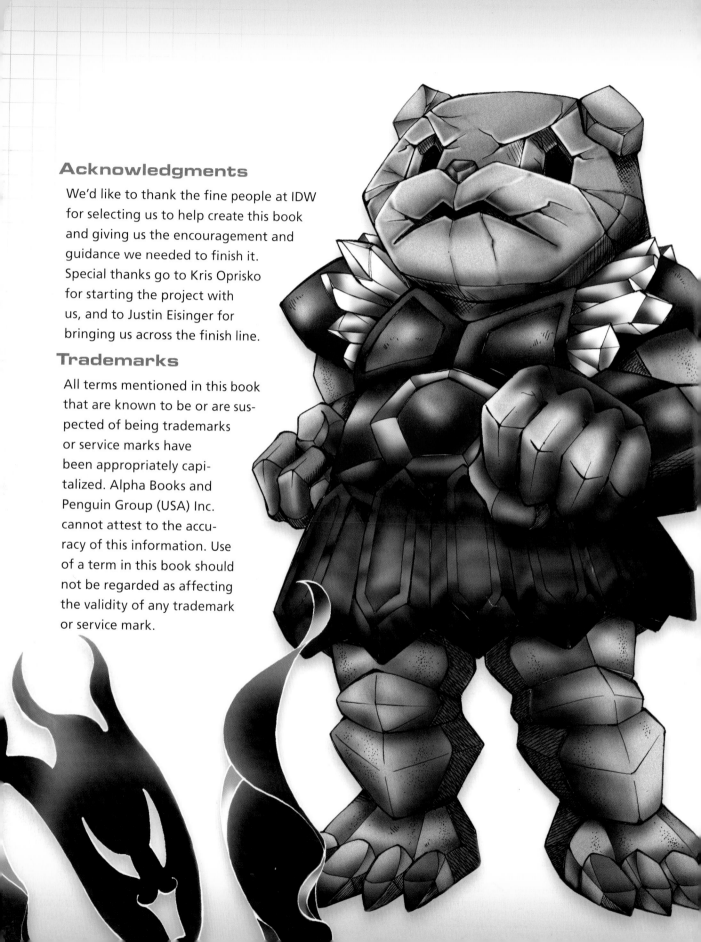

Acknowledgments

We'd like to thank the fine people at IDW for selecting us to help create this book and giving us the encouragement and guidance we needed to finish it. Special thanks go to Kris Oprisko for starting the project with us, and to Justin Eisinger for bringing us across the finish line.

Trademarks

Part 1

Things that Walk Like Men

While *The Complete Idiot's Guide to Manga Fantasy Creatures Illustrated* is an advanced course, we're still going to start out with easier subjects and work our way forward. This section starts out with humans, or things that walk and talk a whole lot like them. All of that figure drawing you've been practicing won't go to waste here.

From there, we'll examine a particularly noxious form of people—or what's left of them: the undead. This includes some classic kinds of monsters, but they all take the form of the humans they once were.

We'll wrap it up with a chapter on creatures of different sizes. Since most drawings aren't done on a 1:1 scale, it's up to you to show the viewer how big or small your creatures are, and we have a bagful of tricks to help you handle that.

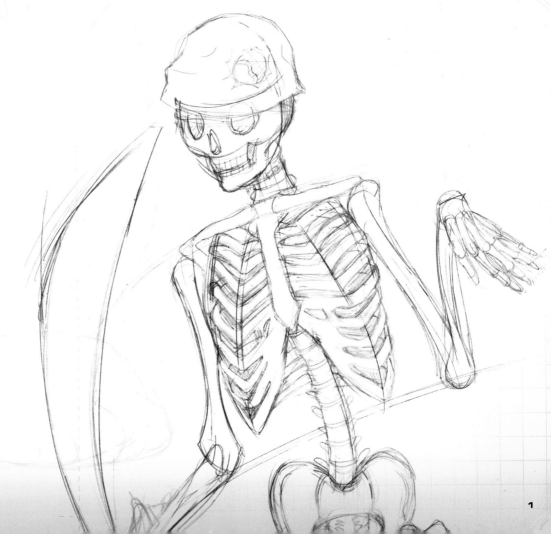

Humanoids:
Sometimes the Worst Monsters Look Like Us

In This Chapter

- Men of honor
- Women of danger
- Monsters that walk like people
- Mixes of monsters and people

The most memorable creatures in any fantasy world, visually at least, are the monsters. But you can't forget about the more common folk—the people who live in the world. Most times, the various peoples in a fantasy world are human, although they can come in all sorts of shapes, colors, and sizes. Sometimes they're called elves, dwarves, or halflings. Other times, they're something stranger or nastier like orcs, goblins, or beastmen.

To give you a baseline from which to begin, we're going to start with a man and a woman. To make things a bit more interesting, though, we're going to dress them in the gear of ancient Japanese warriors and give them the weapons such people might use as a samurai and ninja.

From there, we move on to a pair of common foes: the goblin and the beastman. These come in all sorts of varieties, which gives you some leeway in your own creations.

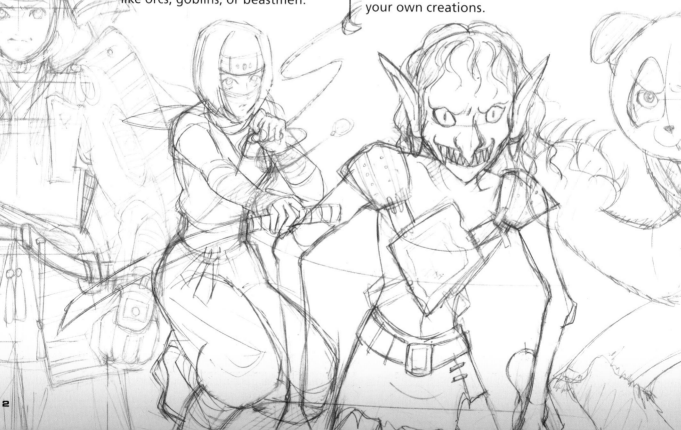

Samurai

Men come in a vast variety of sizes, builds, and colors. For this figure, we're going to choose a mighty warrior from ancient Japan, a *samurai*. To make things interesting, we'll add his traditional armor and weapons.

Manga-nese

Samurai are noble warriors who fought in feudal Japan. Reportedly, they lived lives of honor under the strict code of *bushido* (the way of the warrior). Their distinct weaponry and armor makes them instantly recognizable.

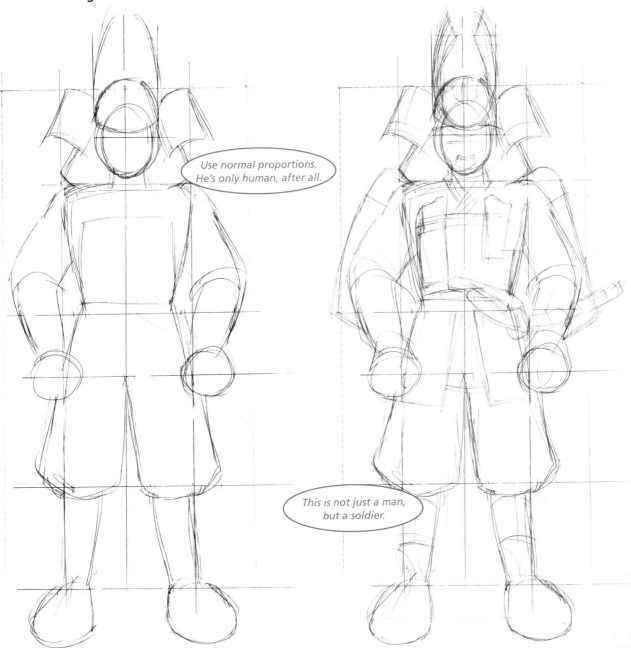

1. Break down the figure into its component shapes. Make the shapes as simple as possible right now. Circles and cylinders should make up most of your figure.

2. Add some more details. Build out the samurai's armor from the human figure you started with.

3

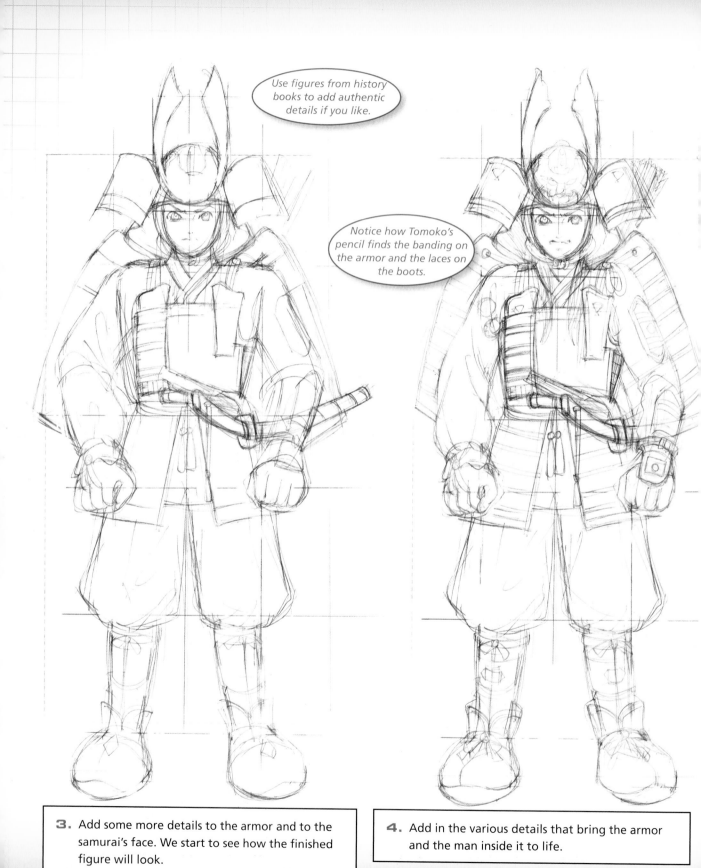

3. Add some more details to the armor and to the samurai's face. We start to see how the finished figure will look.

4. Add in the various details that bring the armor and the man inside it to life.

Samurai carried a set of weapons called a *daisho*. This consists of two curved, single-edged swords. The longer sword is called a *katana,* and the shorter is the *wakazashi.*

Chimeric Koans

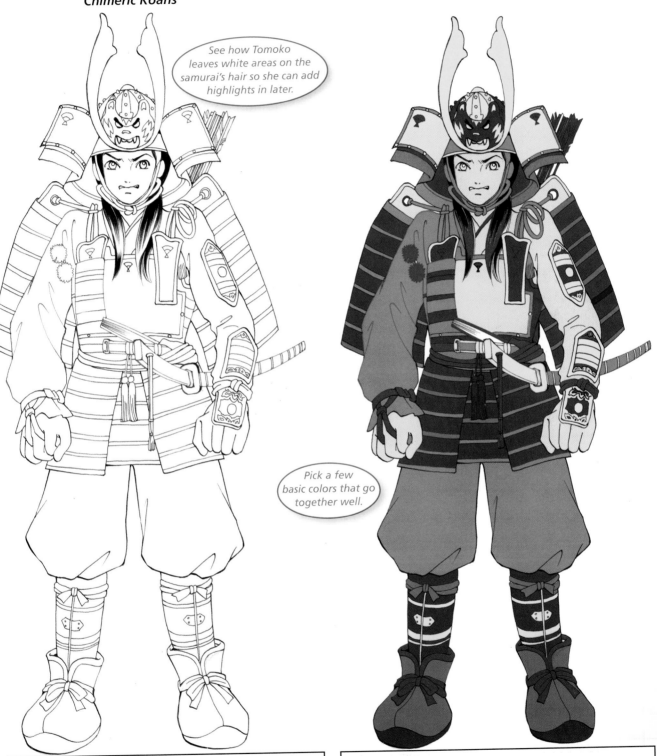

See how Tomoko leaves white areas on the samurai's hair so she can add highlights in later.

Pick a few basic colors that go together well.

5. Now it's time to lay down some inks. Don't bother with using solid blacks throughout an entire shape. You can handle those parts during the coloring stages.

6. Samurai come in all kinds of colors, but they're often seen in reds, golds, and silvers.

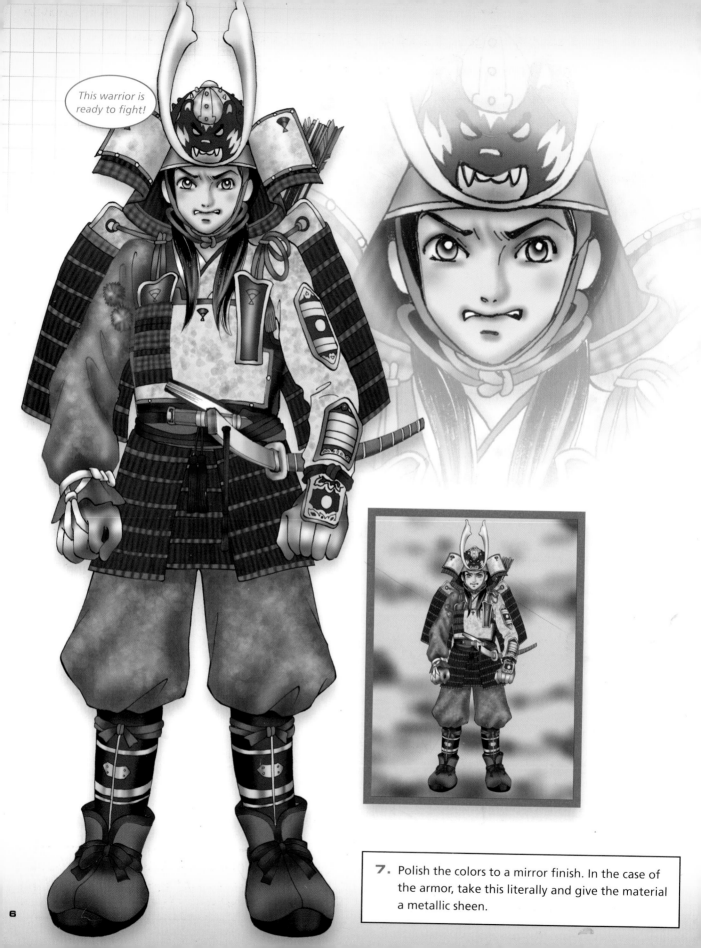

This warrior is ready to fight!

7. Polish the colors to a mirror finish. In the case of the armor, take this literally and give the material a metallic sheen.

Ninja

Legendary Japanese assassins, the ninjas relied on stealth and secrecy to carry out their missions. In this sense, they are the polar opposite of the samurai. They fight silently and care little for the *bushido* concepts of honor.

Pearls of Wisdom

There's little proof that ninjas as we know them in popular entertainment ever existed. Their very existence was meant to be a secret, after all, so they left behind little in the way of written records. Still, the nimble, black-suited killers are just too much fun to pass by.

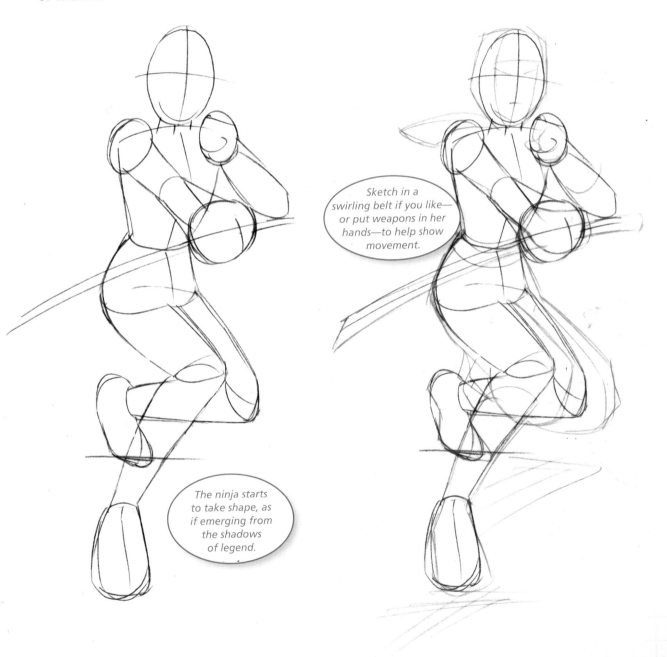

Sketch in a swirling belt if you like—or put weapons in her hands—to help show movement.

The ninja starts to take shape, as if emerging from the shadows of legend.

1. Ninjas tend to be lithe, slender, and nimble people. Your ninja should have a build something like that of a modern gymnast.

2. Lay in a few more details. Since ninja clothing is relatively tight, you don't have to worry as much about changing the figure's shape later.

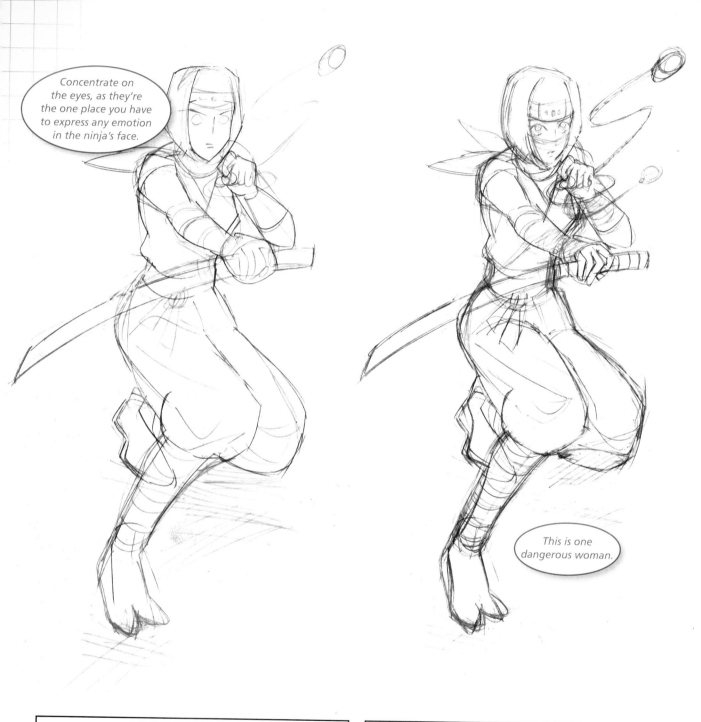

3. Add in some features and details here. Remember that the ninja mask obscures everything but the woman's eyes.

4. Concentrate on the last few details here. Make sure you show the weapons and how they're held. You can use foreshortening here to show where the ninja's weapons are pointed.

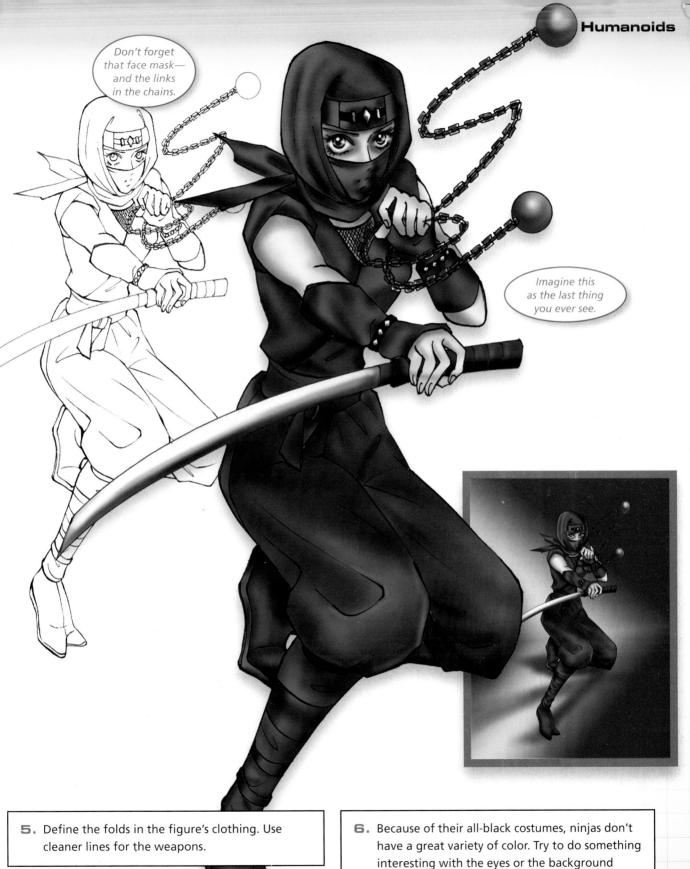

Don't forget that face mask—and the links in the chains.

Imagine this as the last thing you ever see.

5. Define the folds in the figure's clothing. Use cleaner lines for the weapons.

6. Because of their all-black costumes, ninjas don't have a great variety of color. Try to do something interesting with the eyes or the background instead. A splash of blood on a shoulder or a shine on the edge of a blade can add a lot, and draw the eyes in as well.

Goblin

Goblins and their ilk include a large variety of monsters that stand like humans but are much nastier. Their skin and hair come in all sorts of noxious colors, from sickly gray through bright orange. They often have enlarged mouths filled with sharp, savage teeth.

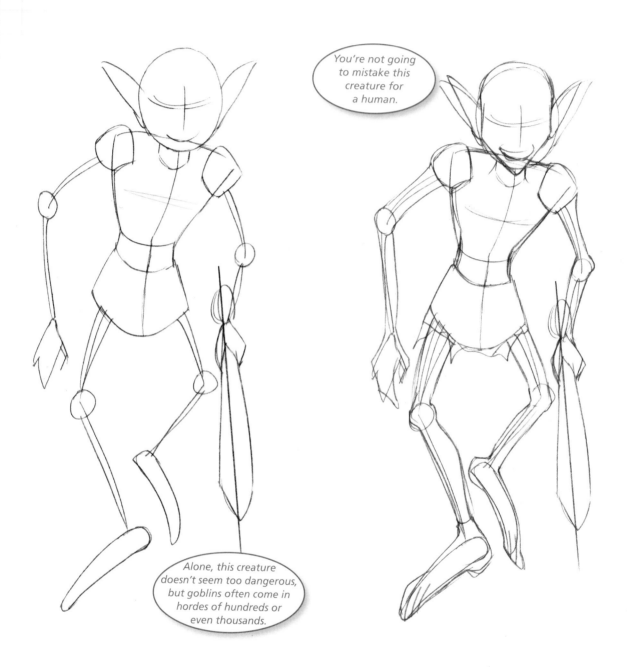

You're not going to mistake this creature for a human.

Alone, this creature doesn't seem too dangerous, but goblins often come in hordes of hundreds or even thousands.

1. For this goblin, we're going to go with a skinny creature with spindly arms and legs.

2. Flesh out the goblin a bit more. Show its big ears and wide mouth.

Chimeric Koans

Play around with all sorts of goblins. Vary their size, color, and attitude as you like. When you're comfortable with them, try clustering a lot of them into a single drawing. By themselves, many goblins don't seem threatening, but in a group they seem like a tsunami of trouble.

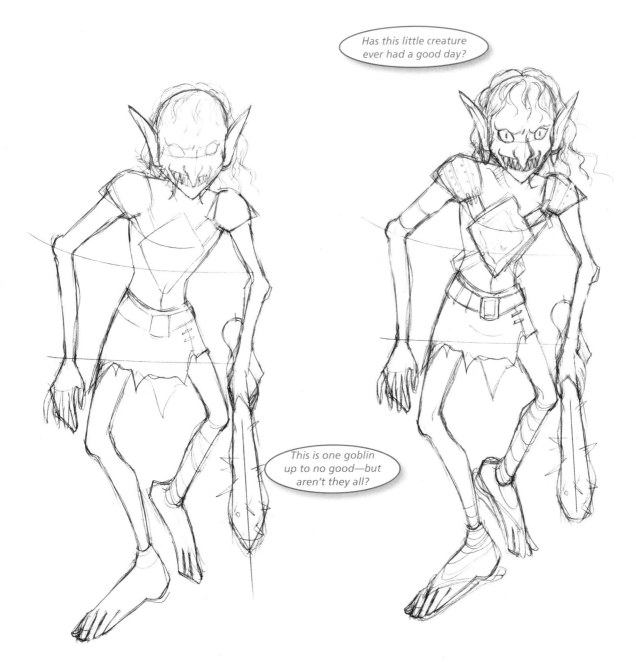

Has this little creature ever had a good day?

This is one goblin up to no good—but aren't they all?

3. Fill in some of the details, particularly on the face. The eyes should glint with mischief or malice.

4. Add in the rest of the details and make the goblin's rottenness show in its clothes, armor, and weapons.

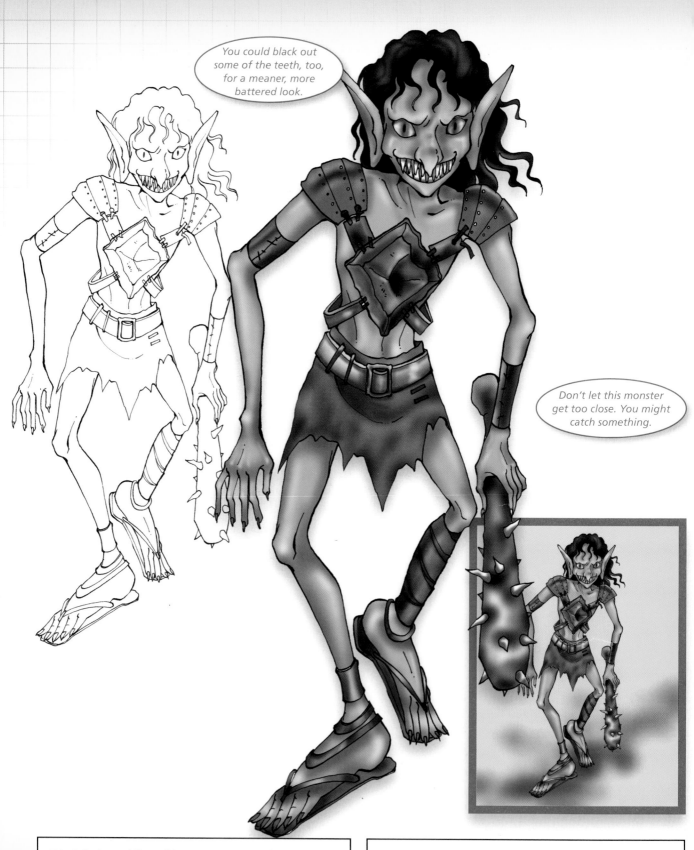

5. Ink the goblin, taking care not to polish too much off of its rough edges.

6. Goblins come in a wide range of putrid colors. Here, Tomoko goes with a gangrenous green, but you can try what repulses you most.

Beastman

For our *beastman*, we're going to try making an innocent-looking creature into a monster. You might not think of a panda as much of a bear when it comes to brawling, but mix the animal with a man and watch the fur start to fly.

Manga-nese

Beastmen are any creatures that combine part of a human and part of an animal, like a minotaur bull's head on a man's body. You can mix and match as much as you like. Many times, a particular breed of beastman is called by the name of the animal, with the suffix "-man" attached to it, like snakeman, wolfman, sharkman, and so on.

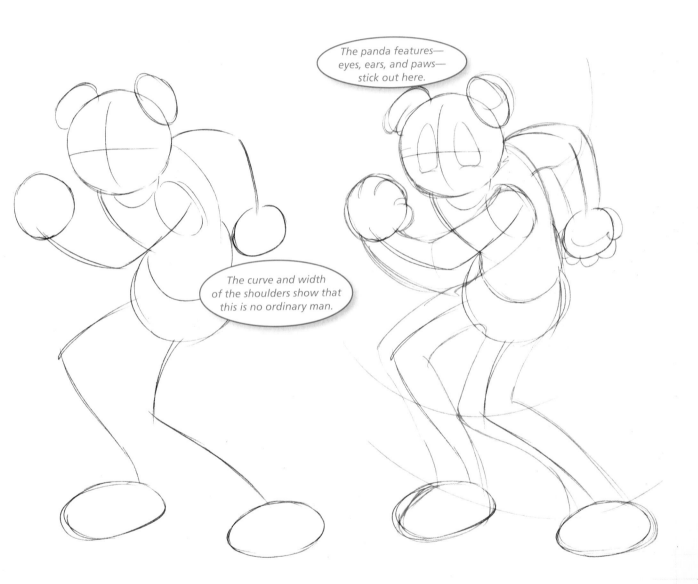

The panda features— eyes, ears, and paws— stick out here.

The curve and width of the shoulders show that this is no ordinary man.

1. Start with a human figure and add some bulk to make it more bearlike.

2. Add in some more shapes, like the beastman's ears. Pay attention to the face, which often has an animal's snout.

13

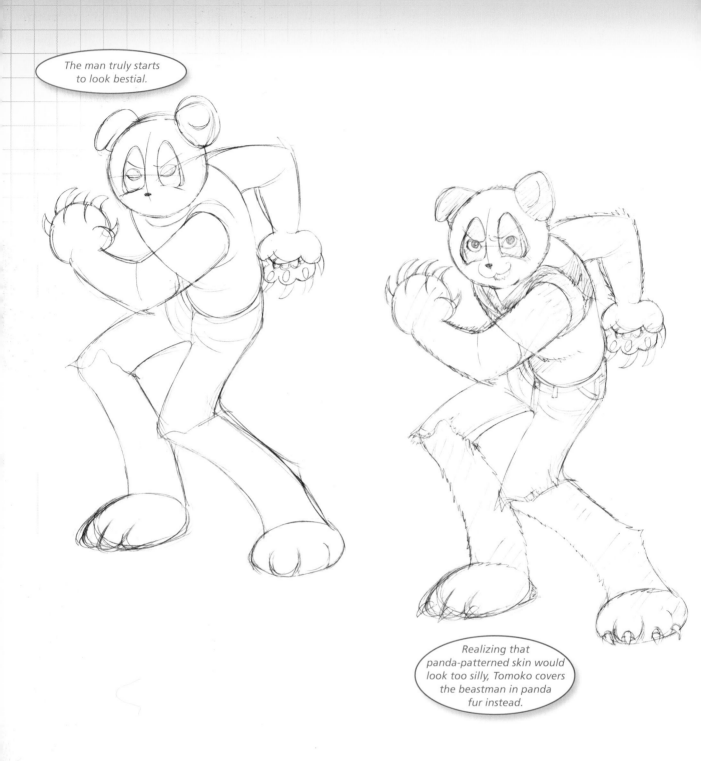

The man truly starts to look bestial.

Realizing that panda-patterned skin would look too silly, Tomoko covers the beastman in panda fur instead.

3. Pick out some more salient details, like the claws.

4. Remember, this is a beastman. While some have a human's skin, this one's covered with fur.

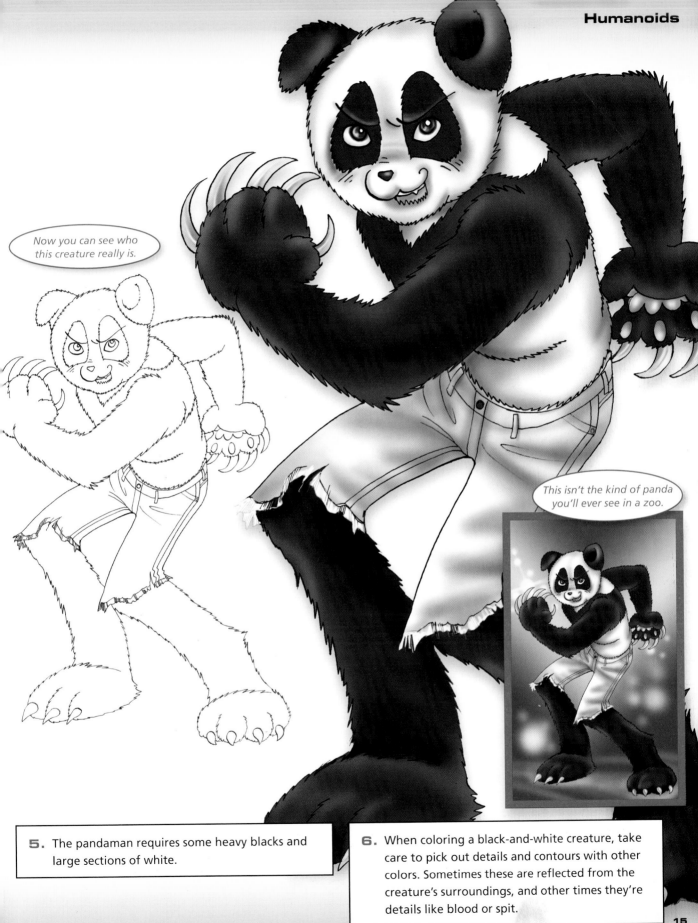

Now you can see who this creature really is.

This isn't the kind of panda you'll ever see in a zoo.

5. The pandaman requires some heavy blacks and large sections of white.

6. When coloring a black-and-white creature, take care to pick out details and contours with other colors. Sometimes these are reflected from the creature's surroundings, and other times they're details like blood or spit.

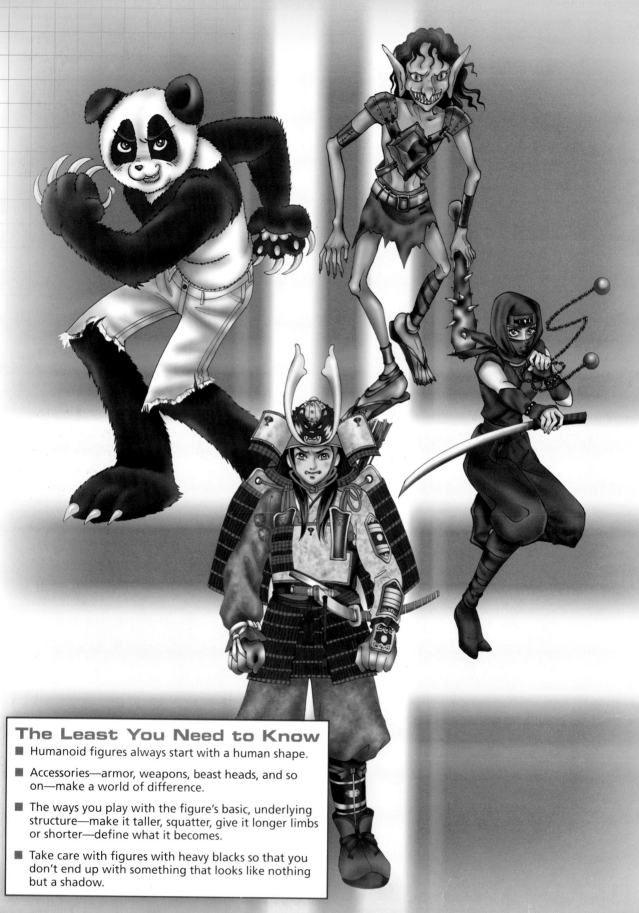

The Least You Need to Know

■ Humanoid figures always start with a human shape.

■ Accessories—armor, weapons, beast heads, and so on—make a world of difference.

■ The ways you play with the figure's basic, underlying structure—make it taller, squatter, give it longer limbs or shorter—define what it becomes.

■ Take care with figures with heavy blacks so that you don't end up with something that looks like nothing but a shadow.

Undead:
You Can't Kill What's Already Dead

In This Chapter

- Bone-headed monsters
- Brain-hungry hunters
- Hopping-mad Asian bloodsuckers
- Suave Anglo creatures of the night

The class of fantastic creatures that's closest to humans is the undead. After all, these monsters were people once. Just because they should be rotting peacefully in a grave doesn't change their basic shape when they're up and shambling about.

Undead come in the most basic of human shapes and the most elaborate. There's a reason that many artists start out by sketching a figure's skeleton, and now you can just use that for your monster of the same name. Vampires can be as flamboyant as a person can get, living the largest kind of unlives. Between them staggers the rotting zombie, visually a half-step from either side.

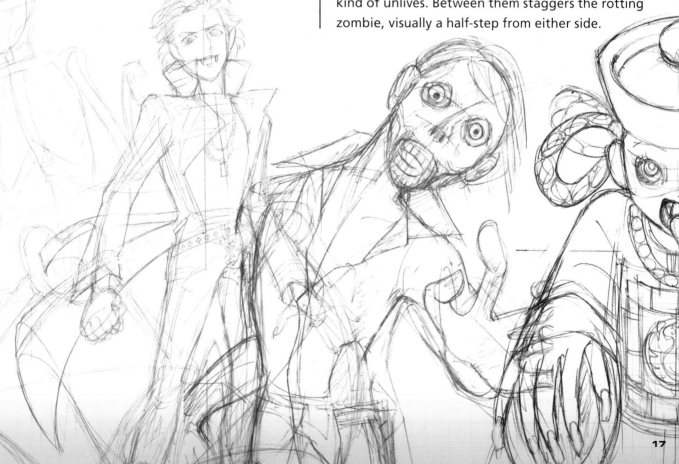

Skeleton

Manga-nese

Undead refers to any creature that ignores the fact that it's supposed to be dead and not moving. Although we most often see undead humans, there's no reason you couldn't find an undead animal or even an undead monster, too.

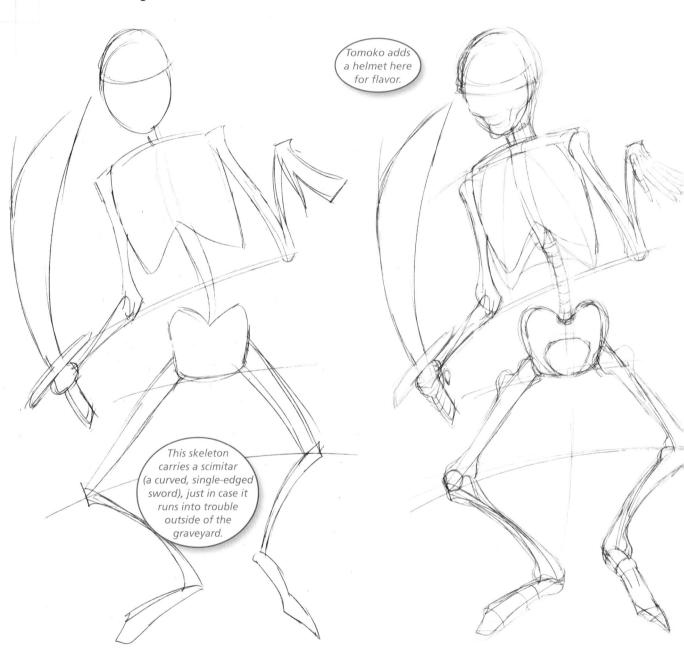

Tomoko adds a helmet here for flavor.

This skeleton carries a scimitar (a curved, single-edged sword), just in case it runs into trouble outside of the graveyard.

1. Break down the figure into shapes. Remember that the skeleton's middle doesn't have any organs or skin obscuring the spine.

2. Tighten up the bones, paying particular attention to the major joints.

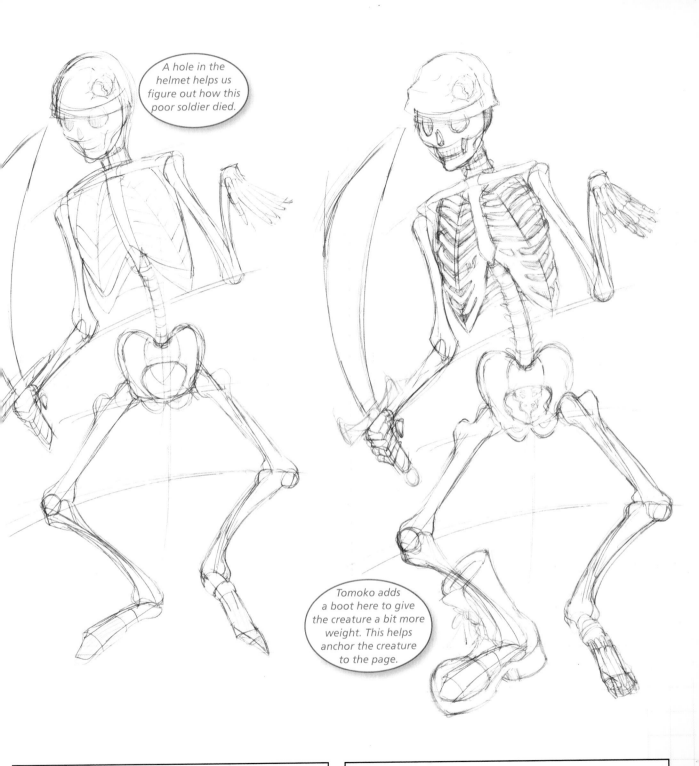

3. Work on the smaller bones now, like the ribs. Add some detail to the face.

4. Add in more details, especially on the face and ribs. Don't forget to draw in the parts of the ribs that can only be seen through the rest of the ribcage.

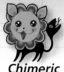

Chimeric Koans

Because they have no muscles—or flesh of any kind—skeletons must be motivated by evil magic. Zombies and vampires at least have some visible means of moving their bones, and the lack of that in a skeleton is probably the most horrifying thing about it.

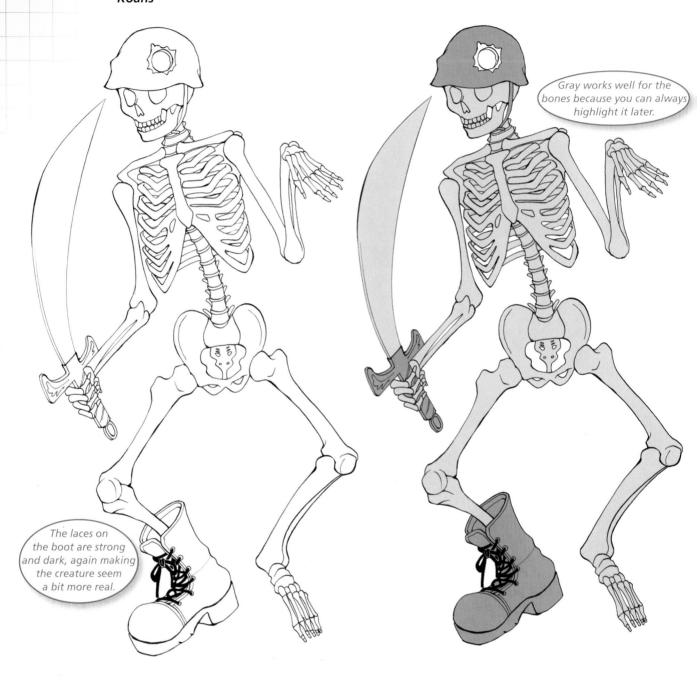

Gray works well for the bones because you can always highlight it later.

The laces on the boot are strong and dark, again making the creature seem a bit more real.

5. Ink the entire creature in lines that are all weighted about the same.

6. Skeletons usually come in bland colors. Pick one for the bones and whatever else you like for any accessories.

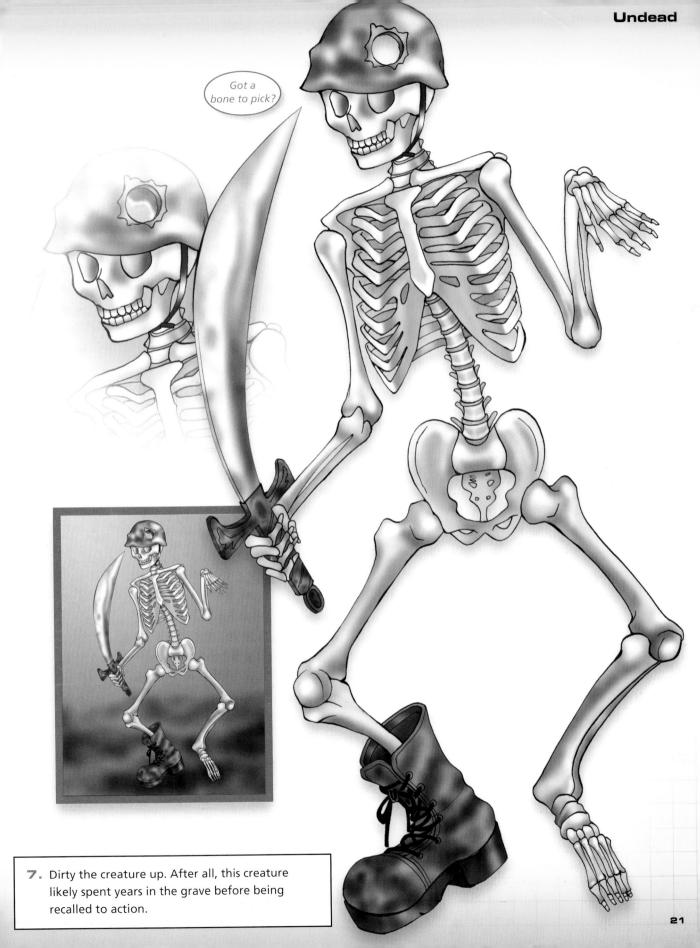

Zombie

As undead creatures go, zombies work much like skeletons. They just haven't been sitting around rotting for so long. Some zombies look like they came fresh from the morgue, while others are a bit riper than that.

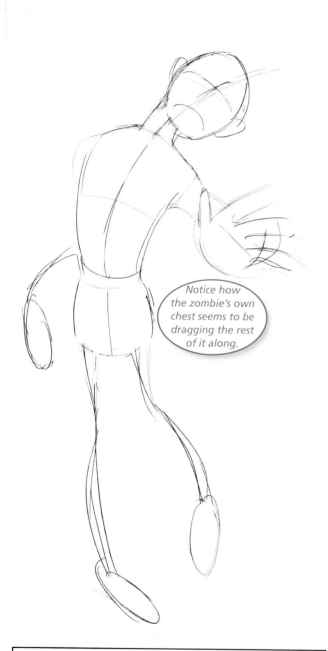

Notice how the zombie's own chest seems to be dragging the rest of it along.

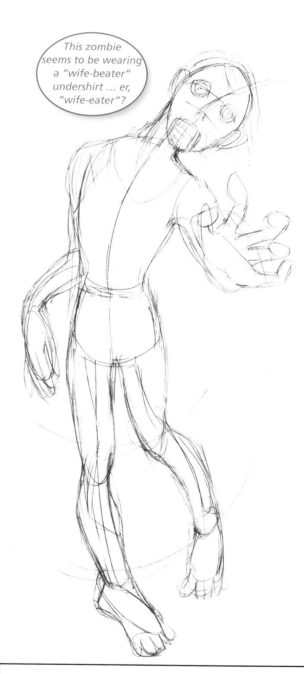

This zombie seems to be wearing a "wife-beater" undershirt ... er, "wife-eater"?

1. Zombies are built like a normal person, but their gait and posture instantly tip off those nearby that there's something wrong here. Be sure to work this into your breakdown of the creature into basic shapes.

2. Tighten up the breakdown. Draw in the undergarments. This serves as a guide as you layer on other clothes.

Pearls of Wisdom

In the real world, zombies are the creation of *bokor*, evil voodoo priests who live in Haiti. There's some evidence that such priests used a fish-based poison to paralyze their victims and then scared them brainless. Of course, in the fantasy worlds of your concoction, zombies can come about for any reason.

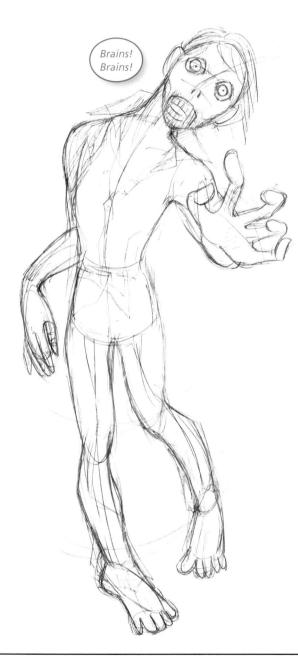

Brains! Brains!

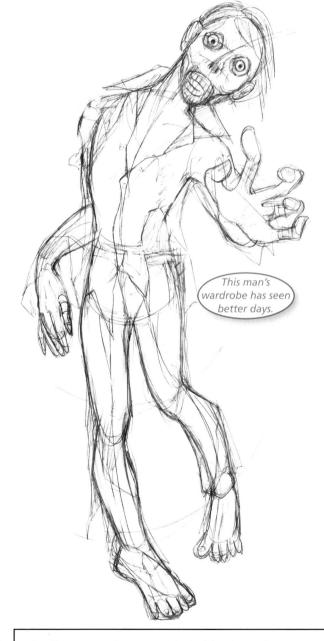

This man's wardrobe has seen better days.

3. Show the hunger in the creature's eyes. Concentrate on the lips, which are drawn back to expose the ready teeth.

4. Figure out the creature's clothing here. Be sure to leave the edges raggedy.

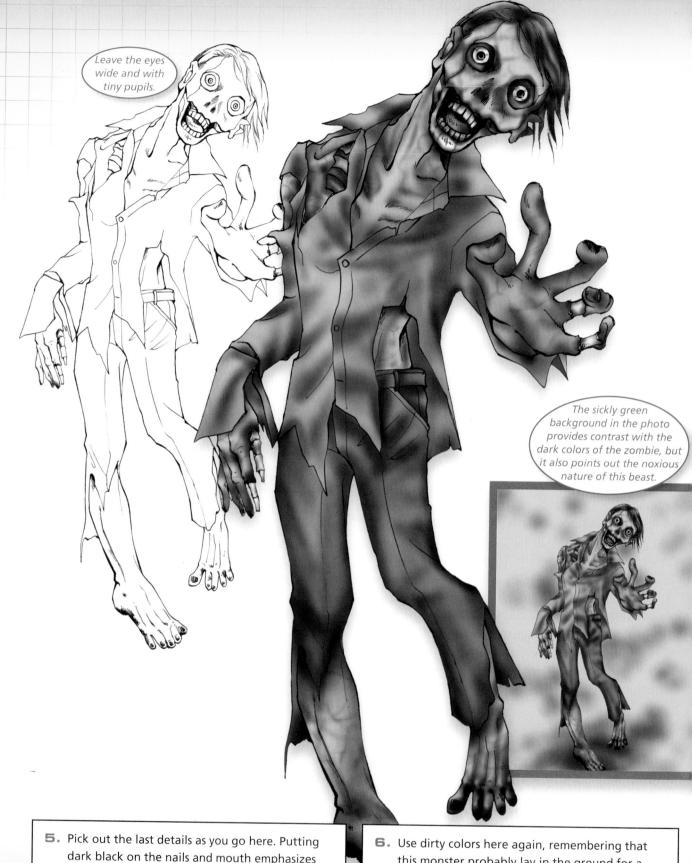

5. Pick out the last details as you go here. Putting dark black on the nails and mouth emphasizes the zombie's state of unlife.

6. Use dirty colors here again, remembering that this monster probably lay in the ground for a while.

Eastern Vampire

While Western vampires (which we'll get to in a bit) have insinuated themselves into nearly every aspect of modern culture, few folks are as familiar with the Eastern varieties. These come in many forms, but the most distinctive is the Chinese *hopping vampire*.

It almost seems like this beast is kneeling down to pray—but it's really out to find prey.

Tomoko adds in loops behind the vampire's ears to represent lengths of braided hair.

1. Start with your basic human shape, but position it so that it looks ready to hop out and grab you.

2. Show more of the creature's hands and clothing. Notice how the hands are almost limp here.

Manga-nese

Hopping vampires spring from Chinese legends about cadavers that jump after their prey, hungering for their lives. They often wear ancient clothes, but they can be dressed any way you like. Supposedly, you can avoid them if you hold your breath, as they can't see very well and find their prey by listening for their fearful breathing.

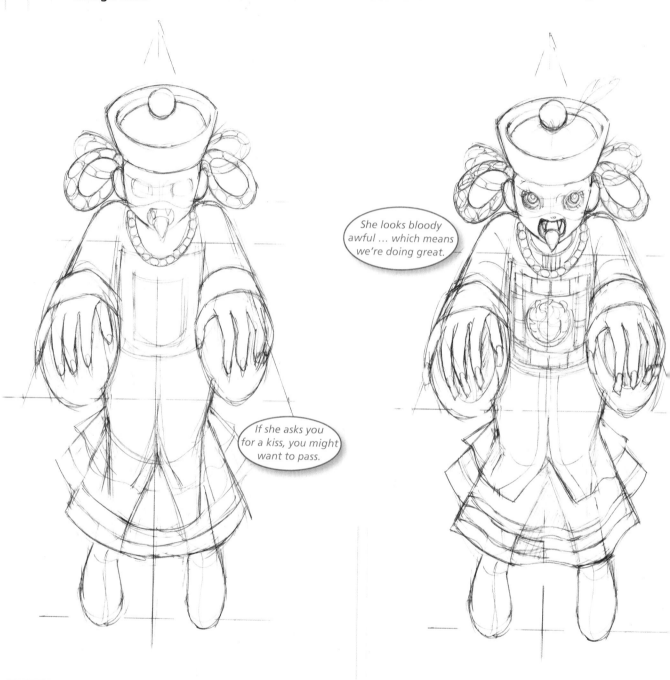

She looks bloody awful ... which means we're doing great.

If she asks you for a kiss, you might want to pass.

3. Work in more detail. Pay close attention to the face. Hopping vampires have long tongues that shoot out from between their fangs.

4. Refine the eyes and face. Extend the nails. Toss on some jewelry or Chinese designs, like the one on this monster's chest.

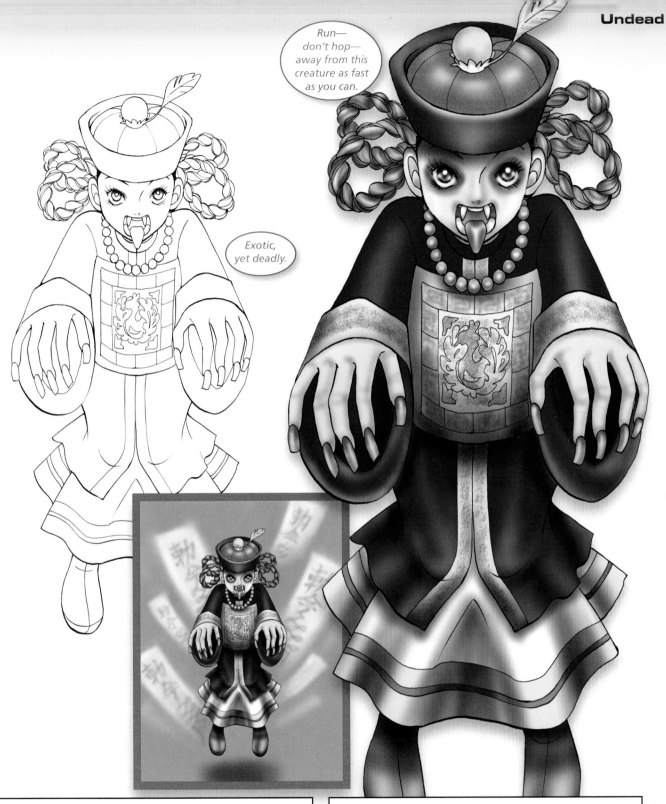

Run—don't hop—away from this creature as fast as you can.

Exotic, yet deadly.

5. Ink with clean lines. Use fainter lines for things like the embroidery on the creature's chest or the design along the hem of her robe.

6. Have fun with the colors. The skin should be pale, of course, but the clothing can be fine and clean and as colorful as you like. Using dark or bright colors highlights the inhuman paleness of the hopping vampire's flesh.

27

Western Vampire

If you don't recognize the Western-style vampire on sight, you've been living under a rock—maybe a headstone of your own. Ever since Bram Stoker wrote *Dracula*, the sexy, well-dressed vampire has been a core concept of Western culture. We've seen dozens of variations on the theme since, which gives you plenty of leeway when coming up with your own.

Tomoko adds a bit of flowing material behind the vampire, which could develop into a coat or a cape.

Tomoko puts large heels on the boots, perhaps to show that the vampire is vain enough to wish to be taller.

1. Start with a normal human figure. It's okay if it's a bit gaunt, but you don't see too many fat vampires. Put him in a proud, almost regal, stance.

2. Work in some more basic shapes over the skeleton. Here we can see the sleeves and lapels of the vampire's trench coat. All of this flows in a wind that swirls around the monster.

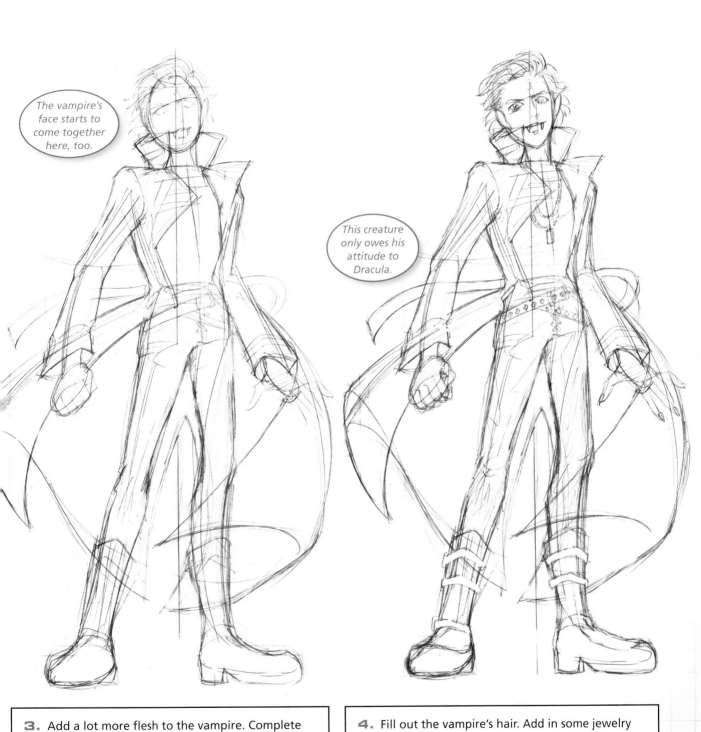

The vampire's face starts to come together here, too.

This creature only owes his attitude to Dracula.

3. Add a lot more flesh to the vampire. Complete the clothing. Show the fingers in the hands.

4. Fill out the vampire's hair. Add in some jewelry and a belt, and show some straps on the creature's boots.

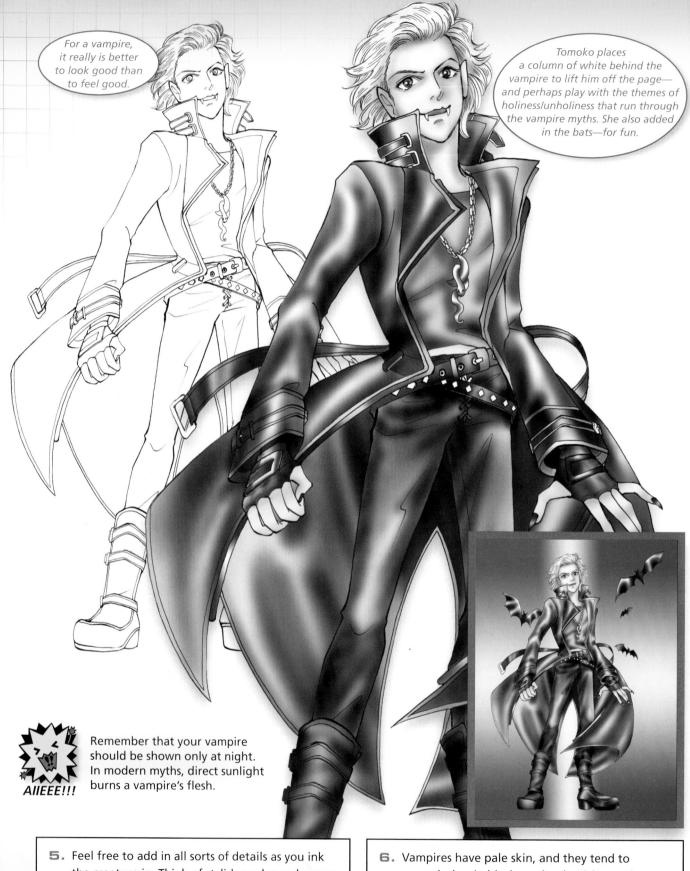

For a vampire, it really is better to look good than to feel good.

Tomoko places a column of white behind the vampire to lift him off the page—and perhaps play with the themes of holiness/unholiness that run through the vampire myths. She also added in the bats—for fun.

AIIEEE!!!

Remember that your vampire should be shown only at night. In modern myths, direct sunlight burns a vampire's flesh.

5. Feel free to add in all sorts of details as you ink the creature in. Think of stylish angles and curves as you go.

6. Vampires have pale skin, and they tend to wear clothes in blacks and reds. Pick a cool background to represent the night air in which most vampires roam.

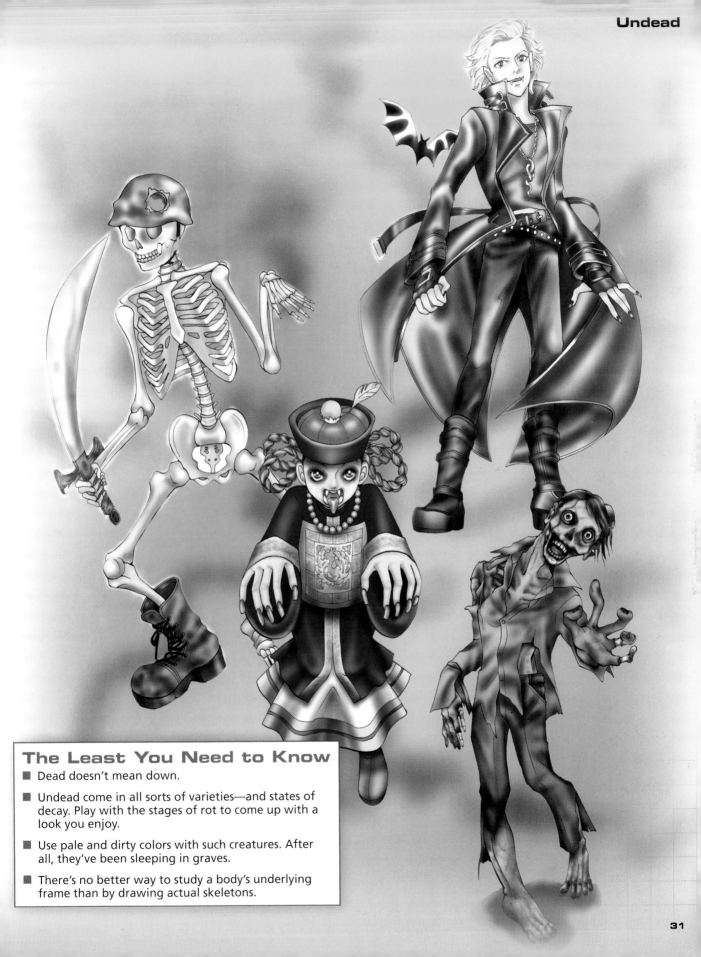

The Least You Need to Know

■ Dead doesn't mean down.

■ Undead come in all sorts of varieties—and states of decay. Play with the stages of rot to come up with a look you enjoy.

■ Use pale and dirty colors with such creatures. After all, they've been sleeping in graves.

■ There's no better way to study a body's underlying frame than by drawing actual skeletons.

Fairies & Giants: 3
Big and Small, Monsters All

In This Chapter

- Short mountain men with long beards
- Tiny women with wings
- Big, crude monsters
- Humongous, one-eyed monsters

Creatures come in all shapes and—just as important—sizes. Now that you've tried your hand at a few human-shaped creatures, it's time to branch out into something new.

For the moment, we're going to stick with humanoids, but we're going to fiddle with their sizes to show you what you can do with them. There's a long tradition in fantasy stories of creatures both great and small, after all.

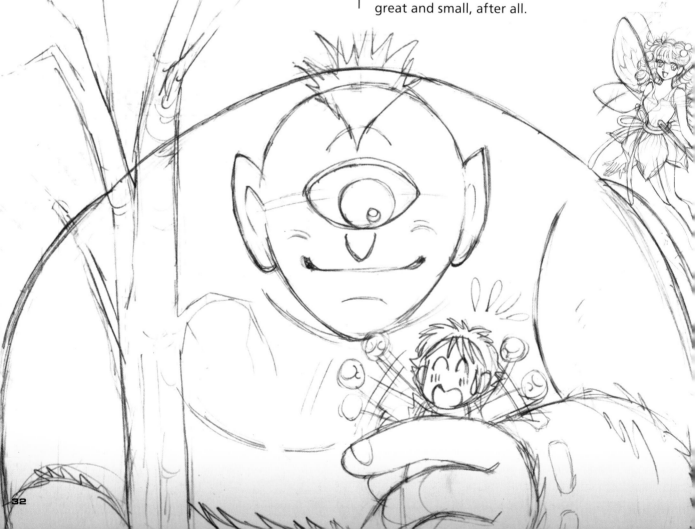

Size Matters

It's not just enough to draw a figure and then say, "Look how big he is. He's huge!" No matter what you say, it's still never going to be any bigger than the size of the paper on which you draw it. You can convey a sense of different sizes, though, by employing a few clever tricks.

Showing Scale

The easiest way to show that a creature is of an odd size is to draw it next to something that has a definite size. If you show a pixie leaning its elbow on the seams of a baseball, it should be clear that this is a tiny person next to a regular-sized ball, not a regular person next to a giant ball.

Conversely, if you show a giant leaning its elbow on a two-story house, it's obvious that the creature is a giant. Unless, of course, it's a regular-sized guy resting on a large dollhouse.

You can play with scale like this in all sorts of ways. The more detail you add to the drawing, the likelier it is that your viewer will instantly understand the size of the creature you've drawn.

AIIEEE!!!

If you're playing with perspective, it can be hard to show how things relate to each other with regard to size. When you want to be clear about sizes, be sure to place the creature and whatever you want to compare it to next to each other. Otherwise, you can fool the eye into thinking it's seeing something else.

Weighty Matters

Another way to show size differences is to add weight to your creature. In most cases, smaller creatures are slighter, while larger creatures are bulkier.

This isn't always the case, of course. The first set of drawings in this chapter focus on a squat—and small—dwarf, for example. In general, though, people expect fragile-looking creatures to be small and tough-stomping beasts to be big.

If you decide to reverse those generalizations for fun, be sure to use comparative objects in the illustration. Otherwise, the viewer may not have any clue as to what the creature's real size is.

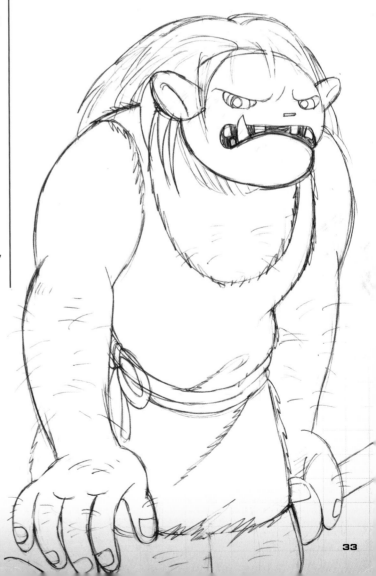

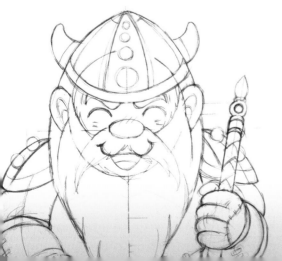

Dwarf

Dwarves are the classic short folk in fantasy stories. They stand between 3 and 5 feet tall, and the males all have long beards. They wear chain mail armor and carry hefty axes. They live in tunnels beneath mountains and spend their days mining metals and gems from the earth.

Chimeric Koans

Although the dwarves depicted in *The Lord of the Rings* are the kind most often seen in fantasy stories, they do come in all sorts of flavors. The only real requirement is that a dwarf be short. After that, it's up to you to play with the creature and make it your own.

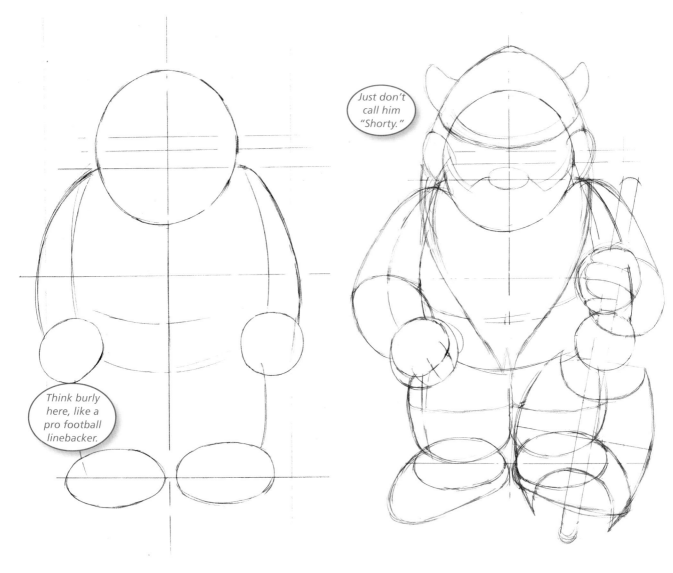

Just don't call him "Shorty."

Think burly here, like a pro football linebacker.

1. Break down the figure into the standard human shape. This time, though, we're going to shorten the limbs a bit more than the torso. This gives the creature the appearance of added weight.

2. Add in details like the helmet and beard. Put an axe in his hand.

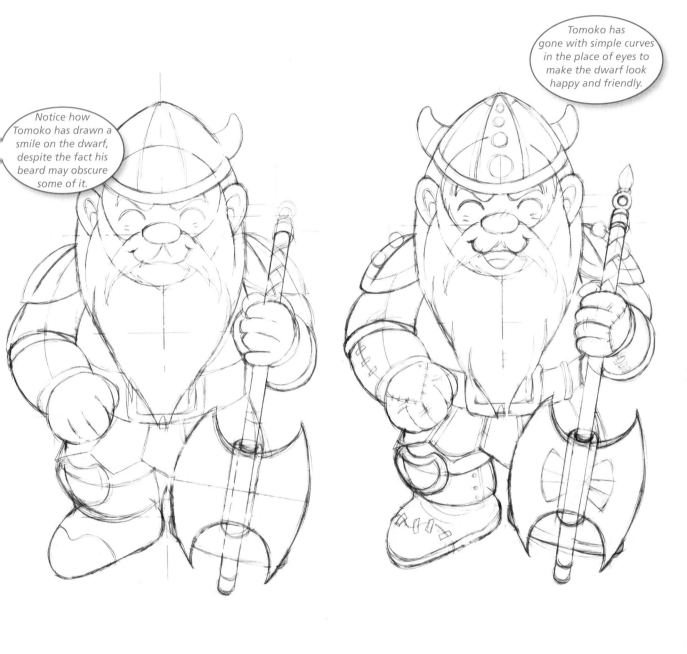

3. Flesh out the hands, and work the finer points of his face. Add shoulder and knee pads for his armor. Show the buckle on his belt and other accessories.

4. Finish up all the little bits. The decorations on the axe, armor, and helmet add a lot to the figure.

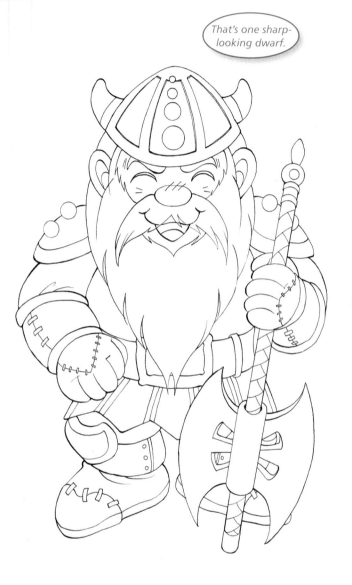

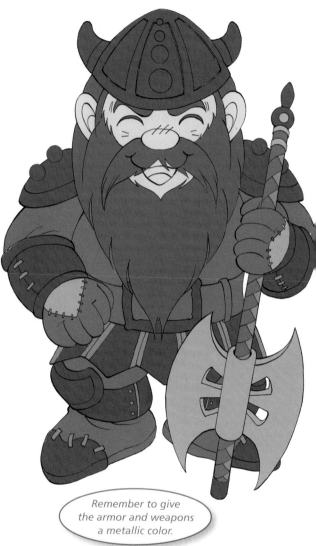

5. Ink in the last bits and remove the pencil lines.

6. Dwarves usually have pale skin and dark hair from being underground all the time. Choose whatever colors you like for the clothing. A bright color would contrast nicely against the rest.

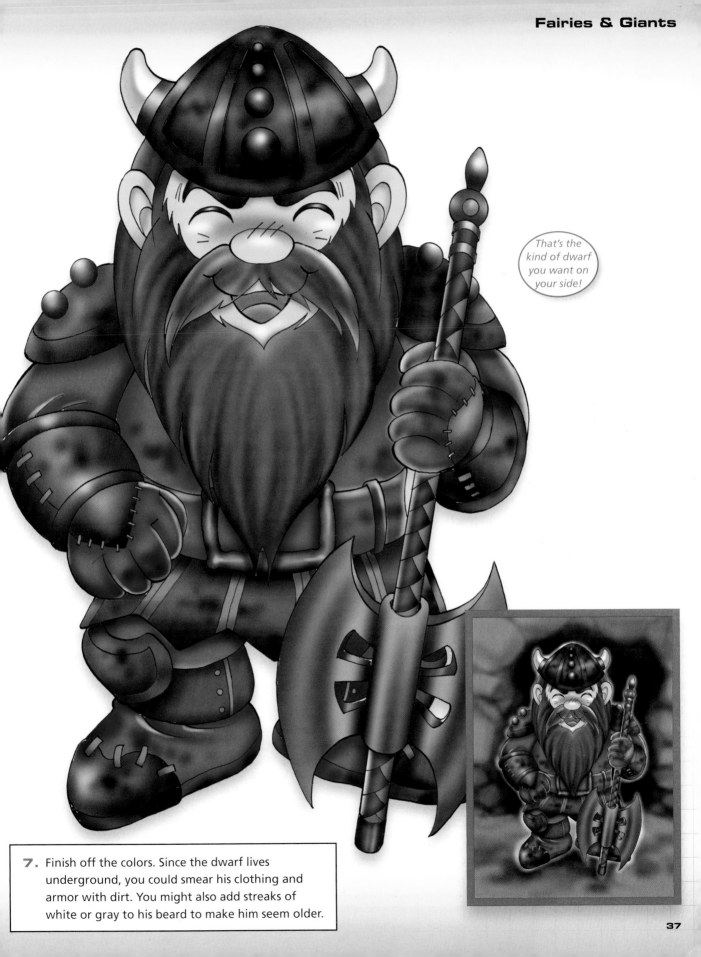

That's the kind of dwarf you want on your side!

7. Finish off the colors. Since the dwarf lives underground, you could smear his clothing and armor with dirt. You might also add streaks of white or gray to his beard to make him seem older.

Pixie

Pixies are a popular type of fairy that flits about on gossamer wings. They're small and light enough to stand on the palm of your hand, but they have the attitude of a giant.

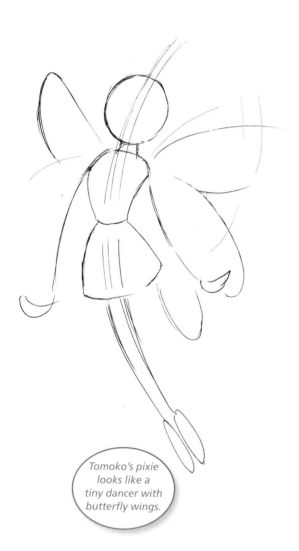

To show movement of the wings, you can use motion lines or, as Tomoko does here, sketch in some ghostly extra wings.

Tomoko's pixie looks like a tiny dancer with butterfly wings.

1. Pixies are thin and lithe. You can extend their arms and legs just a little bit to emphasize this, if you like.

2. Make the figure a bit more human here. Use long, gentle curves for the muscles in the limbs.

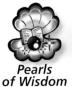

**Pearls
of Wisdom**

The most famous pixie of all is Tinkerbell from J. M. Barrie's
Peter Pan. You can model your own pixies on her, if you like, but
try giving them a twist. There's nothing like a punk pixie.

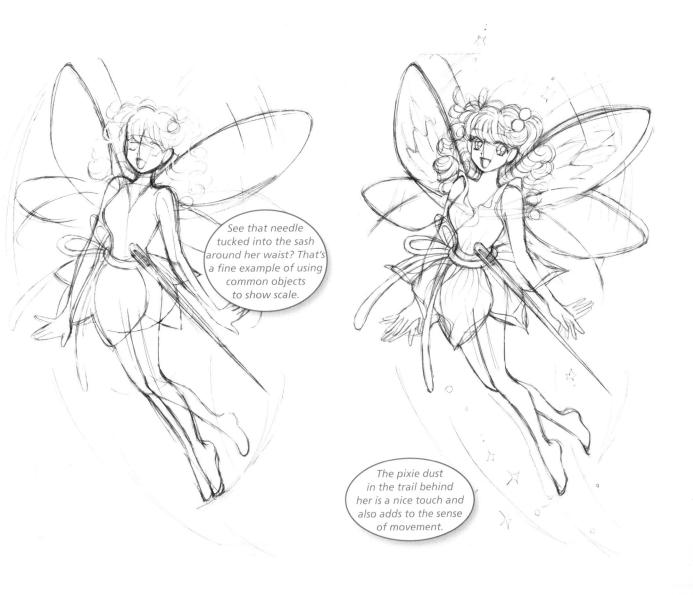

*See that needle
tucked into the sash
around her waist? That's
a fine example of using
common objects
to show scale.*

*The pixie dust
in the trail behind
her is a nice touch and
also adds to the sense
of movement.*

3. Now it's time to work in the elements that make
fairies so cute. Add hair, a skirt, and the details of
the face.

4. Decorate the wings, refine the lines, and
complete the eyes and mouth.

Hard to imagine that something like this could ever hide in a forest.

You don't even have to ink the motion lines at all if you wish. You can just show them in colors in the next step.

5. Bring the pixie to life here. Use lighter lines, especially on the wings, to show once more how light and airy she is.

6. Pixies come in all sorts of bright colors, often pinks, purples, and oranges. They make their clothes from leaves and flowers, again in bright colors.

Troll

Trolls stand about 9 feet tall and are mean, snaggle-toothed cranks. They don't have a social bone in their bodies, and can barely stand each other's company, much less that of the smaller folk.

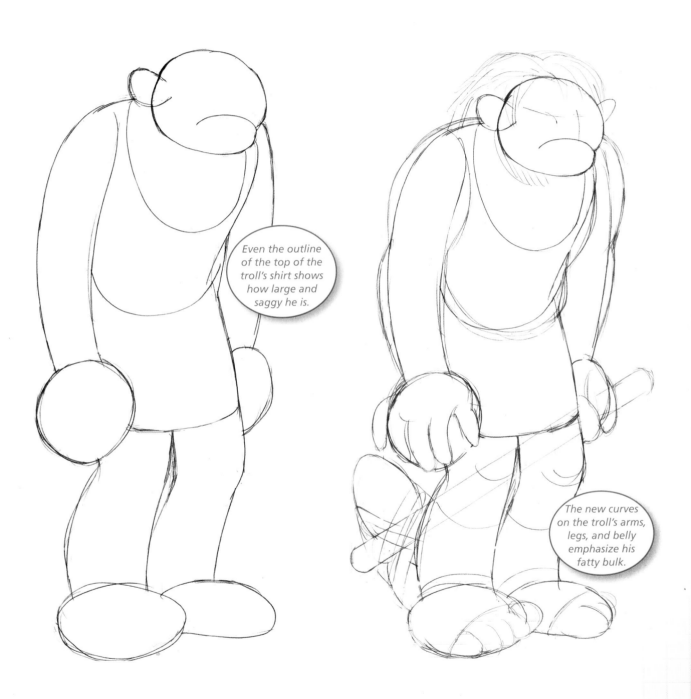

Even the outline of the top of the troll's shirt shows how large and saggy he is.

The new curves on the troll's arms, legs, and belly emphasize his fatty bulk.

1. To show how big this guy is, we use thick arms and legs with hands and feet like hams. The slouched shoulders make him look both mean and overburdened by his own weight.

2. Flesh out the muscles and fingers, and give the troll a rough-hewn axe, which he drags on the ground behind him. Add a miserable patch of hair to top things off.

Some legends say that trolls sprang from the earth in the dark of night. If sunlight strikes them, they turn to stone. For that reason, they only haunt the night. Or maybe they're just night owls. Who knows?

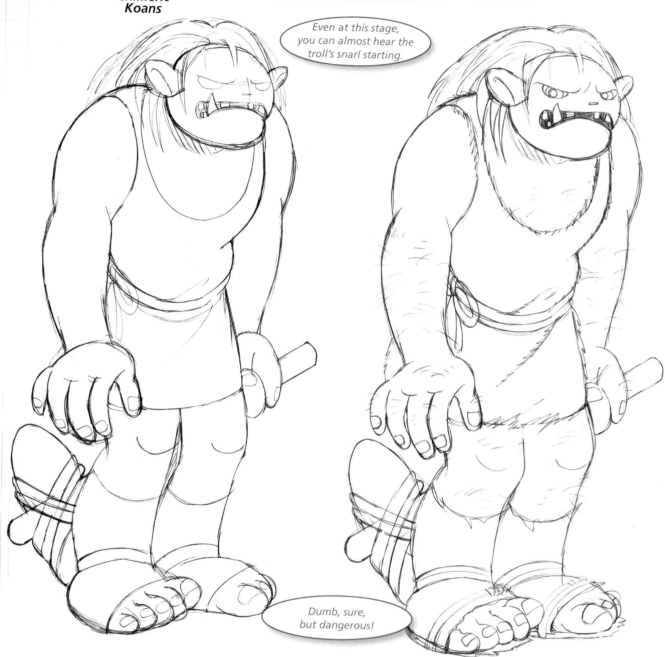

Even at this stage, you can almost hear the troll's snarl starting.

Dumb, sure, but dangerous!

3. Work on the face here. Add in those beady eyes set under a low forehead and toss some fangs into the bottom of that wide, angry jaw.

4. Finish up the details here. Show the beadiness of the eyes. Add hair across most of the creature's body. Fray the edges of his clothing.

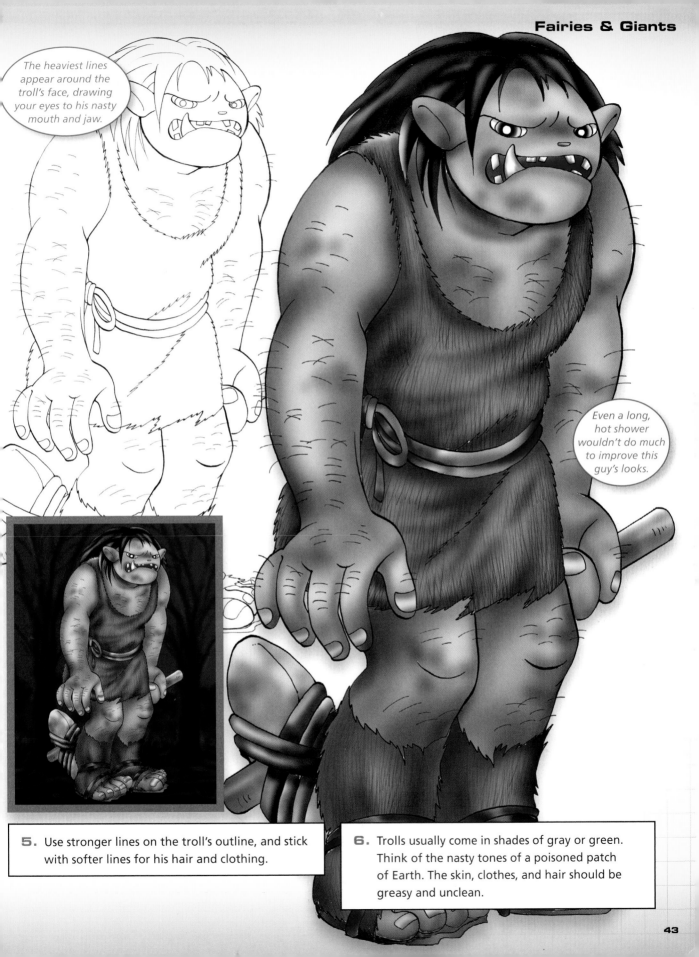

The heaviest lines appear around the troll's face, drawing your eyes to his nasty mouth and jaw.

Even a long, hot shower wouldn't do much to improve this guy's looks.

5. Use stronger lines on the troll's outline, and stick with softer lines for his hair and clothing.

6. Trolls usually come in shades of gray or green. Think of the nasty tones of a poisoned patch of Earth. The skin, clothes, and hair should be greasy and unclean.

Giant

Now that we've tackled a tall creature, it's time to pull out the stops and try out something truly gigantic. Giants are the leviathans of the land, massive creatures who use trees as walking sticks or clubs.

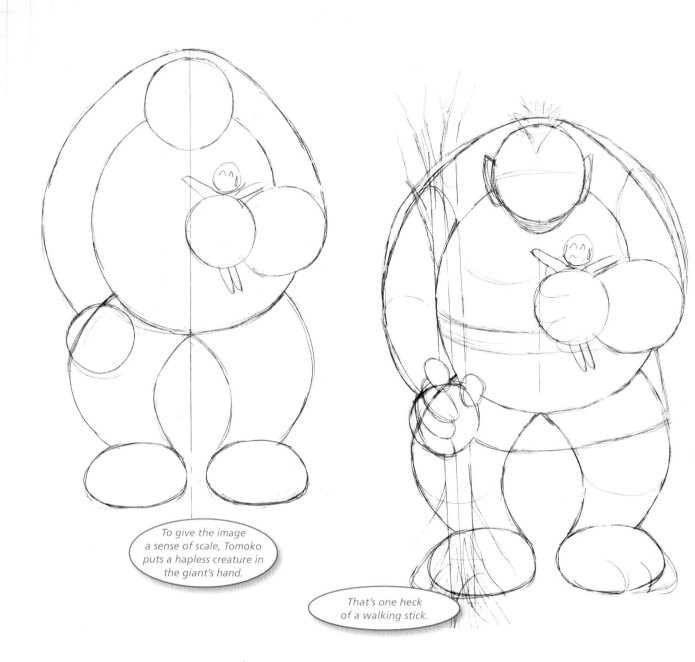

To give the image a sense of scale, Tomoko puts a hapless creature in the giant's hand.

That's one heck of a walking stick.

1. Begin with a human shape, but give it shoulders so huge and hunched that it seems like its head is set below them. Everything about the giant is round, including the shape its legs make.

2. Work in curves to define the giant's clothes. Put a tree in its hand to help with the sense of scale again. Give him some ears and put a tuft of hair on his head.

Pearls of Wisdom

Another way to emphasize the sheer size of something like a giant is to show only a part of it, like an eye, a hand, or a mouth. This implies that the creature is so large that it can't fit on a page, no matter how far away the viewer may be.

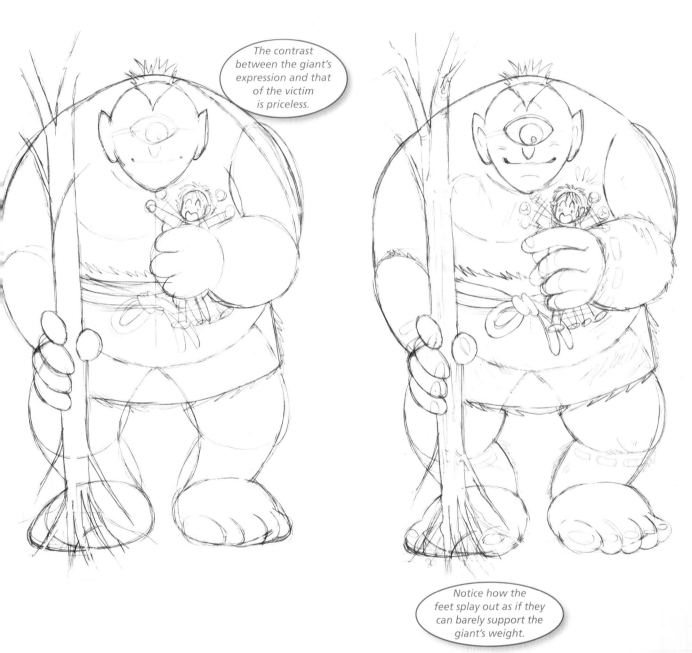

The contrast between the giant's expression and that of the victim is priceless.

Notice how the feet splay out as if they can barely support the giant's weight.

3. Show the eyes (or in this case, eye) and draw in ghosts of the victim's arms as it struggles to get free. Define the tree a bit more, as well as the giant's belt and tunic.

4. Show the edges of the giant's clothing, which is made from the fur of some massive animal, perhaps a wooly mammoth. It's not much more than a skirt because it's hard to find even that much material.

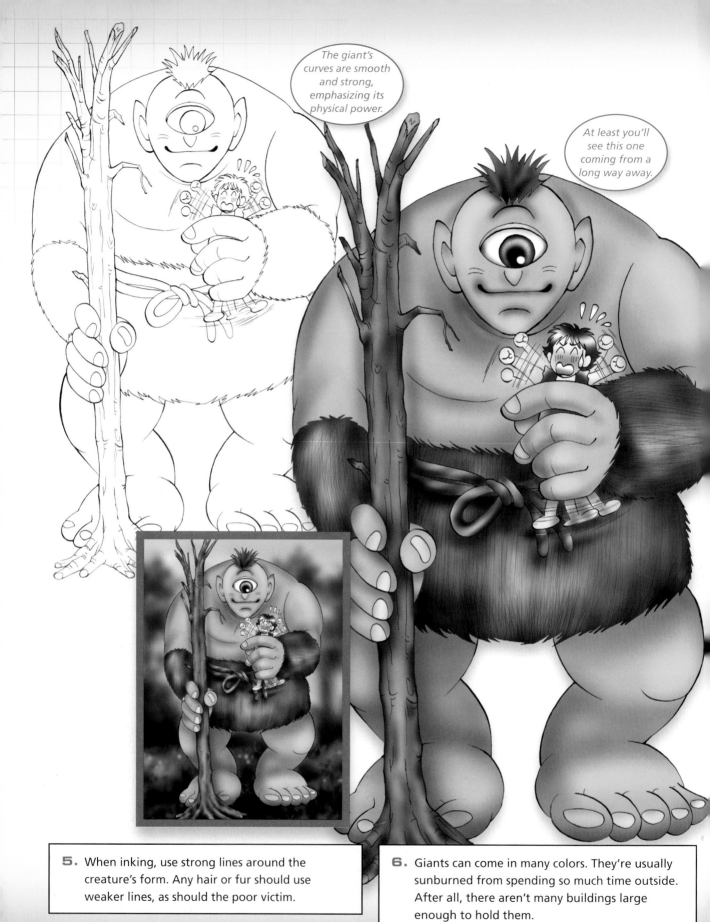

5. When inking, use strong lines around the creature's form. Any hair or fur should use weaker lines, as should the poor victim.

6. Giants can come in many colors. They're usually sunburned from spending so much time outside. After all, there aren't many buildings large enough to hold them.

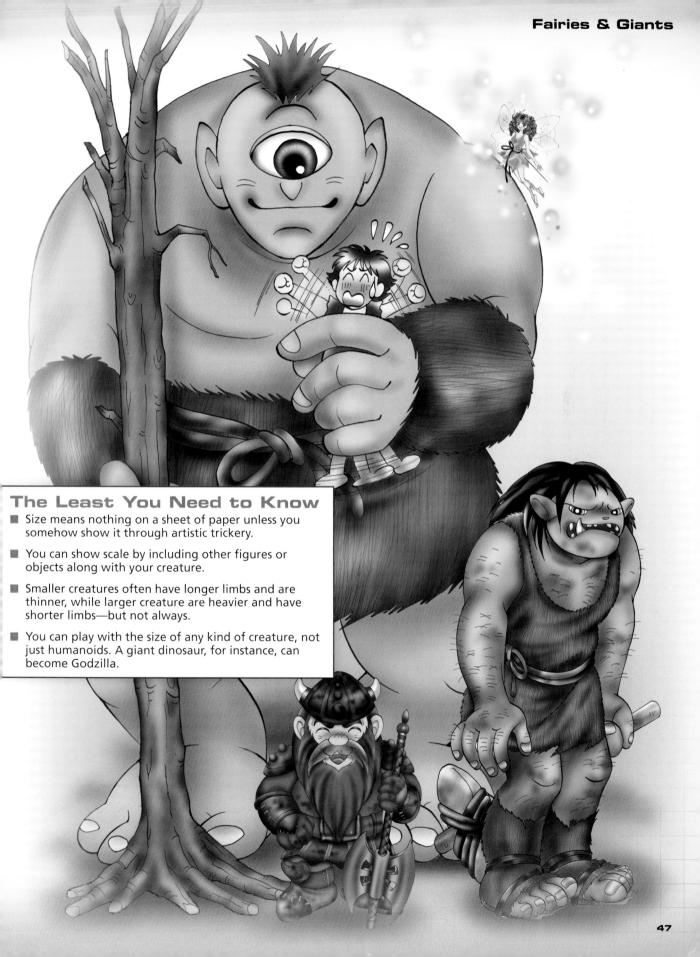

The Least You Need to Know

■ Size means nothing on a sheet of paper unless you somehow show it through artistic trickery.

■ You can show scale by including other figures or objects along with your creature.

■ Smaller creatures often have longer limbs and are thinner, while larger creature are heavier and have shorter limbs—but not always.

■ You can play with the size of any kind of creature, not just humanoids. A giant dinosaur, for instance, can become Godzilla.

Part 2
Beasts and Monsters

Here we leave humans behind and cover stranger forms. As before, we start with the basics: animals, ranging from beasts of burden to the most ferocious predators to walk the planet.

Then we take off on a fantastic flight and deal with demons, dragons, elementals, and creatures that fly high above or swim far below. Through-

out, we consider both Eastern and Western cultures and how our cultures affect our creatures.

In the end, we leave even our fair planet far behind in our search for exciting subjects for illustration. There are no lengths to which we won't go in our hunt for adventure and fun.

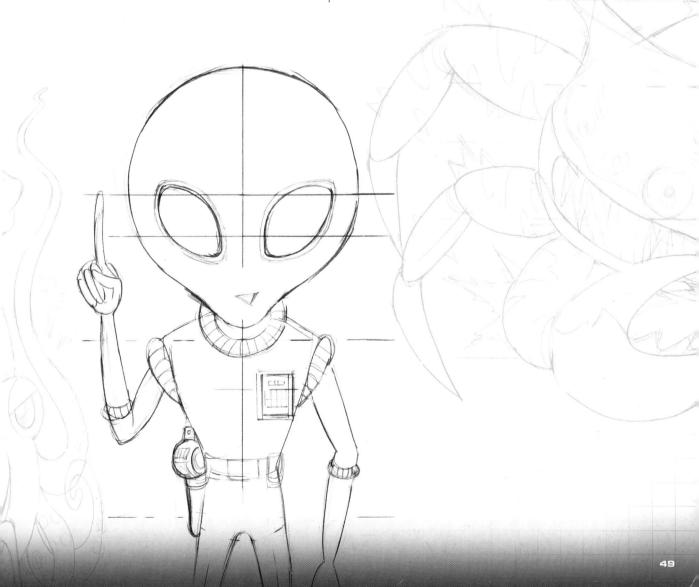

Animals:
Common Creatures Play Their Parts

In This Chapter

- Proud steeds, and pretty too
- Those who hunt in packs
- Bears bigger than a teddy
- Dangerous dinosaurs
- Hunting cats on the prowl

Drawing creatures that either are or resemble people can be great fun, but it's time to venture off that well-beaten path. Before we jump straight into crafting the strangest creature around, though, we need to go back to basics.

Certain kinds of creatures figure large in fantasy manga and literature of all types. We can all remember reading fairy tales where the hero encountered beautiful and exotic animals, such as the majestic unicorn, on his journey.

Such heroes fought all sorts of beasts as well, like bears or tigers. They might have even run into a massive lizard or—worse yet—a dinosaur. Now, as you draw these creatures, your imagination is the only limit.

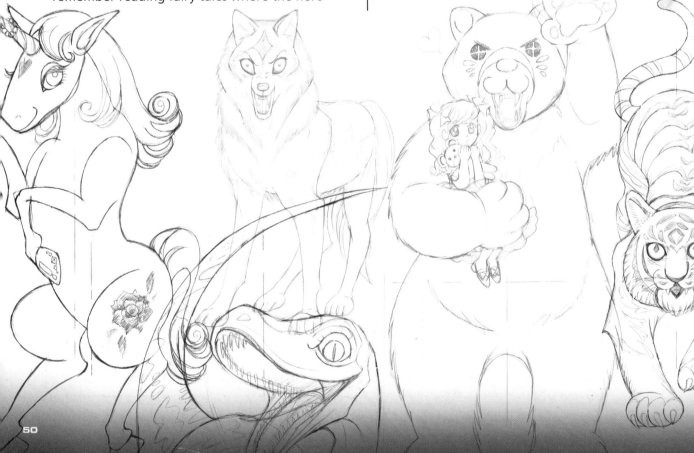

Unicorn

Many fantasy stories are set in medieval or feudal times, when people relied on animals for fast and reliable transportation. The most common sort was the horse. To liven things up a bit from the start, we'll play with the icon of the horse and give it a single horn atop its head. Instant unicorn!

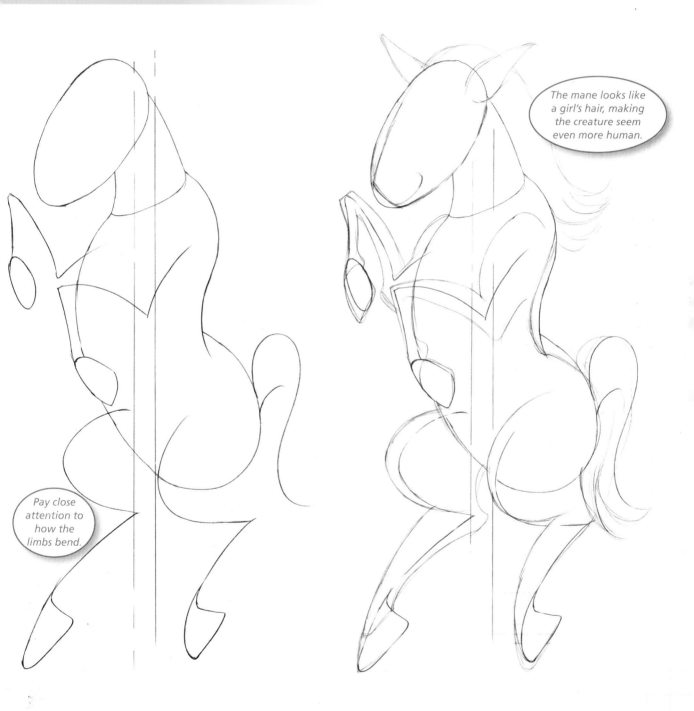

The mane looks like a girl's hair, making the creature seem even more human.

Pay close attention to how the limbs bend.

1. Start with your breakdown. Note how Tomoko puts the unicorn up on its hind legs. This both makes it seem more human and gives the creature a dynamic pose.

2. Add some bulk to the creature's body and limbs. Add its ears and mane.

While we're working with regular animals here, in many manga such creatures are as smart as humans and sometimes can even talk. To represent this, Tomoko has given the creatures eyes that are more human than they would be in reality.

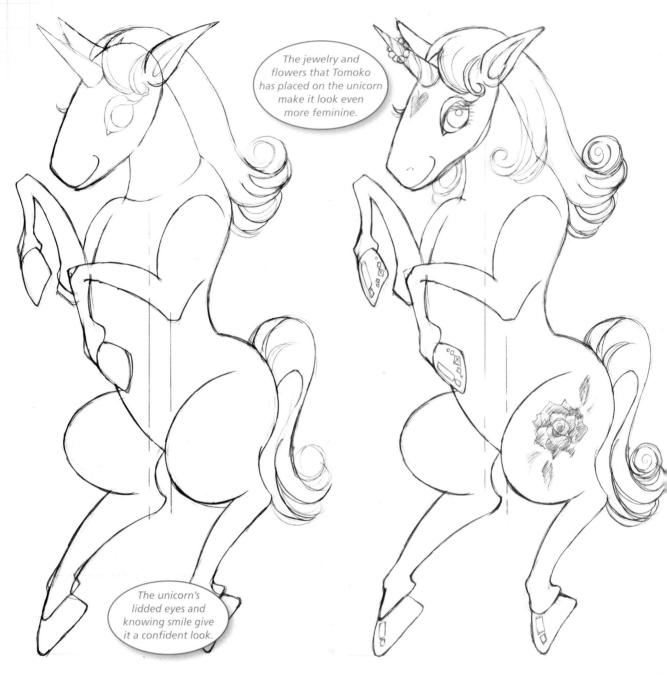

The jewelry and flowers that Tomoko has placed on the unicorn make it look even more feminine.

The unicorn's lidded eyes and knowing smile give it a confident look.

3. Refine the larger shapes. Add in the eyes and give some more depth to the hair.

4. Add in details like a shine on the creature's hooves, more hair, and so on.

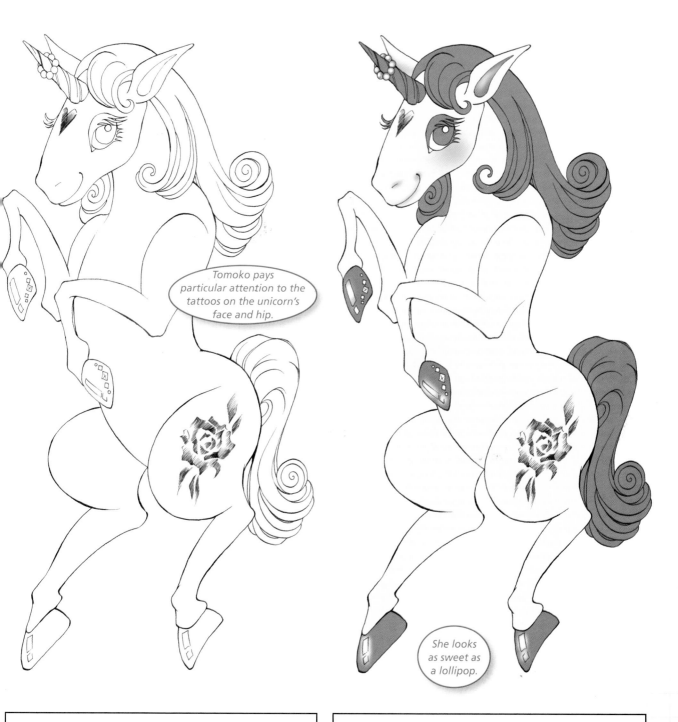

Tomoko pays particular attention to the tattoos on the unicorn's face and hip.

She looks as sweet as a lollipop.

5. With your inks, use stronger lines for the body and limbs and softer lines for the swirls in the hair and horn.

6. Since we've gone decidedly girly with this figure, use feminine colors as well. A soft cream for the body and crimson for the hooves, horn, and hair works well.

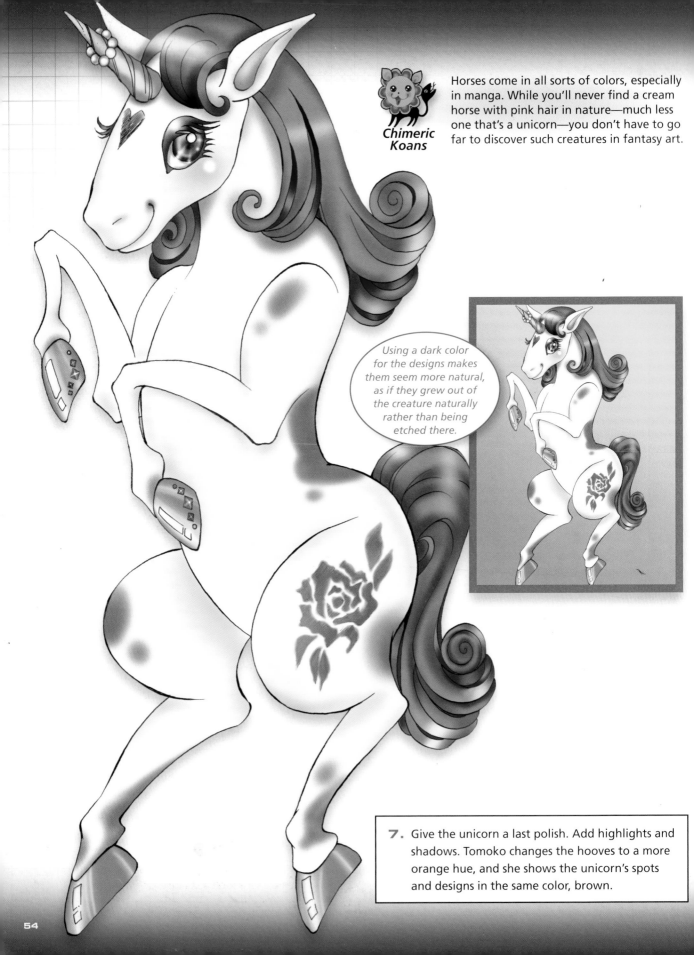

Horses come in all sorts of colors, especially in manga. While you'll never find a cream horse with pink hair in nature—much less one that's a unicorn—you don't have to go far to discover such creatures in fantasy art.

Using a dark color for the designs makes them seem more natural, as if they grew out of the creature naturally rather than being etched there.

7. Give the unicorn a last polish. Add highlights and shadows. Tomoko changes the hooves to a more orange hue, and she shows the unicorn's spots and designs in the same color, brown.

Wolf

Wolves have much of the same anatomy as dogs, although they tend to be far more feral and vicious. You can use the figure in this section as a model for a dog if you like. Just make the creature look a bit kinder in the end.

AIIEEE!!!

Because it's easy to confuse wolves and dogs, be sure to emphasize the figure's wolfish details. If you don't, your monster might end up coming off more like a puppy.

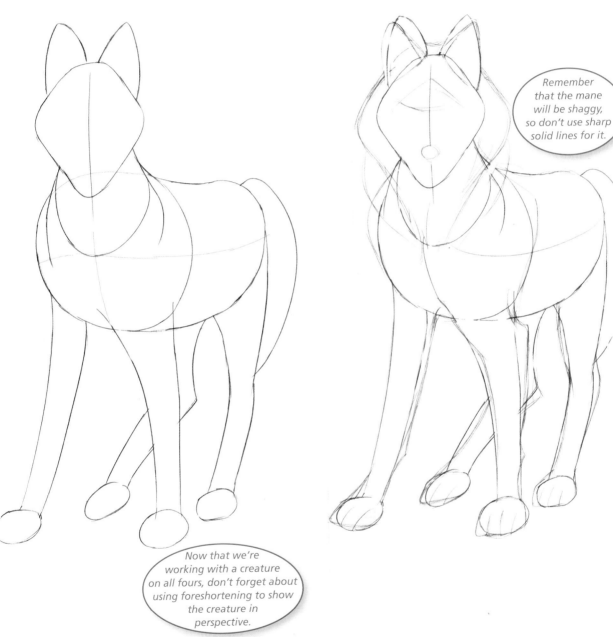

Remember that the mane will be shaggy, so don't use sharp solid lines for it.

Now that we're working with a creature on all fours, don't forget about using foreshortening to show the creature in perspective.

1. Break down the wolf's shape into simple parts. Pay close attention to how the limbs bend.

2. Add some bulk to the wolf. Give it a shaggy mane to make it look less like a dog.

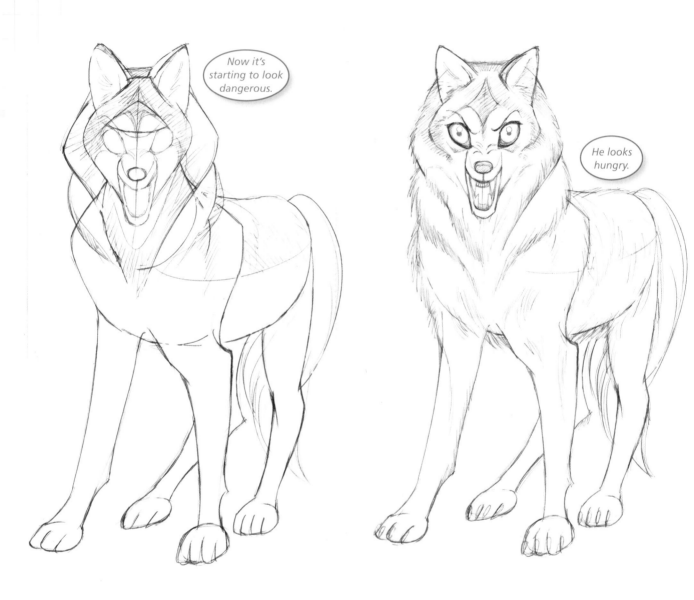

3. Concentrate on the wolf's face here. The cast of the eyes transforms it from animal into predator. Sketch in the variations of its coat, and flesh out its tail a bit.

4. Use fine, parallel lines (hatching) to shade in the fringes of the wolf's coat. This makes it look more natural, less like a cartoon. Add some pupils into those eyes and fill the mouth with teeth.

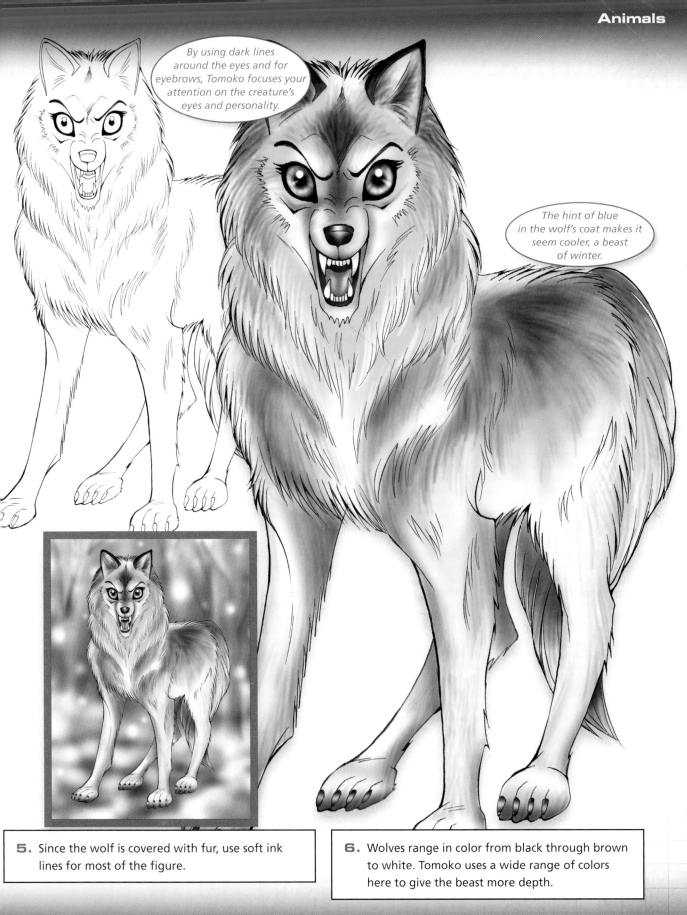

By using dark lines around the eyes and for eyebrows, Tomoko focuses your attention on the creature's eyes and personality.

The hint of blue in the wolf's coat makes it seem cooler, a beast of winter.

5. Since the wolf is covered with fur, use soft ink lines for most of the figure.

6. Wolves range in color from black through brown to white. Tomoko uses a wide range of colors here to give the beast more depth.

Bears are normally sedate and safe creatures—unless you threaten something they care about. In nature, this could be a mother bear's cub. In manga, though, it could be the bear's pet girl.

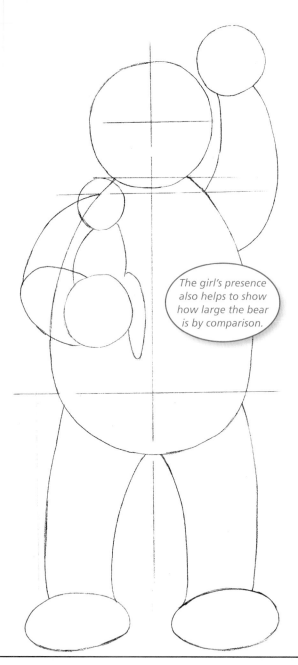

The girl's presence also helps to show how large the bear is by comparison.

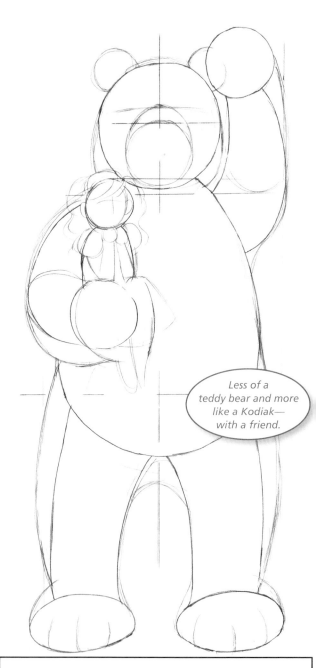

Less of a teddy bear and more like a Kodiak—with a friend.

1. Bears can rear up on their hind legs to attack, so Tomoko does that here to make the creature seem more human. The way the bear stands and holds the girl in its arms makes it seem more like a giant than an animal at this stage, but that's what we're shooting for.

2. Bulk up the bear a bit. This makes it look less like a giant. Add in the ears and sketch in the girl's hair. Is she just a doll herself? At this point, it's hard to tell.

AIIEEE!!!

Snouts can be tricky to draw, especially if you tackle them straight on. Tomoko shows the length of the bear's snout, despite the angle, by adding in the arched band over it. Without this, the bear might seem as if it had no snout at all.

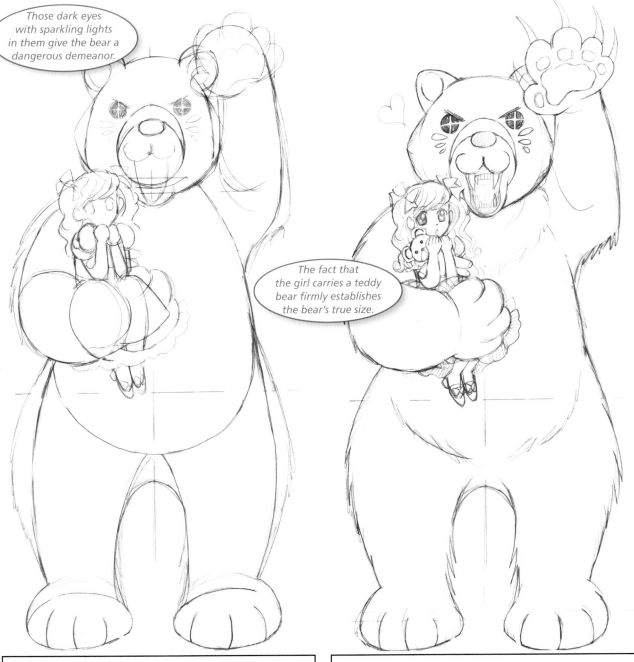

Those dark eyes with sparkling lights in them give the bear a dangerous demeanor.

The fact that the girl carries a teddy bear firmly establishes the bear's true size.

3. Cover the bear in fur and add some outstretched fingers to its paw. Separate them just a bit to show how the bear threatens the viewer.

4. Put talons on the bear and fill its mouth with savage teeth. The markings on the face help emphasize the shape of the beast's head.

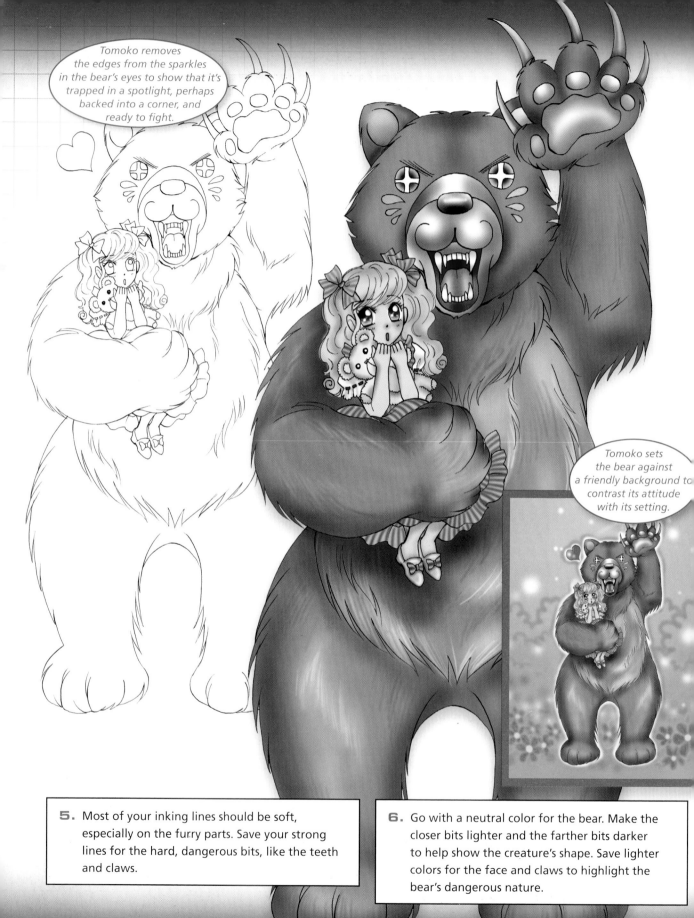

Tomoko removes the edges from the sparkles in the bear's eyes to show that it's trapped in a spotlight, perhaps backed into a corner, and ready to fight.

Tomoko sets the bear against a friendly background to contrast its attitude with its setting.

5. Most of your inking lines should be soft, especially on the furry parts. Save your strong lines for the hard, dangerous bits, like the teeth and claws.

6. Go with a neutral color for the bear. Make the closer bits lighter and the farther bits darker to help show the creature's shape. Save lighter colors for the face and claws to highlight the bear's dangerous nature.

Lizard

Lizards come in all sorts of shapes and sizes, from the lowly gecko right up to the Komodo dragon. We're going to try something even more outlandish and work with a dinosaur. By their cold-blooded nature, lizards are strange and creepy creatures when compared to mammals, and they make great villains.

Velociraptors are small, vicious dinosaurs that hunt for meat in packs. They mostly chase down other dinosaurs, but they're not all that picky. If you've seen *Jurassic Park*, you've seen velociraptors.

Manga-nese

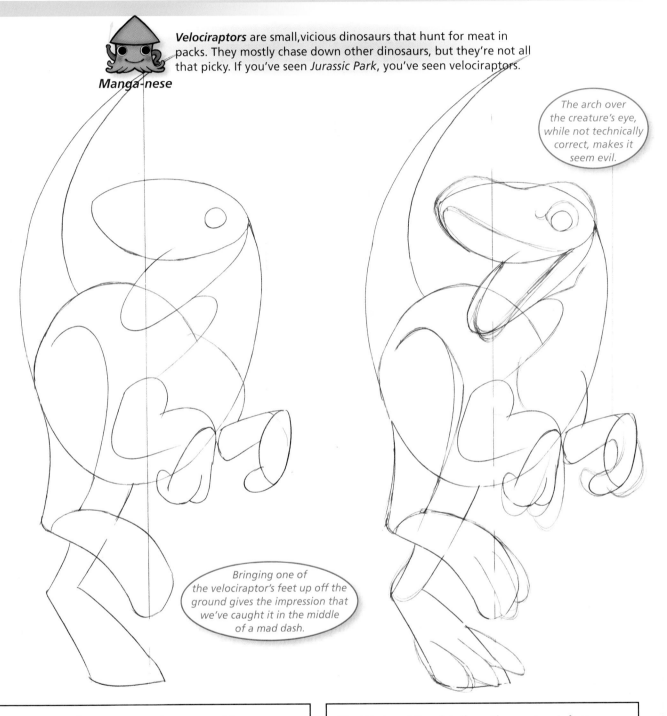

The arch over the creature's eye, while not technically correct, makes it seem evil.

Bringing one of the velociraptor's feet up off the ground gives the impression that we've caught it in the middle of a mad dash.

1. For our figure, we're going to go with a *velociraptor,* one of the most dangerous of all the great lizards. Note how the shapes break down. The legs fold backward, and the arms are smaller and droop into claws. The long neck twists back on itself.

2. Work out the details on the creature's face, arms, and feet. These help make it seem like it's moving fast.

Chimeric Koans

No one really knows what color a dinosaur's skin was, although scientists have all sorts of theories. Take advantage of that to color your dinosaur the way you want it to look, and then declare it to be authentic!

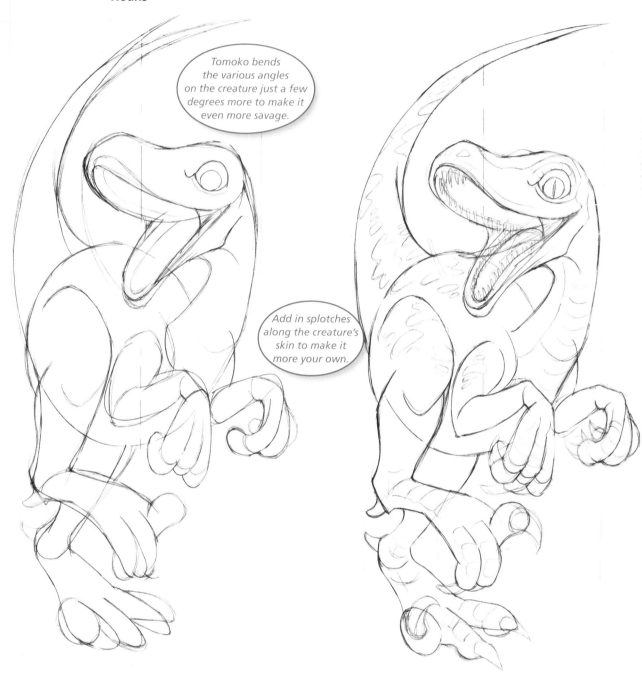

Tomoko bends the various angles on the creature just a few degrees more to make it even more savage.

Add in splotches along the creature's skin to make it more your own.

3. Add in some more details. Note how Tomoko moves some of the velociraptor's talons into the attack position. She also added some muscle lines to the creature's body and legs.

4. Finish off the eyes, work in some scales, and pick out the dangerous parts. Notice the talons and the teeth.

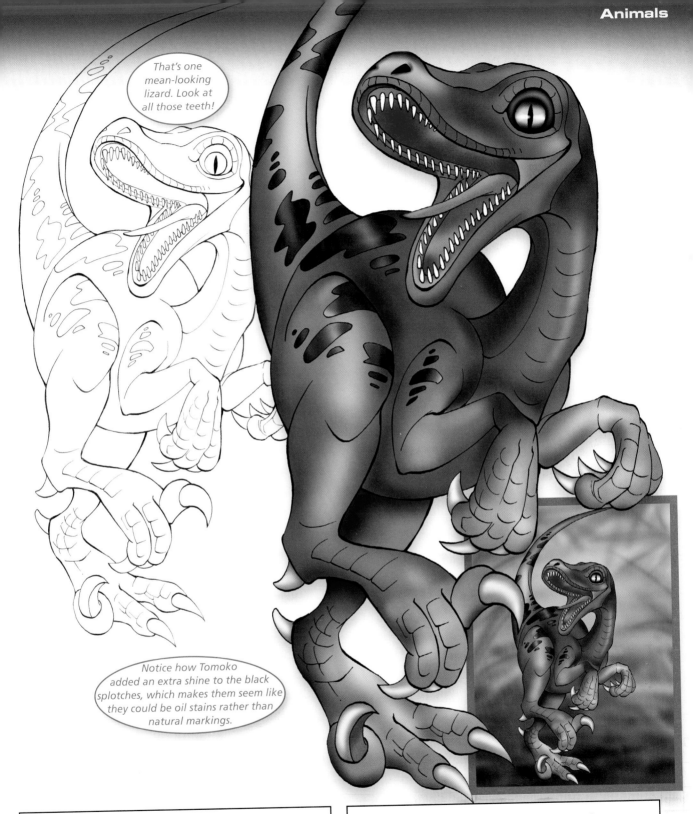

5. Use strong ink lines along the edges of the creature's body. Show scales and splotches in weaker lines. You can pick these out better later in the coloring stage.

6. For the sake of variety, Tomoko makes her velociraptor stick out against its jungle background. Perhaps that's why these beasties are now extinct: poor coloration.

Tiger

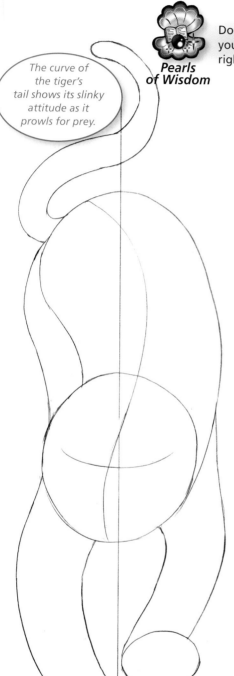

Pearls of Wisdom

Don't be afraid to change a pose, even just a little bit, once you get started. In Step 1, the tiger's head is canted to its right, but in Step 2, we can see that it's coming straight at us.

The curve of the tiger's tail shows its slinky attitude as it prowls for prey.

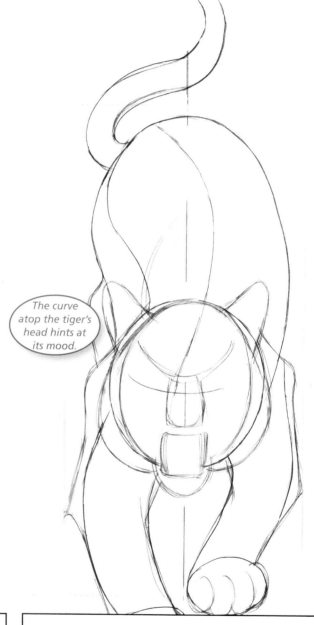

The curve atop the tiger's head hints at its mood.

1. Tomoko chooses to go with a high shot of a tiger coming straight at us. Imagine yourself sitting in a tree in the jungle and watching this beast prowl toward you. Notice that the tiger's body hides most of its back legs, but the shape of the back and the tail show the creature's length.

2. Add some bulk to the tiger's head and shoulders. Leave its hindquarters sleek. This brings the eye forward to the creature's front.

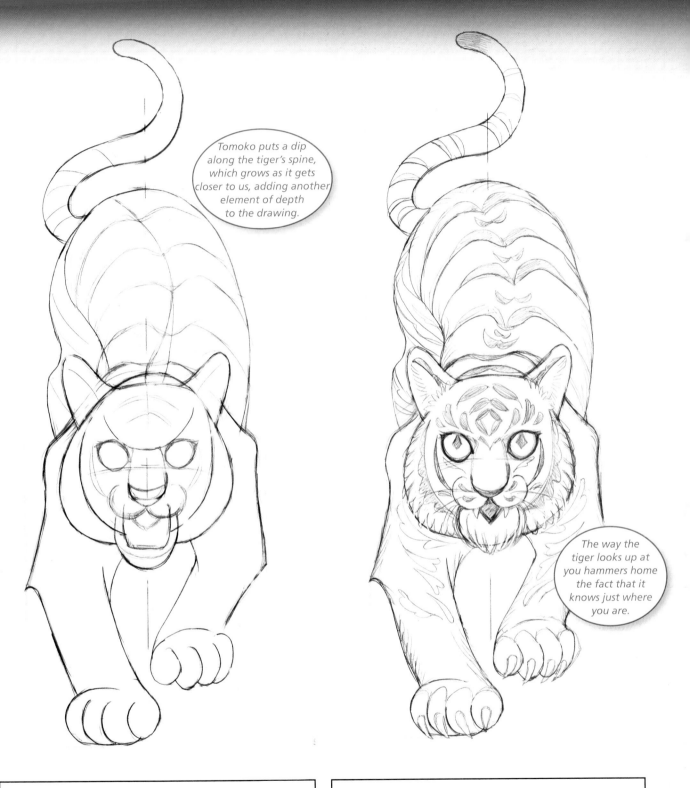

Tomoko puts a dip along the tiger's spine, which grows as it gets closer to us, adding another element of depth to the drawing.

The way the tiger looks up at you hammers home the fact that it knows just where you are.

3. Add in some lines to use as a frame of the tiger's unique markings. Work in the creature's eyes and snout.

4. Pay close attention to the tiger's markings. Fill in the pupils, and put some teeth in that beast's bite.

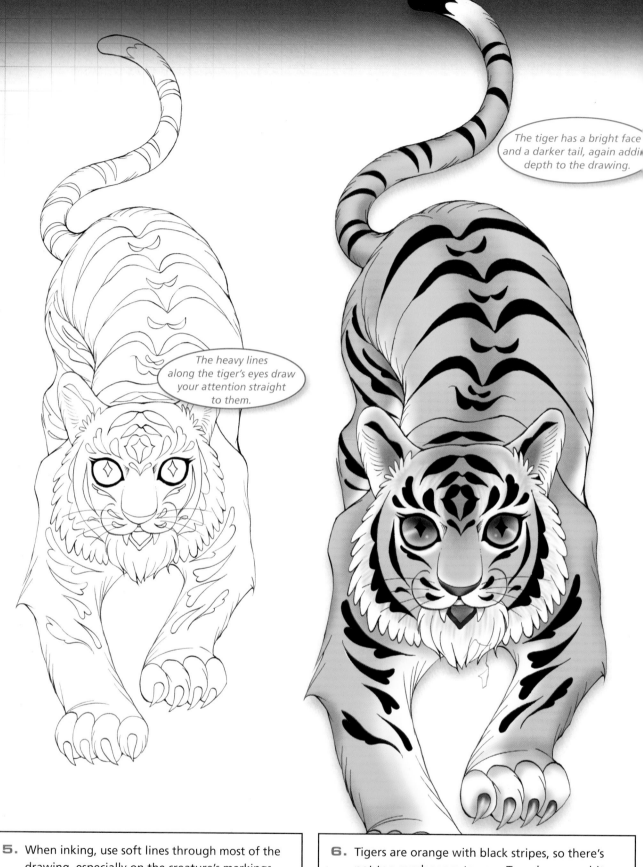

The heavy lines along the tiger's eyes draw your attention straight to them.

The tiger has a bright face and a darker tail, again addi[ng] depth to the drawing.

5. When inking, use soft lines through most of the drawing, especially on the creature's markings. When coloring the creature later, you can really bring those out.

6. Tigers are orange with black stripes, so there's not too much room to vary. Tomoko uses white to add in some highlights near the tiger's front.

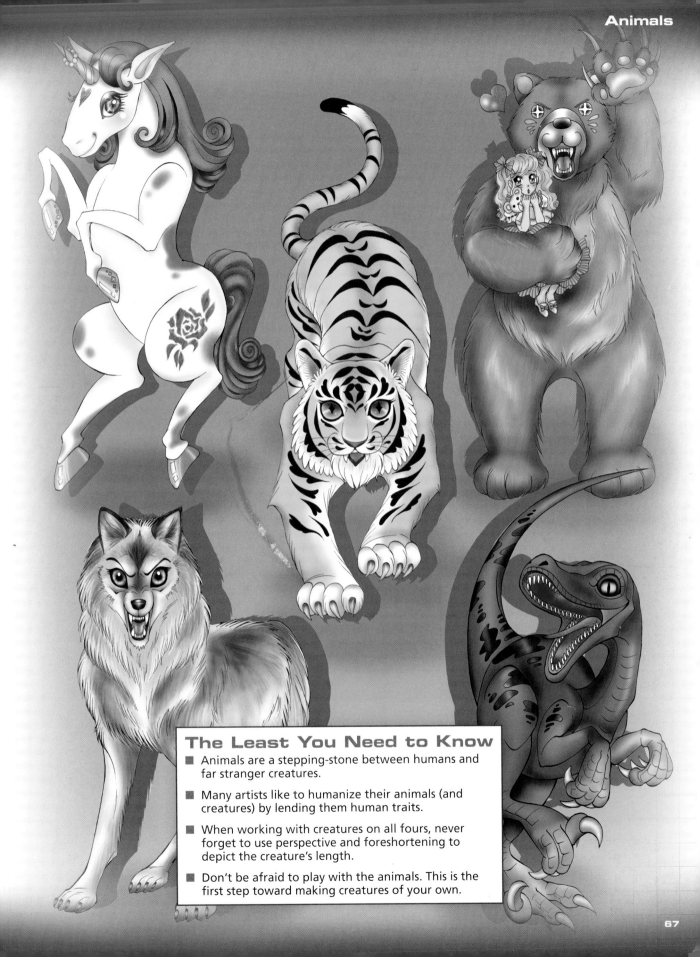

The Least You Need to Know

■ Animals are a stepping-stone between humans and far stranger creatures.

■ Many artists like to humanize their animals (and creatures) by lending them human traits.

■ When working with creatures on all fours, never forget to use perspective and foreshortening to depict the creature's length.

■ Don't be afraid to play with the animals. This is the first step toward making creatures of your own.

Demons & Dragons:
The Worst of the Worst

5

In This Chapter

- Demons from Hell
- Dragons from European myth
- An oni with an iron club
- Dragons from Asian myth

Of all the creatures of myth and legend, the two types that inspire the most fear—and the most stories—are demons and dragons. It's no surprise that these archetypal creatures can be found in all sorts of societies throughout the world. The idea of a giant, winged snake, or a red-skinned creature from Hell catches fire in all but the dullest imaginations.

Just because these creatures appear in different cultures, though, doesn't mean they're identical in every case. While most Westerners could probably recognize an oni (a Japanese creature) as a demon, they can also tell at a glance that this monster is not one of their own.

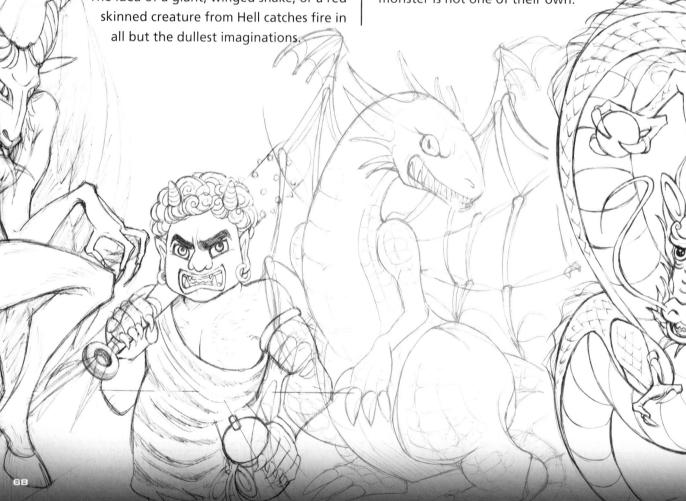

Western Demon

A huge variety of demons populate Western (Judeo-Christian, for these purposes) art and literature. Despite this, they often have a few things in common that make them easy to recognize: horns, reddish skin, often wings (either batlike or feathered), forked tongues, and the like.

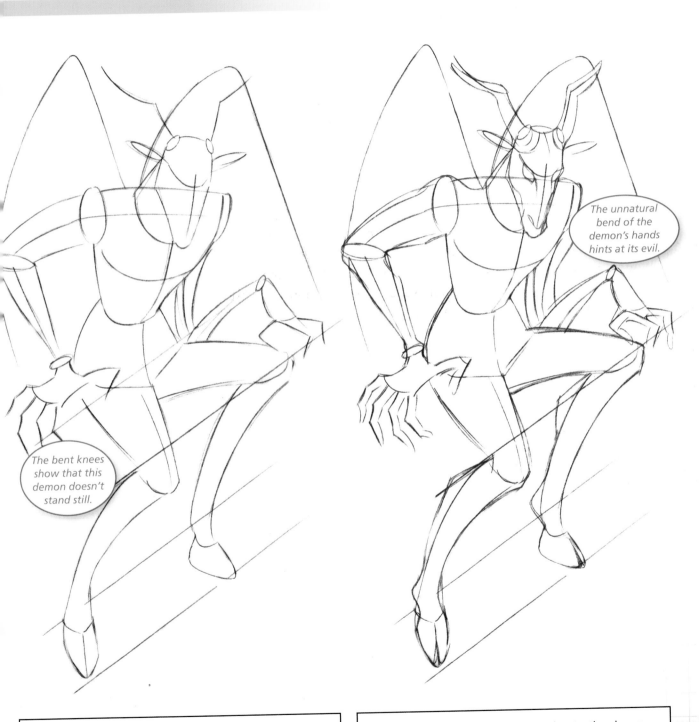

The bent knees show that this demon doesn't stand still.

The unnatural bend of the demon's hands hints at its evil.

1. Start with your basic shapes. Include the creature's wings. Note how the head is shaped like a stag and the hands have long, dangerous fingers.

2. Build in some bulk. Pay attention to the cloven feet and the stretching horns.

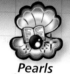

**Pearls
of Wisdom**

You don't have to include every possible visual cue for a Western demon in your creations. Often, it's enough to just add a set of tiny horns to a normal person, or a snake's eyes. These subtler creatures can be all the more appalling.

The arch of the wings shows that this demon is hovering, ready to attack.

The feathers remind the viewer that some demons are fallen angels.

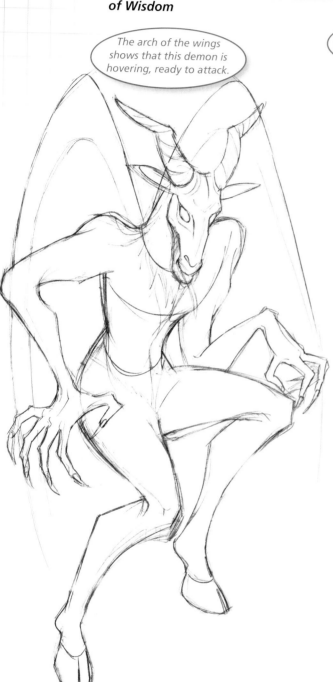

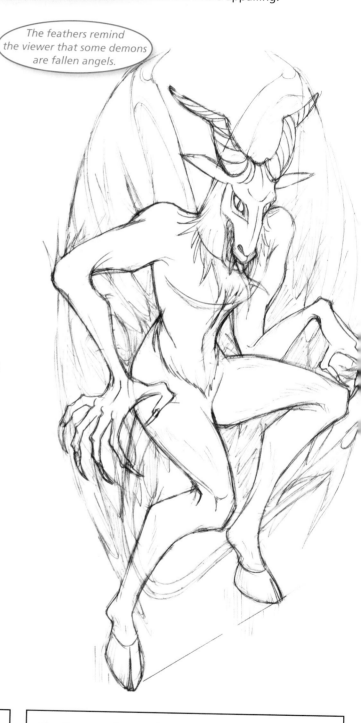

3. Refine the figure's edges. Pick out details on the face and fingers. Rough in the arch of the wings better.

4. Remove the roughed-in lines and add a fringe around the creature's neck. Show the feathers on the wings. Add in a tail.

Chimeric Koans

Monsters of all sorts are tied to the cultures from which they spring. When drawing or creating your creatures, use this to give your concoctions their own distinctive points. Think about how, for instance, a sea serpent from the Mississippi delta would look different than one found in Lake Superior or the Gulf of Mexico.

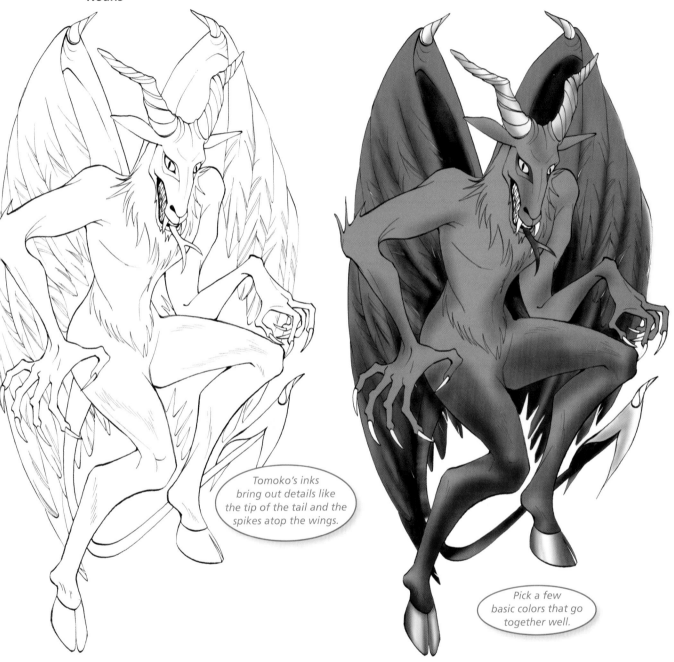

Tomoko's inks bring out details like the tip of the tail and the spikes atop the wings.

Pick a few basic colors that go together well.

5. For the inks, use stronger lines on the demon's edges. The ruffles on its fur and on the feathers should be softer.

6. Western demons often come in red. Make the wings black to provide contrast with the red, and color the dangerous parts—hooves, talons, spikes, horns—white to make those parts pop.

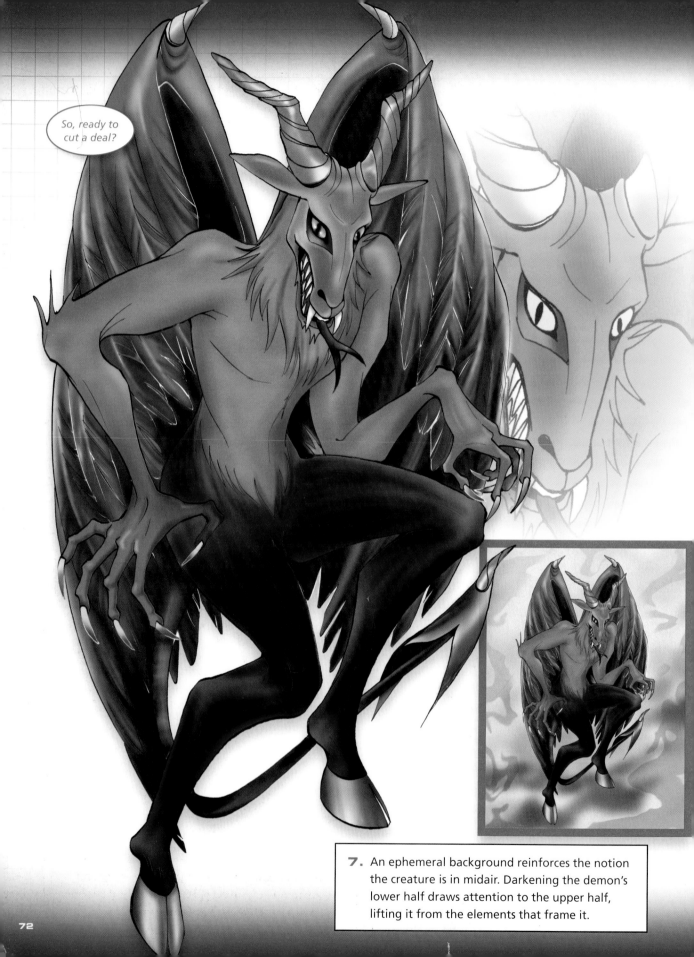

So, ready to cut a deal?

7. An ephemeral background reinforces the notion the creature is in midair. Darkening the demon's lower half draws attention to the upper half, lifting it from the elements that frame it.

Western Dragon

In medieval tales, Western dragons may have once looked more like thin and twisting wyrms, but in modern myths they look more like massive killing machines. Reptilian features, mouths filled with teeth, and batlike wings show up in most versions. Not all dragons are evil, and some can even be cute, if you like.

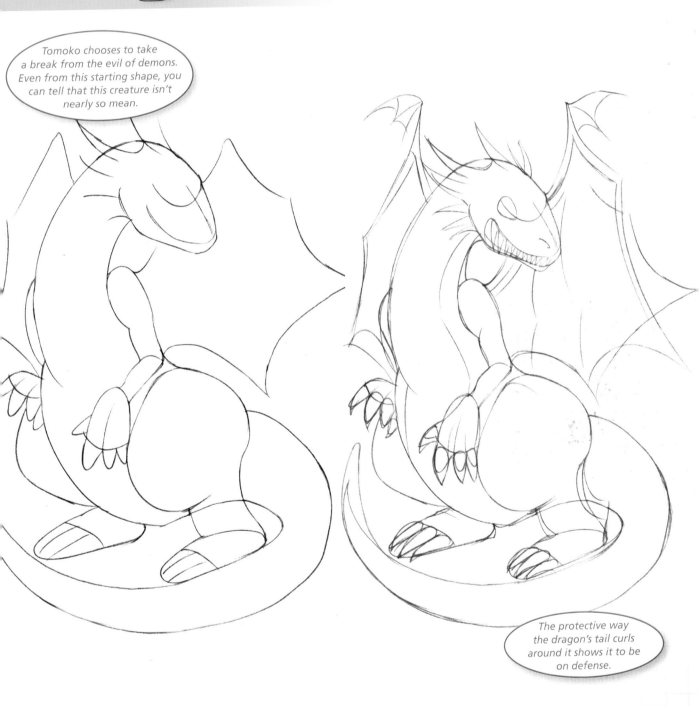

Tomoko chooses to take a break from the evil of demons. Even from this starting shape, you can tell that this creature isn't nearly so mean.

The protective way the dragon's tail curls around it shows it to be on defense.

1. Western dragons tend to be large and powerful. They sit on thick haunches and have batlike wings and a thick tail.

2. Add in details like the edges of the wings and an outline of the dragon's underbelly, which will come in a different color when we're done.

While demons come in lots of different forms, the archetype of a dragon is less flexible. If you're drawing a creature that comes without wings or doesn't have scales, you probably have something other than a dragon on your hands.

The wide, round eyes give the dragon an inhuman look while still maintaining its innocence.

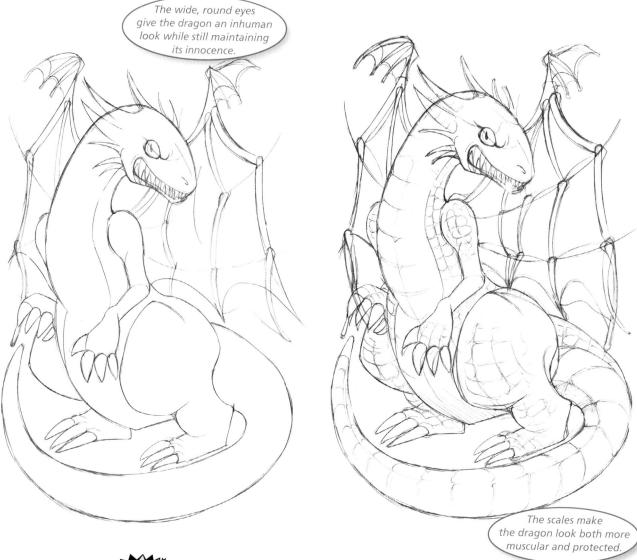

The scales make the dragon look both more muscular and protected.

AIIEEE!!!

This dragon shows just why you should use lines of different weight. If you used only lines of the same weight, the creature's scales would chop the creature up into a checkerboard.

3. Pick out more details, like the bones that run through the dragon's wings. These make the figure more solid.

4. Show the scales here. On a dragon, this is a big job, as they cover almost the entire creature.

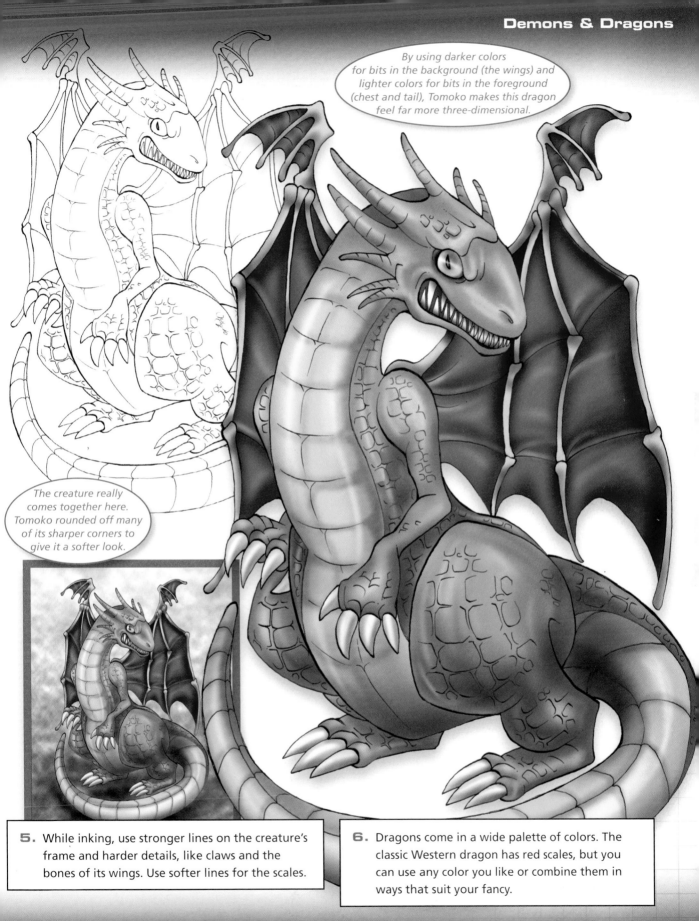

By using darker colors for bits in the background (the wings) and lighter colors for bits in the foreground (chest and tail), Tomoko makes this dragon feel far more three-dimensional.

The creature really comes together here. Tomoko rounded off many of its sharper corners to give it a softer look.

5. While inking, use stronger lines on the creature's frame and harder details, like claws and the bones of its wings. Use softer lines for the scales.

6. Dragons come in a wide palette of colors. The classic Western dragon has red scales, but you can use any color you like or combine them in ways that suit your fancy.

Eastern Demon

Demons across the world have a few details in common. Usually if you point out that a creature is a demon, someone can spot this, no matter if they're from Japan or the United States. To illustrate this point (literally), we're going to tackle an oni.

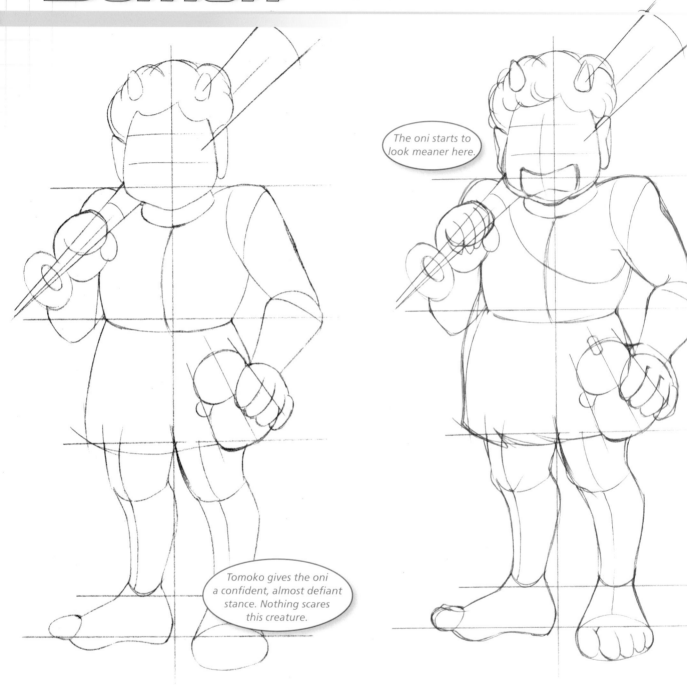

The oni starts to look meaner here.

Tomoko gives the oni a confident, almost defiant stance. Nothing scares this creature.

1. The oni is a broad creature with thick arms. It carries a club over its shoulder.

2. Add in some more details. The hair is traditionally curly, and an oni holds its mouth in a grimace.

Pearls of Wisdom

Oni come in all sorts of colors, although reds, blues, blacks, and greens are most common; and they usually carry an iron club called a *kanabo*. Parents sometimes use tales of oni to scare naughty children. When Japanese kids play tag, the one who is it is called the oni.

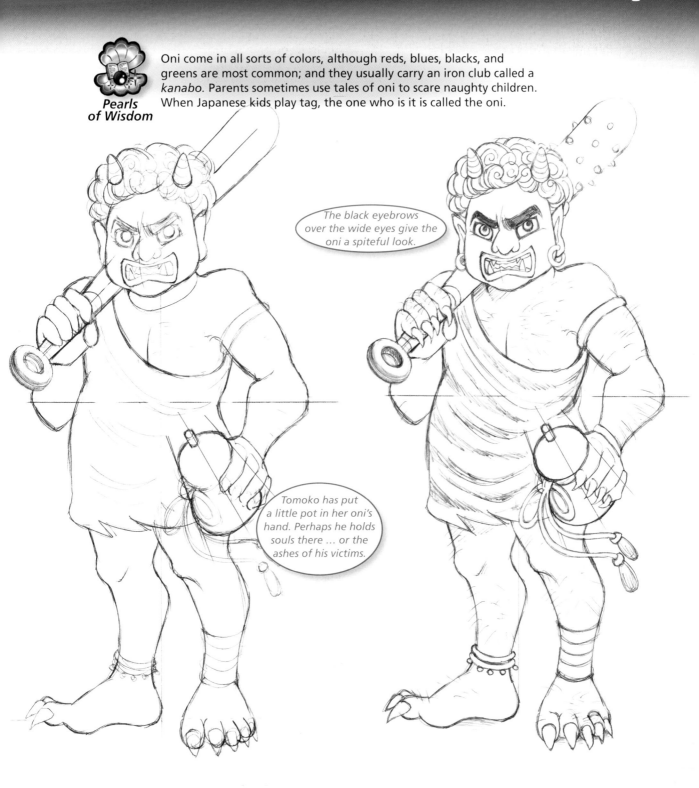

The black eyebrows over the wide eyes give the oni a spiteful look.

Tomoko has put a little pot in her oni's hand. Perhaps he holds souls there … or the ashes of his victims.

3. The oni wears a tiger's skin wrapped around itself like a toga. You could just use it as a loincloth instead. Add in details on the face and add claws to the toes and fingers.

4. Make everything clearer. Show the tiger's stripes on its skin. Pay attention to the oni's jewelry and to the spikes on its club. These are low and wide so they hurt without actually stabbing into a victim.

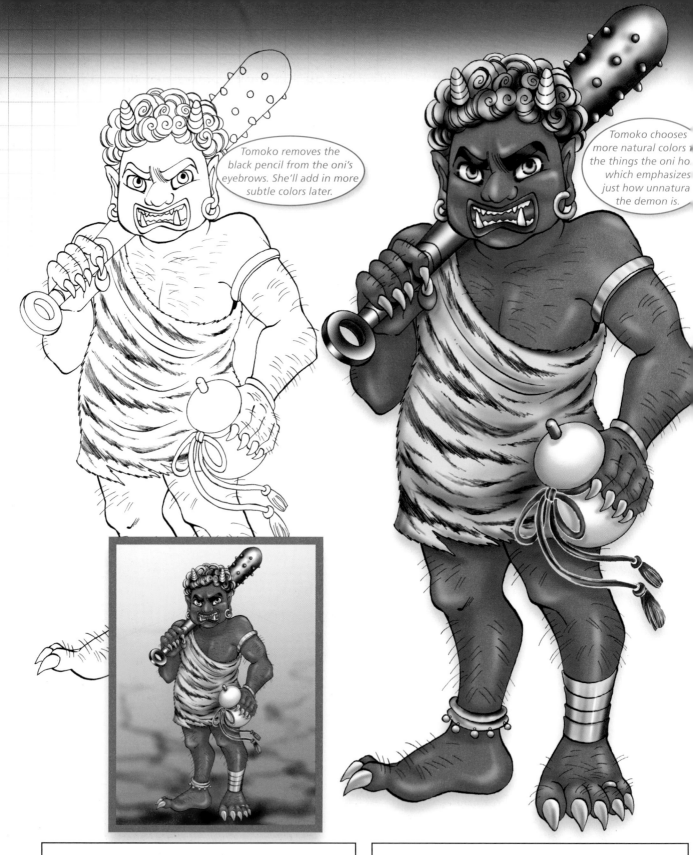

Tomoko removes the black pencil from the oni's eyebrows. She'll add in more subtle colors later.

Tomoko chooses more natural colors ⟶ the things the oni ho. which emphasizes just how unnatura the demon is.

5. Ink the oni. Add hair to its arms, chest, and legs, but with a lighter touch. Lines of different weight in the hair make it look more natural than just a bunch of curly strokes.

6. This oni is red with golden highlights. The strong contrasts highlight the inhuman character of the demon.

Eastern Dragon

Eastern dragons, found throughout Asian cultures, are more slender and sinuous than their Western brethren. They snake through the air more like a serpent than a lizard. While they have scales, their crests seem more like fur or feathers than the hornlike or chitinous bits found on a Western dragon.

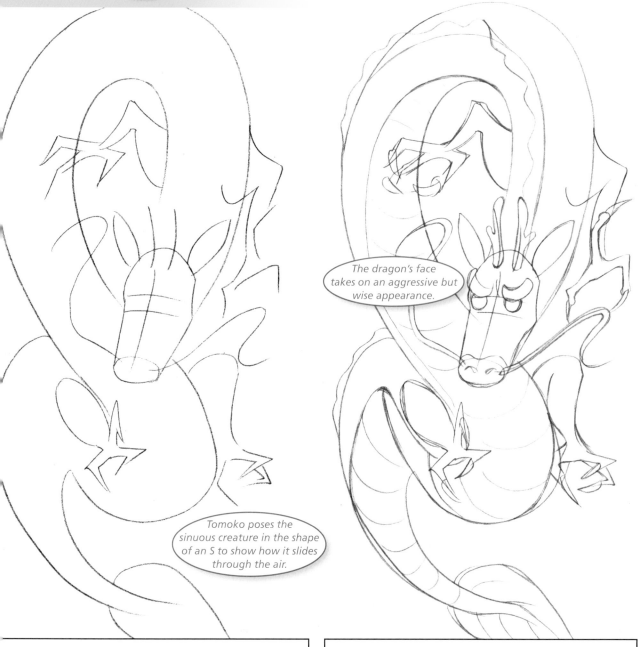

The dragon's face takes on an aggressive but wise appearance.

Tomoko poses the sinuous creature in the shape of an S to show how it slides through the air.

1. To show how this dragon moves, block him out in a snaky pattern. Notice the placement of the limbs, which are nearly identical in how they look and are used.

2. Work in some details. Show the banding of the scales, which are more like those of a snake's belly than that of a lizard. Focus on the face, picking out the shape of the eyes and eyebrows, plus the *Fu Manchu moustache*, horns, and the crests atop its head.

Manga-nese

A **Fu Manchu moustache** is a long, thin moustache with ends that hang from the wearer's face, so named for an evil Asian genius found in Sax Rohmer's pulp novels. Eastern dragons had facial features that resemble such a moustache long before Rohmer started writing. Whether men wore such moustaches to resemble dragons or artists gave the dragons such moustaches to resemble men, no one can say.

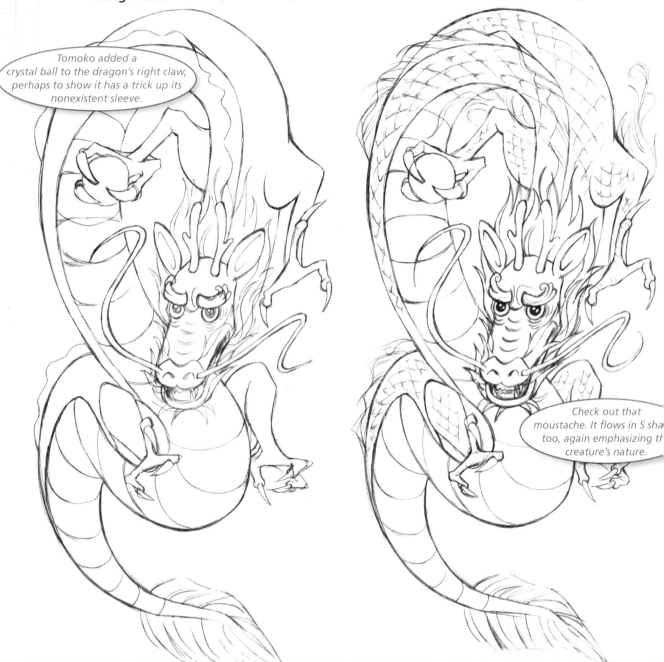

Tomoko added a crystal ball to the dragon's right claw, perhaps to show it has a trick up its nonexistent sleeve.

Check out that moustache. It flows in S sha[pe] too, again emphasizing th[e] creature's nature.

3. Add in more details. Show the pupils in the eyes and the mane that surrounds the dragon's head.

4. Work in the scales along the dragon's back and top. Again, these look like those atop a snake, and they contrast with the bands on the belly.

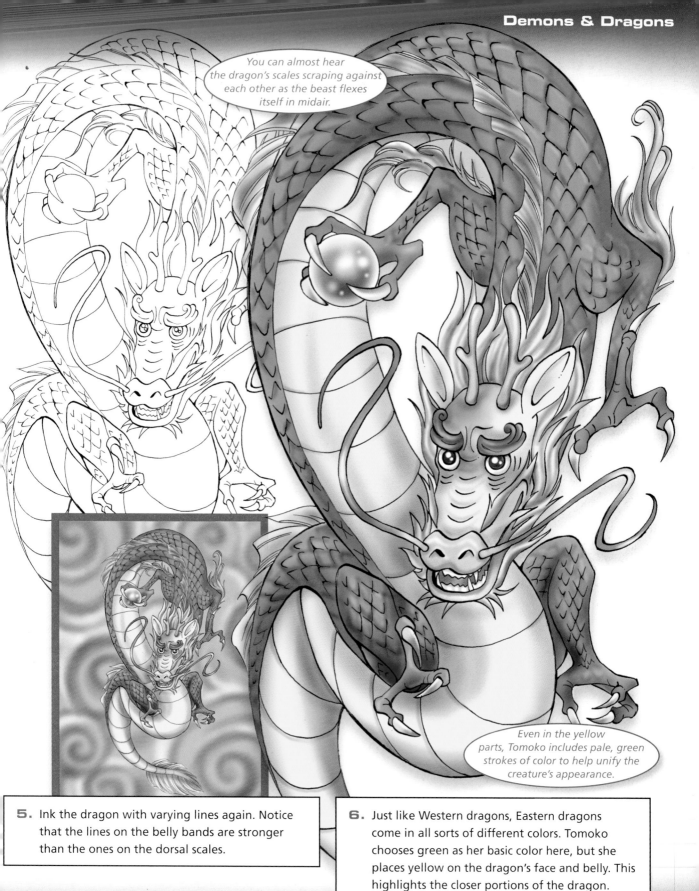

You can almost hear the dragon's scales scraping against each other as the beast flexes itself in midair.

Even in the yellow parts, Tomoko includes pale, green strokes of color to help unify the creature's appearance.

5. Ink the dragon with varying lines again. Notice that the lines on the belly bands are stronger than the ones on the dorsal scales.

6. Just like Western dragons, Eastern dragons come in all sorts of different colors. Tomoko chooses green as her basic color here, but she places yellow on the dragon's face and belly. This highlights the closer portions of the dragon.

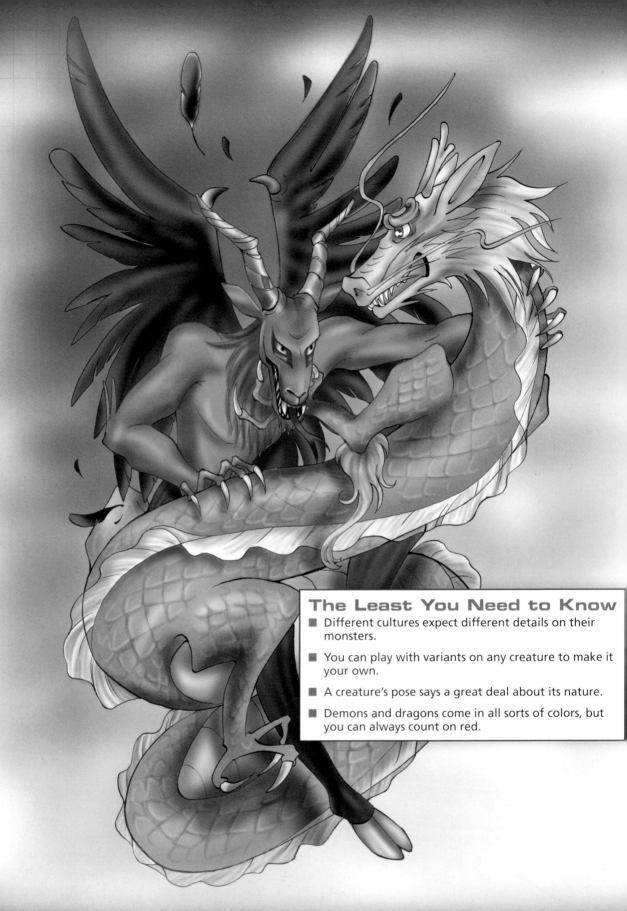

The Least You Need to Know

- Different cultures expect different details on their monsters.

- You can play with variants on any creature to make it your own.

- A creature's pose says a great deal about its nature.

- Demons and dragons come in all sorts of colors, but you can always count on red.

Elementals:
Back to Basics

In This Chapter

- Rocky rascals of the earth

- Airy abominations of the sky

- Fiery fiends of the blaze

- Splashy specters of the sea

- Dark devils of the netherworld

In ancient times—long before anyone had come up with notions of atoms, much less atomic weight or a periodic table—people believed there were four basic elements: earth, air, fire, and water. Some societies added a fifth element, like wood or metal. We're going to stick with the four classical elements, though, and add one other that fits better with modern sensibilities: void.

Creatures composed of these basic substances are called *elementals.* Although they're often shown in some humanoid form, they can take any other shape you like: a wall, a sphere, or anything else.

This makes elementals both challenging and fun to draw. It can be hard to make them look just right, but on the other hand it's difficult to get them wrong.

Manga-nese

An **elemental** is one of the four or five substances that make up the whole of the universe, according to ancient schools of thought.

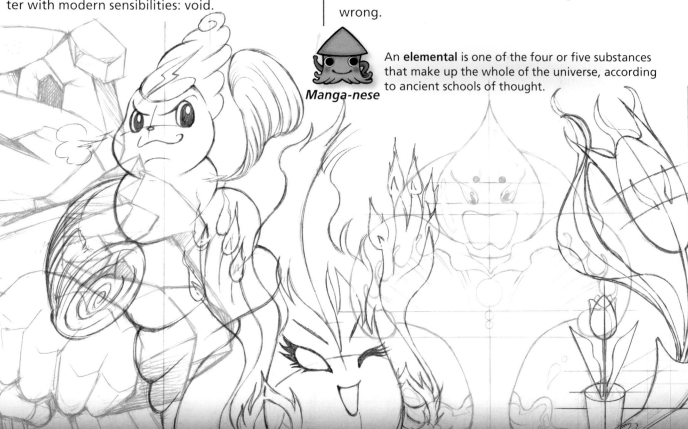

Earth Elemental

We'll start with the most basic of this sort of creature: the earth elemental. These monsters are made of living rock, although they can move—and attack—like people. They may move slowly due to their tremendous mass, but it's almost impossible to even knock a chip off their shoulders—or anywhere else on them.

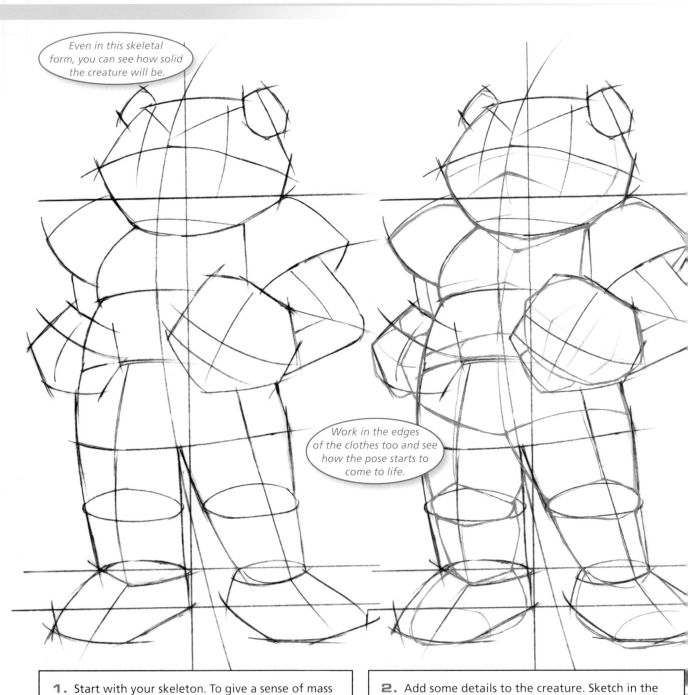

1. Start with your skeleton. To give a sense of mass to the creature, notice how we use shorter limbs and wider shoulders and hips.

2. Add some details to the creature. Sketch in the mouth and fingers.

Chimeric Koans

Some creatures that look like elementals are just monsters in an elemental's epidermis. Imagine a giant bear covered with skin that resembles rock. That thick skin might even be made of rock. However, if you could break through it, you'd find flesh and blood beneath.

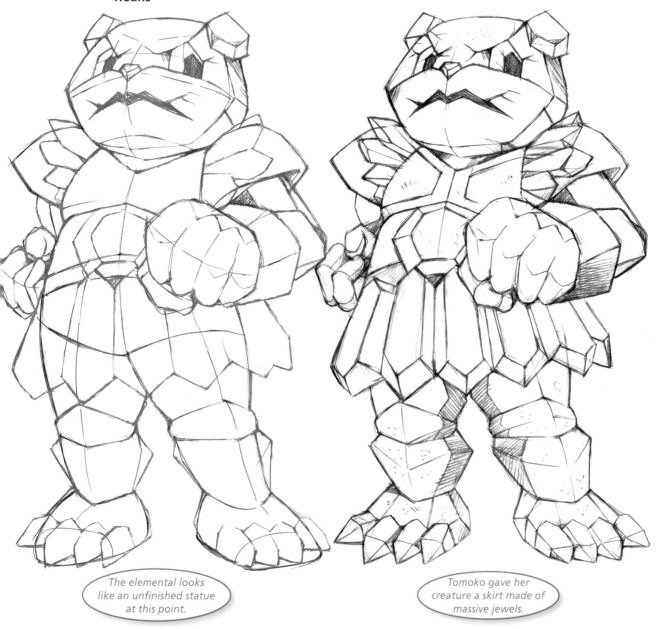

The elemental looks like an unfinished statue at this point.

Tomoko gave her creature a skirt made of massive jewels.

3. Add the creature's rocky flesh. It's important to show how thick the creature is. This adds to the feeling that it would be heavy enough to crush anything unfortunate enough to get in front of it.

4. Work in the final details. Add in whatever flourishes you desire, and remove underlying lines to emphasize what your final picture will look like.

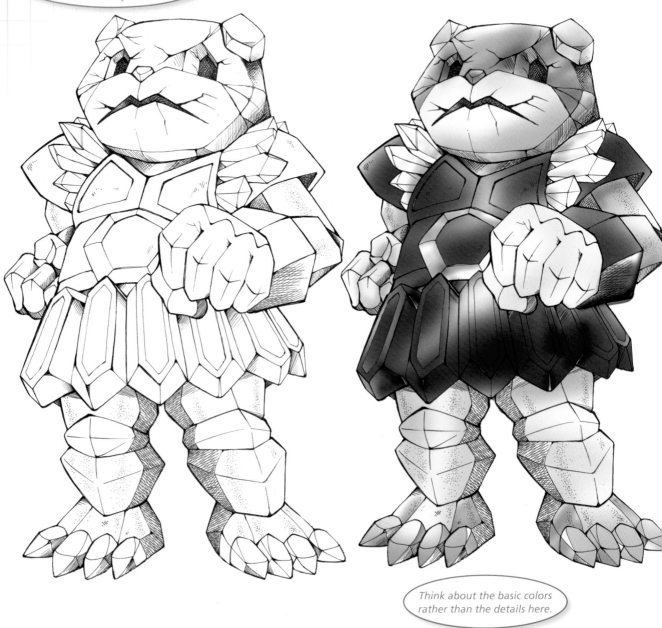

Don't be afraid to give your beast some unique details to make it all your own.

Think about the basic colors rather than the details here.

5. When inking the creature, you can make it look smooth as polished granite or rough as sandstone. To give it some character, you can add cracks or show where chips have been knocked off the beast.

6. For colors, think—what else?—earth tones. Browns and grays work best. If you prefer something more colorful, think of other sorts of "earth," like metals or gems. You could even make some parts of the body one color and other parts entirely different, just for variety's sake.

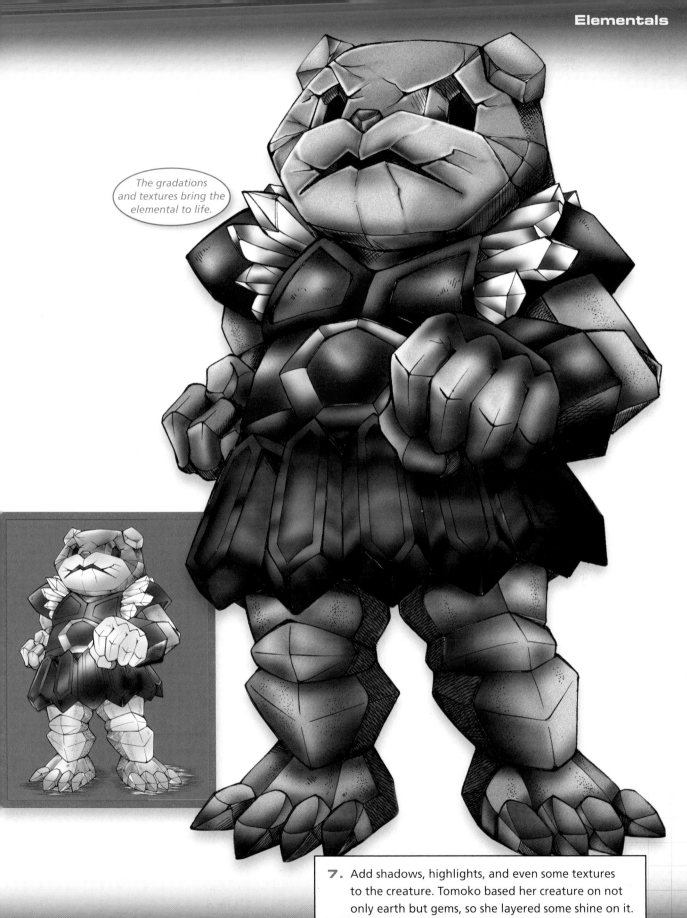

The gradations and textures bring the elemental to life.

7. Add shadows, highlights, and even some textures to the creature. Tomoko based her creature on not only earth but gems, so she layered some shine on it.

Air Elemental

Air elementals are as different from earth elementals as you can get. They have little or no substance and can even be invisible. Of course, that's not much fun to draw, so we'll assume they're somehow not quite as pure as fresh, untainted air.

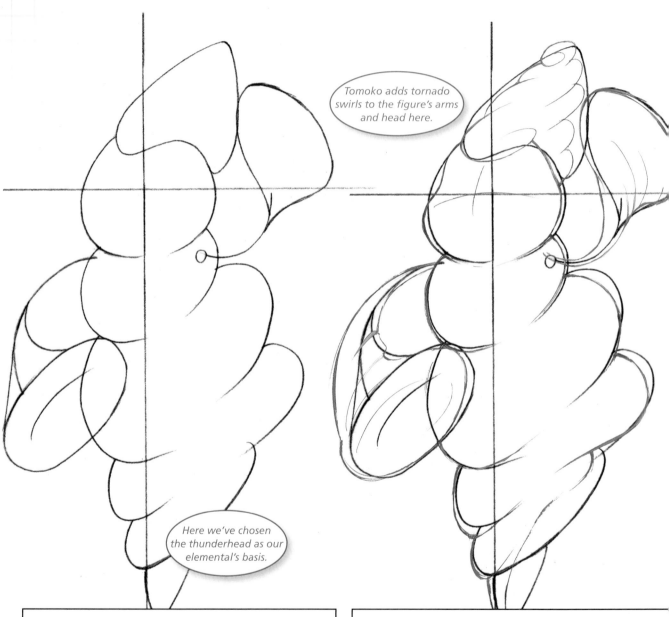

Tomoko adds tornado swirls to the figure's arms and head here.

Here we've chosen the thunderhead as our elemental's basis.

1. Choose simple shapes that reflect your air elemental's essential qualities. If it's as gentle as a breeze, it may seem as thin as a piece of paper. If it prefers to be a tornado, though, work with stronger shapes instead. Or, some people prefer clouds, as they offer something more visible, if not substantial.

2. Give your elemental a bit more character. Refine the rough shapes into something more defined.

AIIEEE!!!

With air elementals so nebulous, it's tempting to skip over the regular steps and just draw something loose. Elementals have an original form that they're most comfortable in, though, and that's what they always return to. Be sure to figure out what that is for your creature before you start twisting the poor thing around like an airy pretzel.

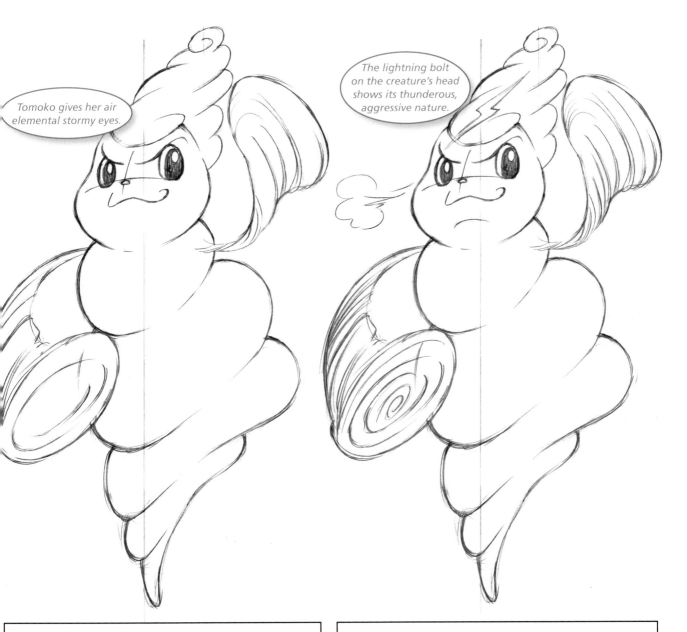

Tomoko gives her air elemental stormy eyes.

The lightning bolt on the creature's head shows its thunderous, aggressive nature.

3. Add in the creature's features. Think windswept here. Flowing lines with wisps trailing off work well and emphasize the creature's windy nature. Remove some of the breakdown lines.

4. Now decorate the creature with a few more details. Add an emblem if you like, or show its chilly breath.

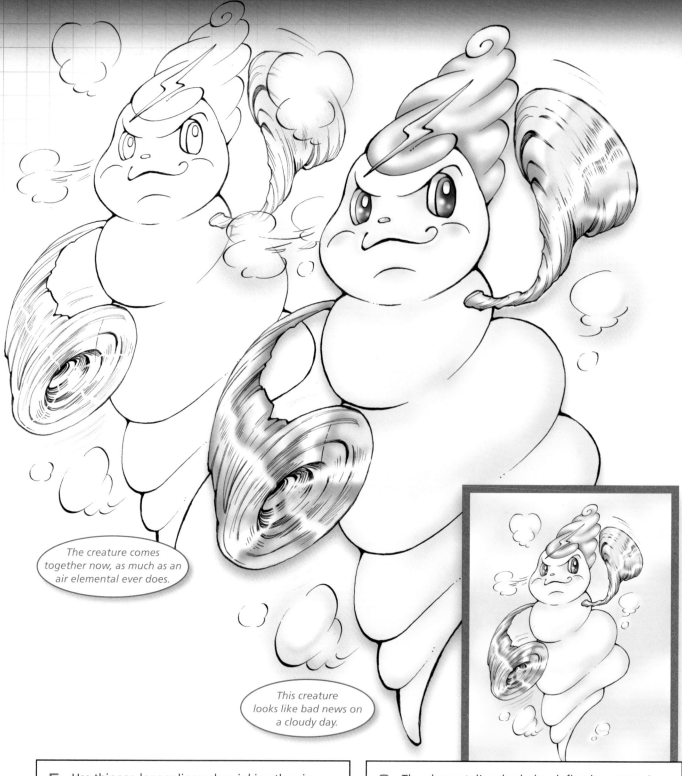

The creature comes together now, as much as an air elemental ever does.

This creature looks like bad news on a cloudy day.

5. Use thinner, longer lines when inking the air elemental. Again, this emphasizes the fact that the creature is made up of nothing but air.

6. The elemental's color helps define its nature. Is it bluish as a clear sky? Gray as a thunderhead? Dark as a storm cloud? Pink as a gentle sunset? Yellow as the dawning sun? In any case, washes and pastels work best here rather than bolder colors. Some air elementals are even transparent, just like the wind they're made of.

Fire Elemental

Fire elementals are the most dangerous of the lot. They can set things ablaze just by getting close to them, and they can be hot tempered. Even when they're friendly, though, don't bother trying to shake hands with them.

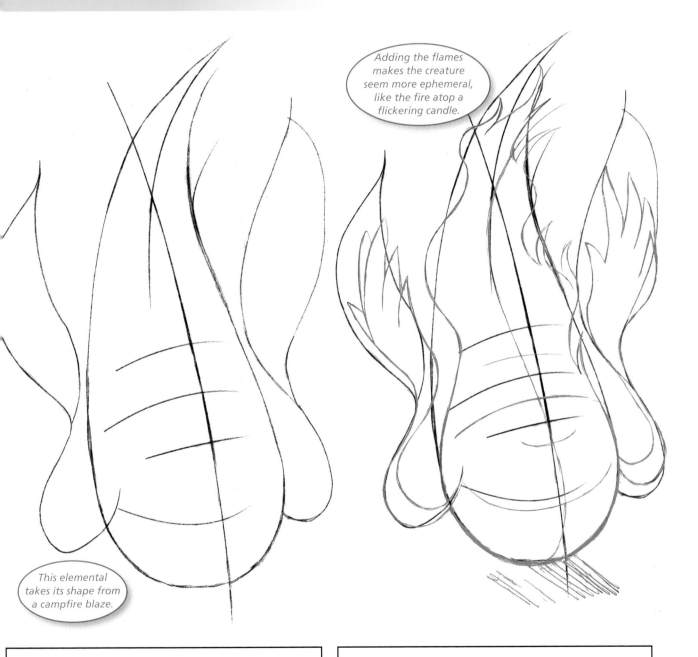

Adding the flames makes the creature seem more ephemeral, like the fire atop a flickering candle.

This elemental takes its shape from a campfire blaze.

1. Fire elementals can take many shapes: a tongue of flame, a burning man, a ring of fire, or whatever other notion burns in your noggin. Sometimes they morph between shapes with a mere flicker. For your drawing, try to find a simple shape and stick with it, working variations on its edges as you go.

2. Work the edges of the creature's flames around the edges of the basic shapes. Show a scorch mark on the ground to emphasize how hot it is.

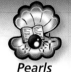
Fire elementals give off their own light. They never stand in shadows, although they can cast their own. The dark patch on the ground below this elemental isn't a shadow—it's a scorch mark.

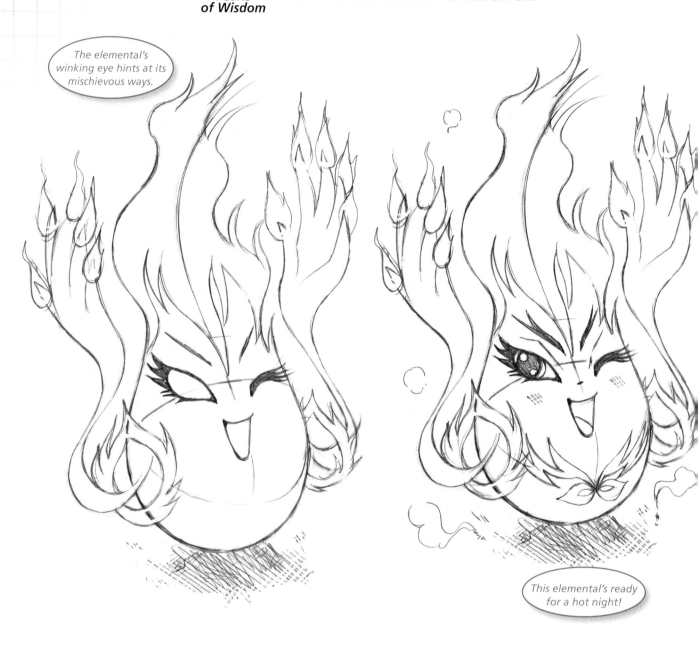

The elemental's winking eye hints at its mischievous ways.

This elemental's ready for a hot night!

3. Pick out the details on the creature's face and along its edges. Let your pencil flow, and try to capture the curving randomness of the flickering flames.

4. Fill in the bits that you've already started on. Add touches that appeal to you, like perhaps a hint at fiery clothing or jewelry.

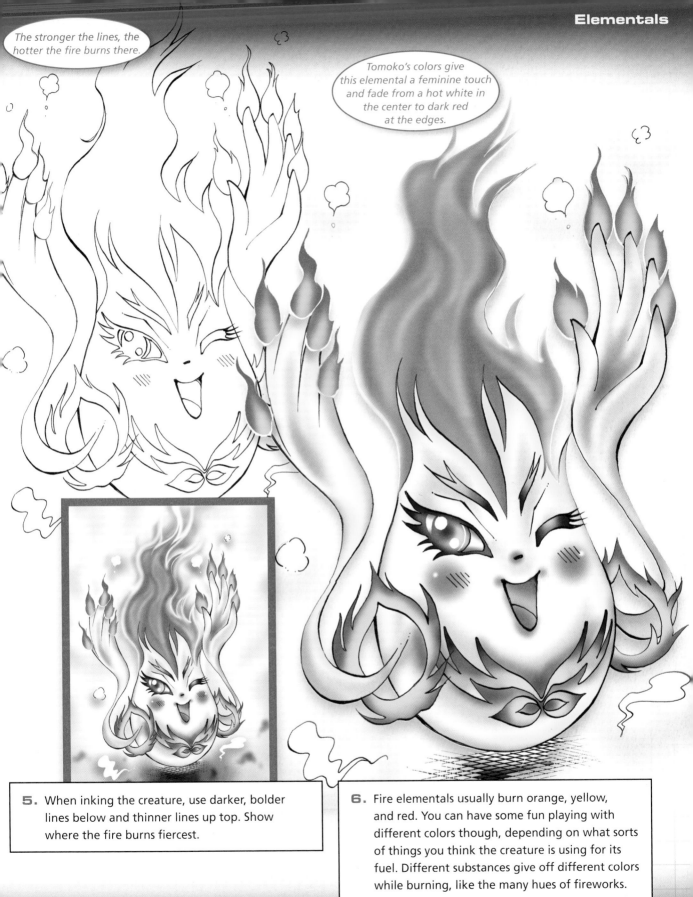

The stronger the lines, the hotter the fire burns there.

Tomoko's colors give this elemental a feminine touch and fade from a hot white in the center to dark red at the edges.

5. When inking the creature, use darker, bolder lines below and thinner lines up top. Show where the fire burns fiercest.

6. Fire elementals usually burn orange, yellow, and red. You can have some fun playing with different colors though, depending on what sorts of things you think the creature is using for its fuel. Different substances give off different colors while burning, like the many hues of fireworks.

Water Elemental

Barring earth elementals, those of the watery variety have the most substance. Still, they're fluid by nature and can spout out of anything from a dirty creek to the deep, blue sea. They might even be as pure and clear as the filtered water from an office cooler. No matter what, though, they're all wet.

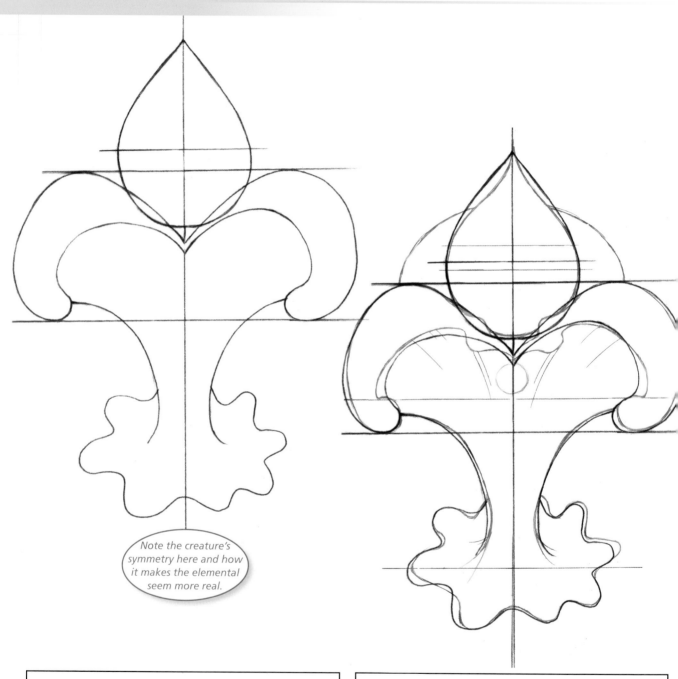

Note the creature's symmetry here and how it makes the elemental seem more real.

1. Figure out your basic shape and stick with it. While you could go with something smooth and placid, it's far more fun to work with crashing surf, so that's what we chose here.

2. Pick out some details and add some motion lines to the creature's body to show its constant action. This makes the creature seem both fluid and moving.

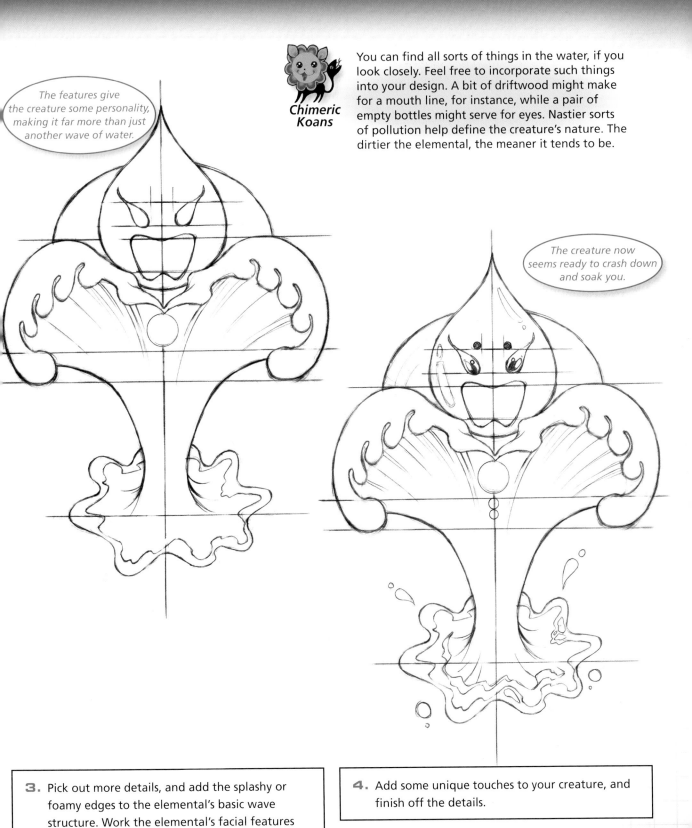

The features give the creature some personality, making it far more than just another wave of water.

Chimeric Koans

You can find all sorts of things in the water, if you look closely. Feel free to incorporate such things into your design. A bit of driftwood might make for a mouth line, for instance, while a pair of empty bottles might serve for eyes. Nastier sorts of pollution help define the creature's nature. The dirtier the elemental, the meaner it tends to be.

The creature now seems ready to crash down and soak you.

3. Pick out more details, and add the splashy or foamy edges to the elemental's basic wave structure. Work the elemental's facial features into the waves.

4. Add some unique touches to your creature, and finish off the details.

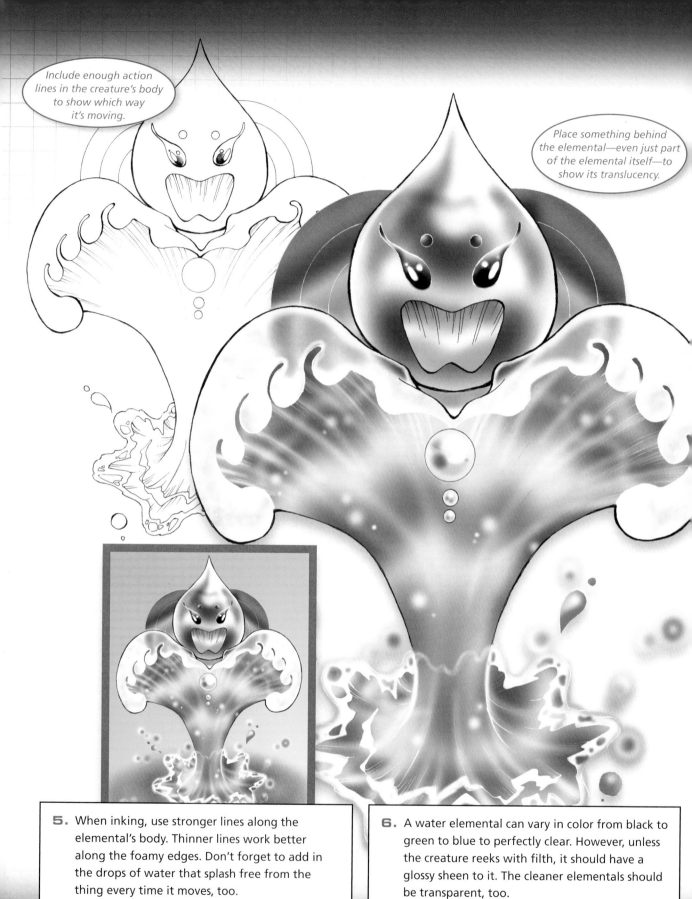

Include enough action lines in the creature's body to show which way it's moving.

Place something behind the elemental—even just part of the elemental itself—to show its translucency.

5. When inking, use stronger lines along the elemental's body. Thinner lines work better along the foamy edges. Don't forget to add in the drops of water that splash free from the thing every time it moves, too.

6. A water elemental can vary in color from black to green to blue to perfectly clear. However, unless the creature reeks with filth, it should have a glossy sheen to it. The cleaner elementals should be transparent, too.

Void Elemental

Void can mean a vacuum, but that's hard to show in a drawing. Instead, it's far easier to think of something else fitting that's both insubstantial and dark, like a shadow, the void of light.

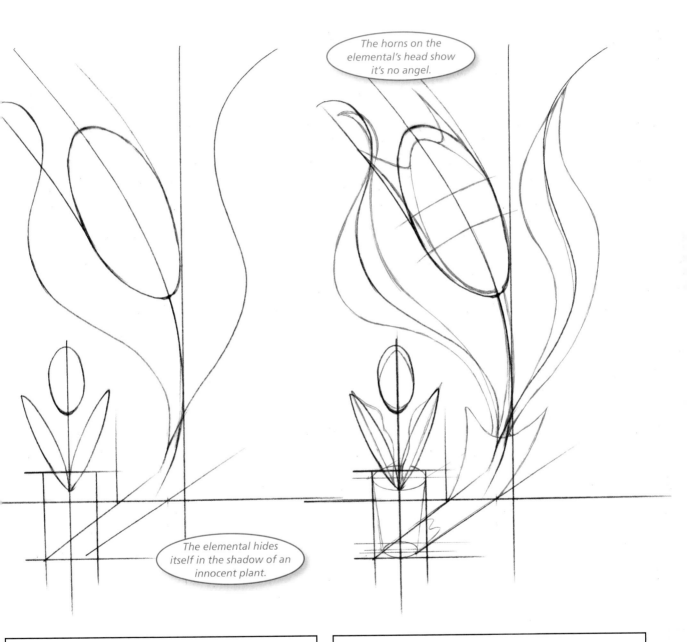

The horns on the elemental's head show it's no angel.

The elemental hides itself in the shadow of an innocent plant.

1. Shadows are flat, so the void elemental follows the contours of the nearby table and wall. Think of the outline of the flower—or whatever other object you like—and imagine it cast on its surroundings. Fold it where parts of the room meet each other.

2. Flesh out the shadow a bit more. Be sure to give the shape of the shadow it's mimicking proper attention.

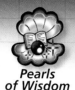

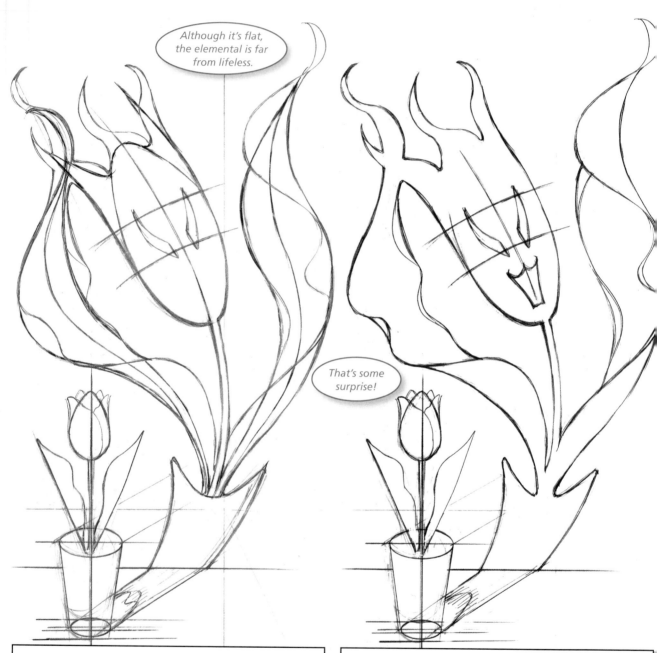

Pearls of Wisdom

While the void elemental we created here is a shadow, don't feel restricted by that. Your elemental could be a sphere of inky blackness that roams through the room. Or a burst of black tentacles spurting out from beneath the floorboards. Or whatever else tickles your fancy, as long as it's something void of substance and light.

Although it's flat, the elemental is far from lifeless.

That's some surprise!

3. Fill in the details of the elemental's outline. Pay more attention to the surroundings, as these will give your drawing the character it deserves. Make sure to include a few differences in the outline to show that the elemental isn't just a strange shadow.

4. Give some love to the details of the elemental's face. Keep the work subtle and let the viewer's eye do the work of figuring it out.

Some victims wonder if they see the void elemental at all—until it's too late.

Images like this can make you start to jump at shadows.

5. Ink in the figure in the foreground with stronger lines. Use lighter lines for the elemental itself. In fact, if you like you can skip inking it at all. This gives it a more nebulous look, perfect for such a strange, amorphous creature.

6. Use bright colors for the foreground figure and surroundings. The void elemental is a stain of darkness in an otherwise sunny world. You can use a flat black for the elemental, but we chose to side with subtlety by going with a blend of grays and blacks instead.

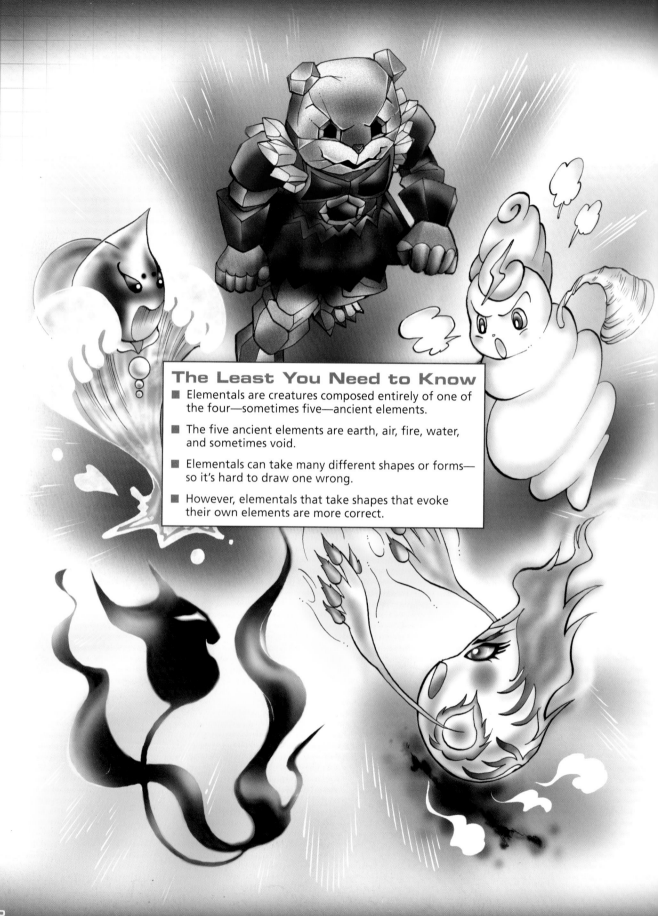

The Least You Need to Know

- Elementals are creatures composed entirely of one of the four—sometimes five—ancient elements.

- The five ancient elements are earth, air, fire, water, and sometimes void.

- Elementals can take many different shapes or forms— so it's hard to draw one wrong.

- However, elementals that take shapes that evoke their own elements are more correct.

In Other Elements:
By Air or by Sea, They're Still Monsters to Me

7

In This Chapter

- ■ A soaring eagle on the hunt
- ■ A bee with a real sting
- ■ A toothy, watery eating machine
- ■ A tangle of tentacles

To this point, we've concentrated on creatures that live mostly on land. Since that's where most manga stories take place, that's fine. Every now and then, though, you may wish to branch out into other areas, like high in the sky or deep in the sea.

So, let's work with some of these creatures to give you a feel for how they work in their own elements. We'll start with an eagle, then move on to an entirely different kind of flyer: a bee. Then we'll tackle a shark, which should help you get a good feeling for fish of all sorts. From there, it's on to something stranger yet: a squid.

Once you master these, you'll be set to come up with your own stranger creations. No longer bound to the earth, though, you can let your imagination soar as high and plunge as low as you like.

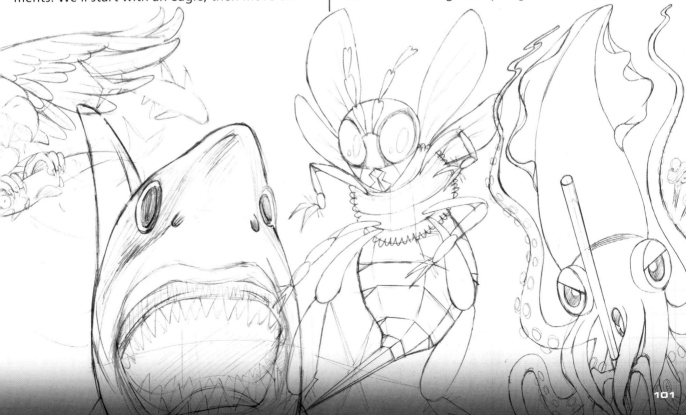

Eagle

There are many birds out there to choose from, but few are as majestic and dramatic as the bald eagle. As the national symbol of the United States, it carries heavy metaphoric load. It may seem ironic to feature such an American creature in a book about drawing Japanese-style comics, but it's just that kind of blend that makes manga in America so intriguing.

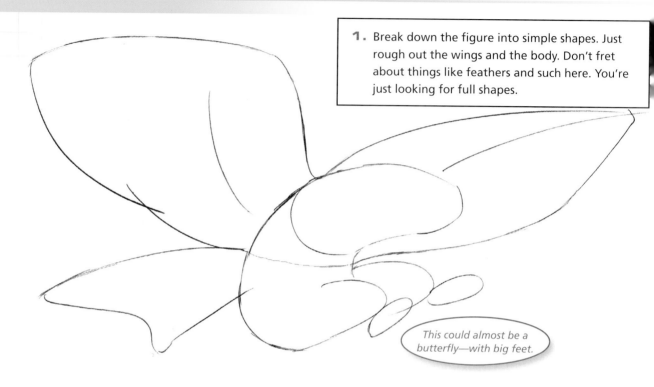

1. Break down the figure into simple shapes. Just rough out the wings and the body. Don't fret about things like feathers and such here. You're just looking for full shapes.

This could almost be a butterfly—with big feet.

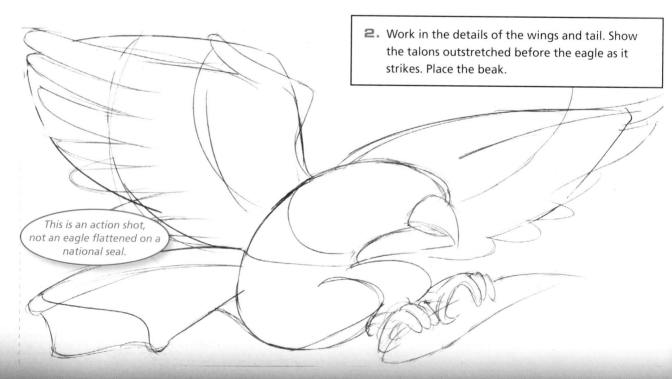

2. Work in the details of the wings and tail. Show the talons outstretched before the eagle as it strikes. Place the beak.

This is an action shot, not an eagle flattened on a national seal.

Pearls of Wisdom

If you don't know exactly what a particular creature looks like, find some reference material to help you out. The Internet is full of freely accessible photos, as is your local library. No one will blame you for this; few of us have the chance to study an eagle up close these days.

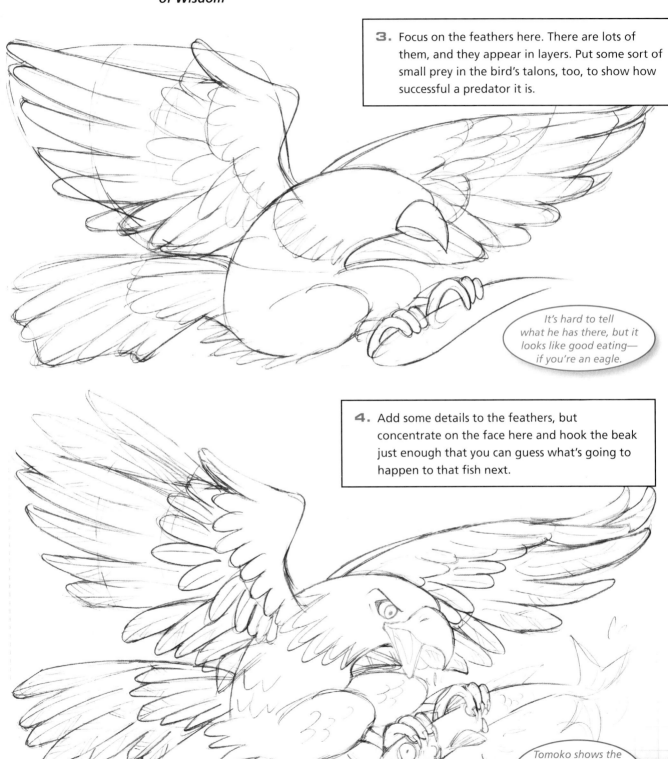

3. Focus on the feathers here. There are lots of them, and they appear in layers. Put some sort of small prey in the bird's talons, too, to show how successful a predator it is.

It's hard to tell what he has there, but it looks like good eating—if you're an eagle.

4. Add some details to the feathers, but concentrate on the face here and hook the beak just enough that you can guess what's going to happen to that fish next.

Tomoko shows the fish's tail flopping back and forth. That's a fresh catch.

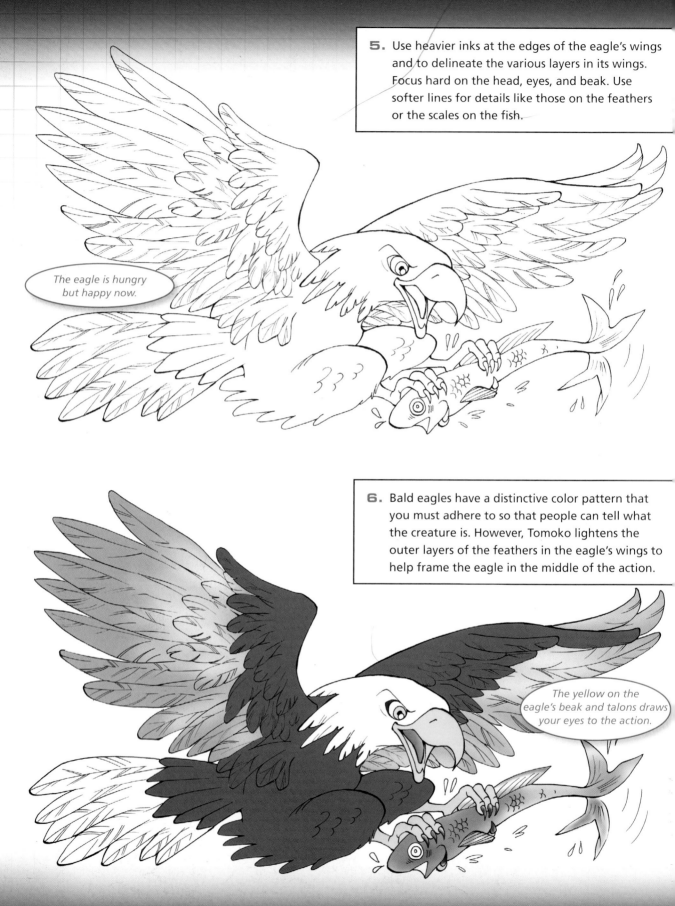

5. Use heavier inks at the edges of the eagle's wings and to delineate the various layers in its wings. Focus hard on the head, eyes, and beak. Use softer lines for details like those on the feathers or the scales on the fish.

The eagle is hungry but happy now.

6. Bald eagles have a distinctive color pattern that you must adhere to so that people can tell what the creature is. However, Tomoko lightens the outer layers of the feathers in the eagle's wings to help frame the eagle in the middle of the action.

The yellow on the eagle's beak and talons draws your eyes to the action.

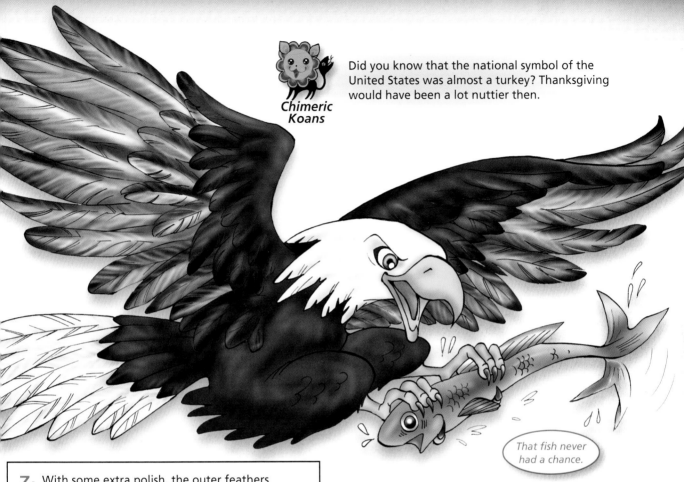

Chimeric Koans

Did you know that the national symbol of the United States was almost a turkey? Thanksgiving would have been a lot nuttier then.

That fish never had a chance.

7. With some extra polish, the outer feathers resemble the inner ones more closely. Adding the water and sky around the creature highlights how the eagle lives in one element but takes its meals from another.

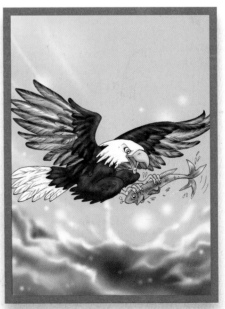

Bee There are millions of different kinds of insects to choose from. We went with a common bee to show a creature that most people should be familiar with, especially those who love *Bee Train's* anime shows. The close-up view allows us to pick out the stranger parts of the bee's anatomy, too.

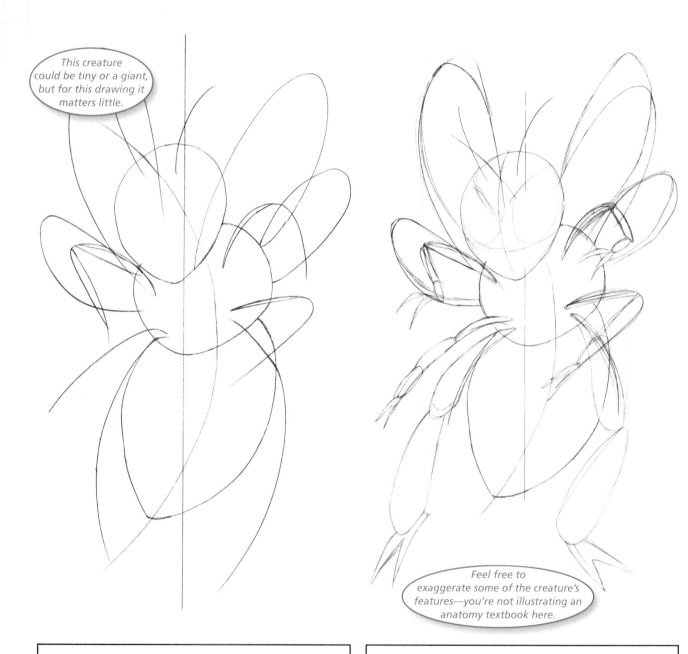

This creature could be tiny or a giant, but for this drawing it matters little.

Feel free to exaggerate some of the creature's features—you're not illustrating an anatomy textbook here.

1. Focus on rough shapes here, particularly for the bee's six limbs, and be sure to show all three parts of the insect's body: head, thorax, and abdomen.

2. Segment the legs and sketch in the location of the eyes.

 Bee Train is the Japanese anime studio most famous for creating the *.hack//SIGN* and *Noir* animated television series.

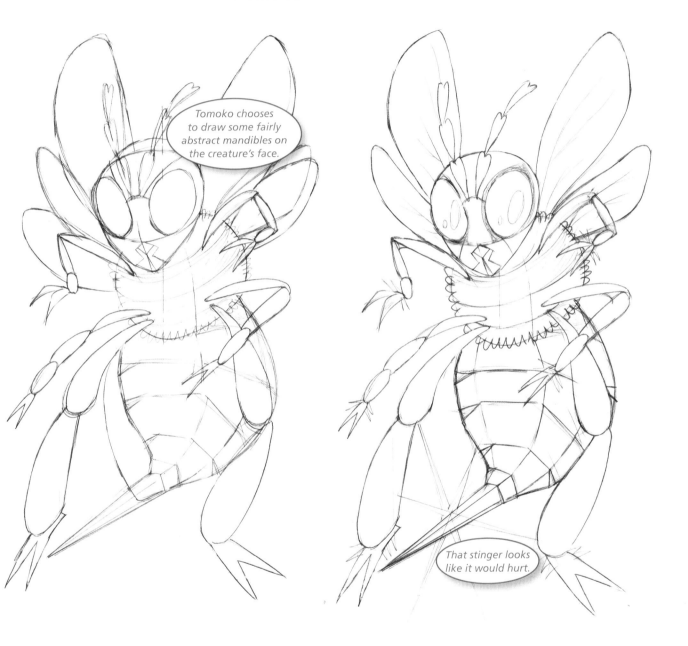

Tomoko chooses to draw some fairly abstract mandibles on the creature's face.

That stinger looks like it would hurt.

3. Put some strips on the bee's middle so you can show its markings. Also, be sure to pick out that vicious stinger on the end of the creature's abdomen. Flesh out the antennae, too.

4. Refine everything. Make the thorax a bit fuzzier. Add some details to the wings, as well as to the body.

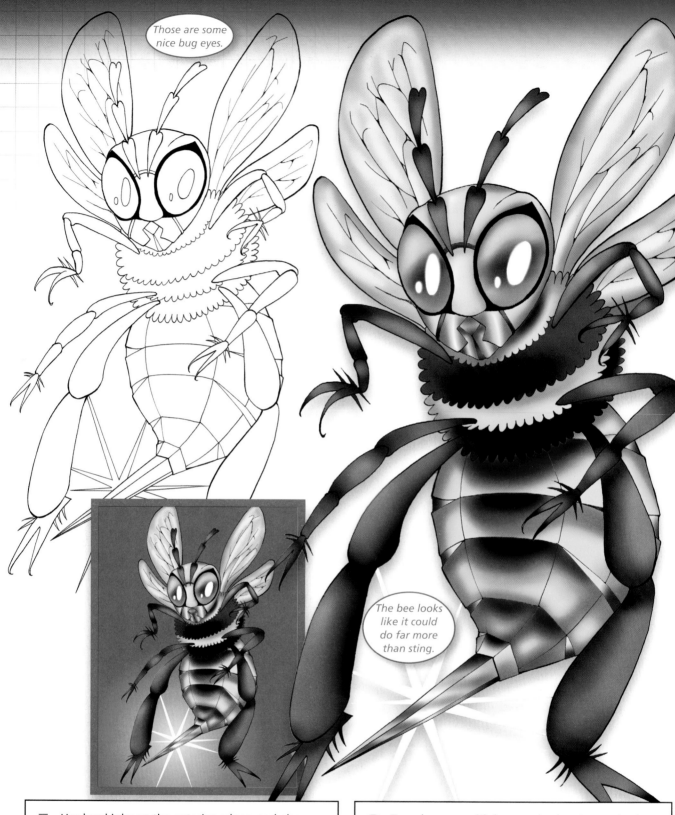

5. Use hard inks on the exterior edges, and also around the eyes. Let the interior marks show through more softly.

6. Tomoko goes with honeyed colors to emphasize the food production rightly associated with bees. Note the steely look of the stinger, including the sunlight glinting across it.

Shark

There's nothing human about a shark. These aren't the kind of fish you keep for pets. They're eating and breeding machines, and that's about it. That makes them a great, if terrifying, basis for your own creatures.

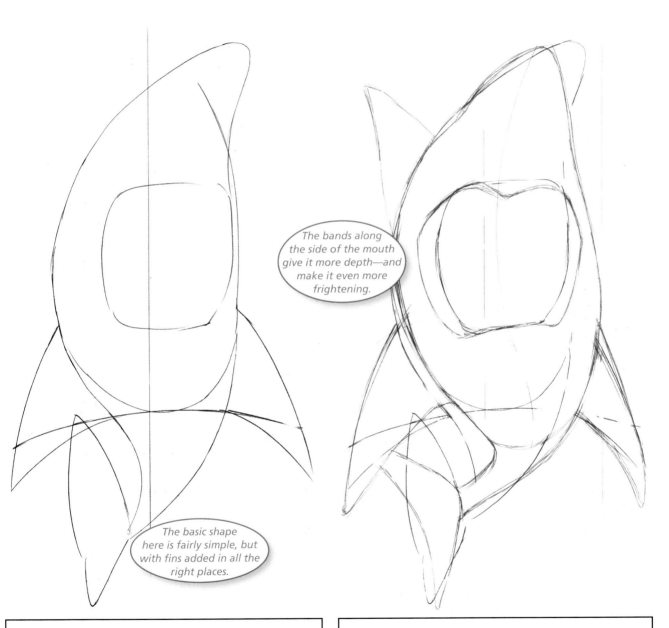

The bands along the side of the mouth give it more depth—and make it even more frightening.

The basic shape here is fairly simple, but with fins added in all the right places.

1. The shark comes straight at us, from above. Note that the mouth is its largest feature.

2. Adjust your shapes a bit more and add that dorsal (top) fin. You may not be able to see the whole fin, but it's become the trademark of hungry sharks everywhere, so don't forget it.

**Pearls
of Wisdom**

Sharks lose and regrow teeth all the time.
You could show some teeth missing with
new ones growing in at different rates.

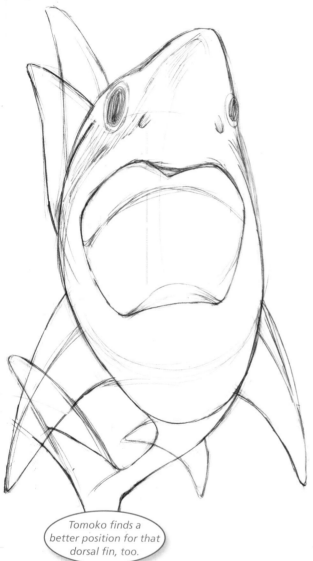

*Tomoko finds a
better position for that
dorsal fin, too.*

*Note how the
rounded banding along the
shark's body gives it both
space and depth.*

3. Place the eyes now, dinner plates of blackness.
Shade the nose to provide the creature some
depth, and sketch in the beast's gums.

4. Use some lines to give the tail and fins more
dimension. Fill in those terrifying rows of teeth.

This beast looks like it could swallow you whole.

That's a whole lot of teeth.

5. Ink the whole thing. Save your darkest lines for the sleek beast's outer edges—except for the edges of the mouth, which should be firm as well.

6. Sharks are generally gray. Tomoko uses lighting to make the creature's skin seem lighter the closer it is. The red gums remind you of how red the shark's mouth is when it bites into something fresh.

Squid

Squid makes for interesting sushi or—when deep-fried—calamari. It's even better as a monster. Just imagine a sailing ship wrapped in the tentacles of a giant squid, only moments before the beast hauls the whole thing to the murky bottom of the sea, crew and all.

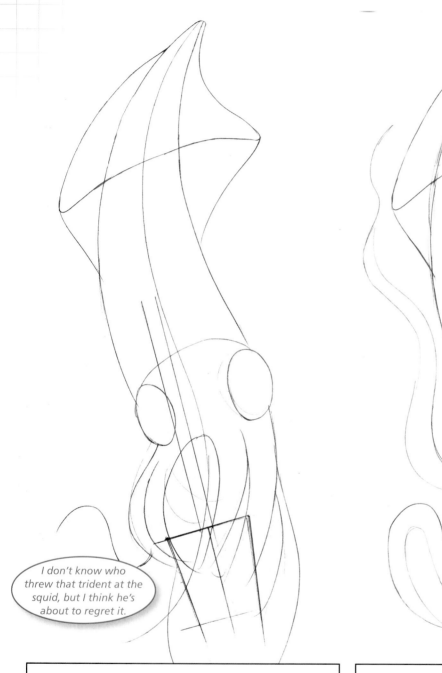

I don't know who threw that trident at the squid, but I think he's about to regret it.

Tomoko's gone with discs for the eyes here, which gives the creature a real Jules Verne look.

1. Work with a conical shape for the squid's body. Remember that a squid has ten tentacles rather than the eight of an octopus. Show them curving around a trident. You don't have to place them all right away, but be sure to not lose track of them all at the end.

2. Beef up the creature's body and fill in the rest of the tentacles now. One or more of them might be out of sight behind the squid's body, but it's best if you can show them all. Otherwise, you'll have to deal with people asking about the missing limbs all the time.

Pearls of Wisdom

Squids squirt ink when scared. This gives them a means of escape when faced with a superior foe.

The lidded eyes make the squid appear irritated—never a good thing.

You don't have to draw in every last sucker a squid would have on its tentacles, just enough to suggest that the limbs are coated with suckers on one side.

3. Show the ridges on the squid's fins, locate its beak, and put lids on its eyes.

4. Add in the rest of the details. This includes the suckers on the tentacles.

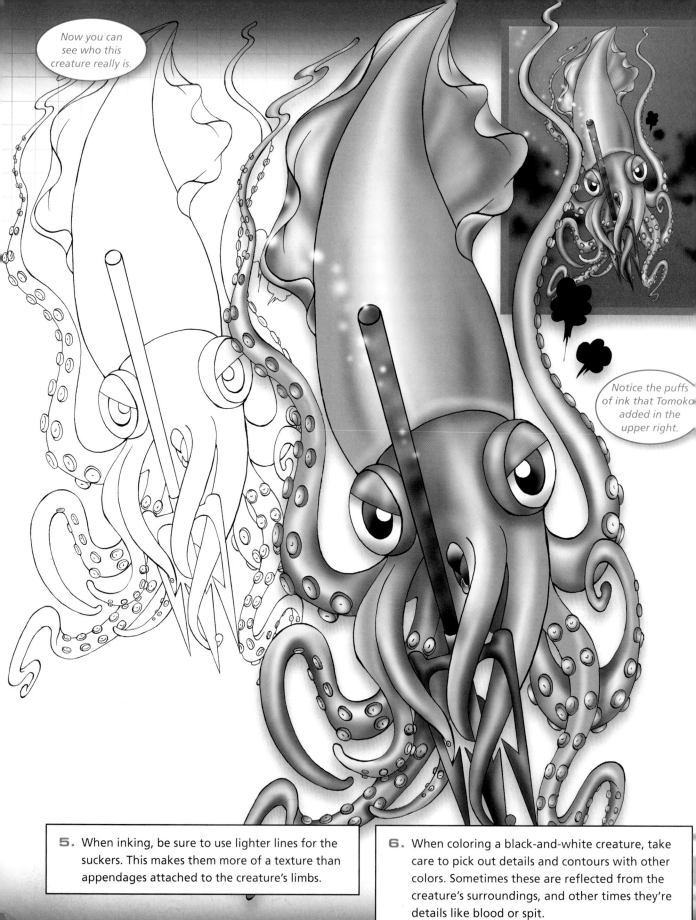

Now you can see who this creature really is.

Notice the puffs of ink that Tomoko added in the upper right.

5. When inking, be sure to use lighter lines for the suckers. This makes them more of a texture than appendages attached to the creature's limbs.

6. When coloring a black-and-white creature, take care to pick out details and contours with other colors. Sometimes these are reflected from the creature's surroundings, and other times they're details like blood or spit.

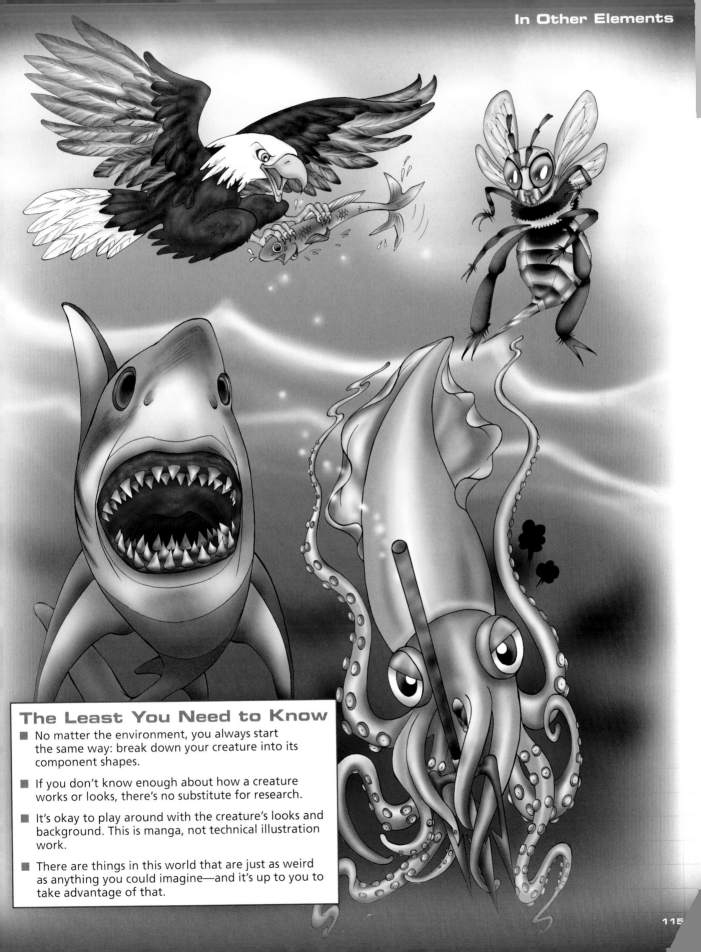

The Least You Need to Know

■ No matter the environment, you always start the same way: break down your creature into its component shapes.

■ If you don't know enough about how a creature works or looks, there's no substitute for research.

■ It's okay to play around with the creature's looks and background. This is manga, not technical illustration work.

■ There are things in this world that are just as weird as anything you could imagine—and it's up to you to take advantage of that.

Out of This World: 8
Creatures from Beyond

In This Chapter

- Kindly kidnapping aliens
- Crablike killers from beyond the stars
- Friendly robots from the future
- Gigantic walking machines of war

Now that we've covered the edges of the earth and plumbed it from the bright blue skies to the inky ocean depths, we're ready to take yet another tangent and fling ourselves entirely off the planet in search of yet more subjects.

Aliens—and other science fiction regulars—come in such a wide variety of flavors that even scratching that particular surface would require a whole other book. So we're just going to pick out a few archetypal highlights and explore them thoroughly.

If you don't recognize them, chances are you haven't been watching or reading enough science fiction. You can fix that with a simple trip to your bookstore, if you're so inclined. Otherwise, just marvel at how strange these creatures are as you learn how to draw them.

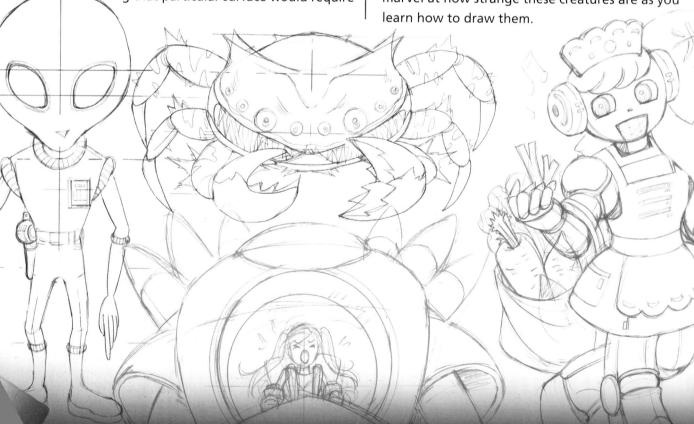

Grays are the kind of aliens that draw crop circles, steal livestock, and kidnap the occasional innocent in an attempt to understand this wacky planet on which we live. Maybe, you think, it would be easier if they'd just ask us, but then we don't really understand it, either.

Pearls of Wisdom

Science fiction, as we understand it, has been with us since the publication of *Frankenstein,* and it shows no signs of fading away. Sometimes it may seem as if we've caught up with the science fiction of our ancestors, but that's progress for you. Don't worry. We'll come up with new frontiers to explore in time.

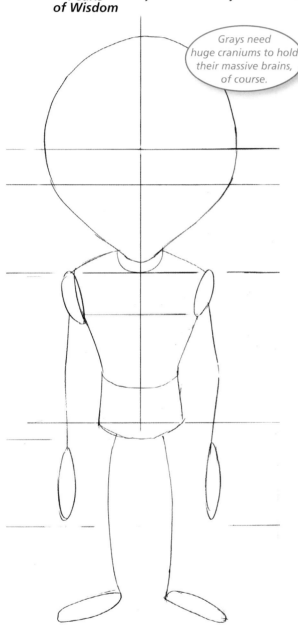

Grays need huge craniums to hold their massive brains, of course.

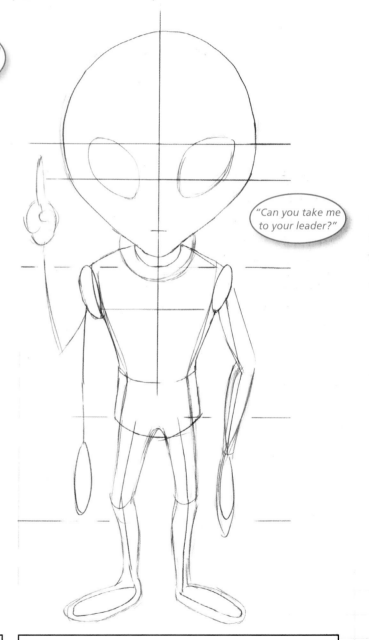

"Can you take me to your leader?"

1. Break the figure down into its component shapes. (If you don't know what the figure looks like, skip ahead a bit, then come back here.) Grays have a huge head and tiny, slim bodies, sort of like chibis (see Chapter 12).

2. Flesh out the figure a bit and add in the large, tear-shaped eyes. Notice how Tomoko has changed the creature's right arm. She likes this pose better, as it gives the gray a questioning look.

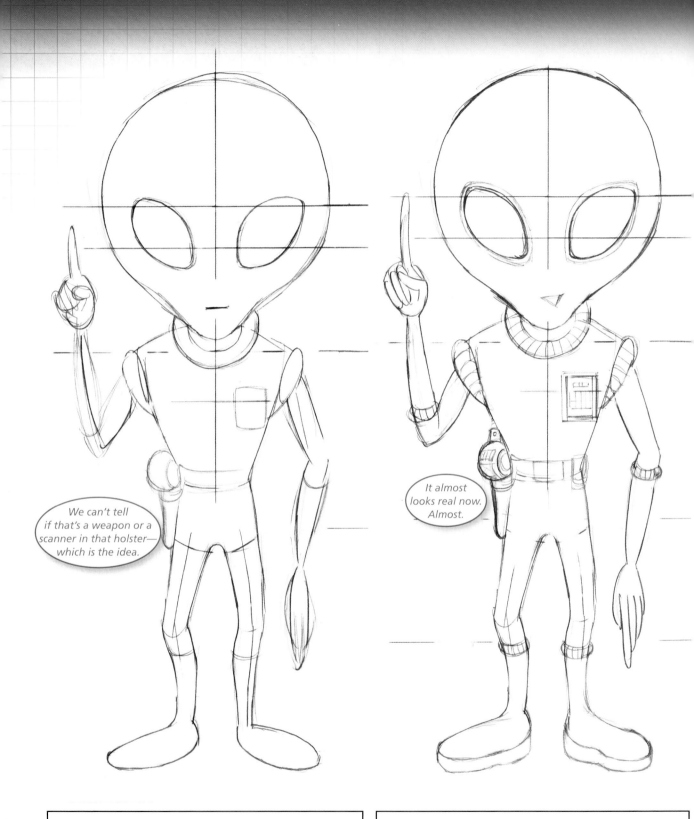

3. Not all grays wear clothes, but we'll go with them here. Work in the details of a space traveler's uniform. Add a device in a holster at its waist.

4. Work on the details on the figure's uniform. Elongate the fingers farther and bring out those eyes as best you can. Form the mouth into a question.

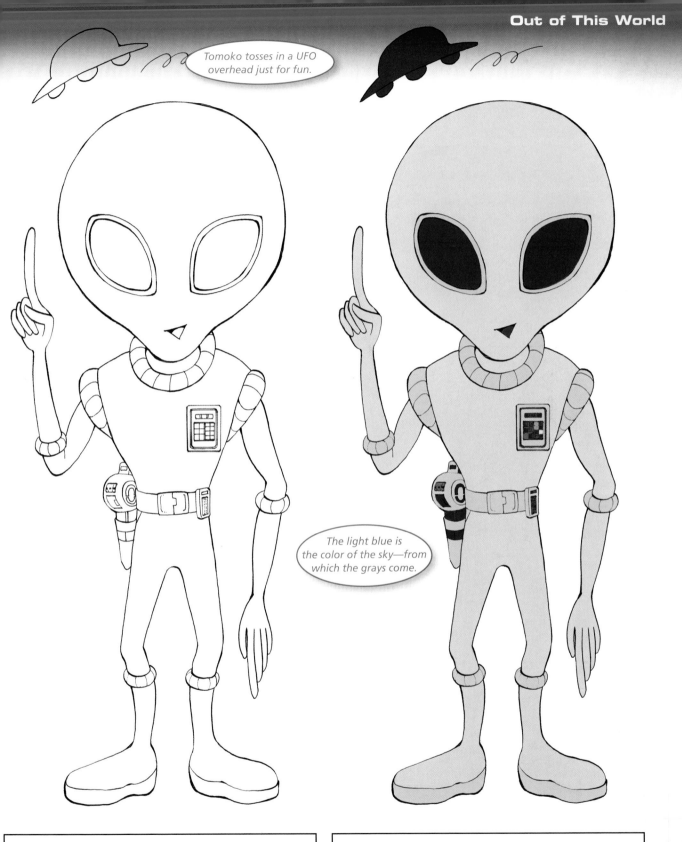

Tomoko tosses in a UFO overhead just for fun.

The light blue is the color of the sky—from which the grays come.

5. Use consistent lines through most of the figure. Only go with thinner lines for the uniform's details, like its cuffs and belt.

6. Guess what color a gray is. Go ahead, guess. Aw, you got it. Pick a secondary color for highlights on the uniform.

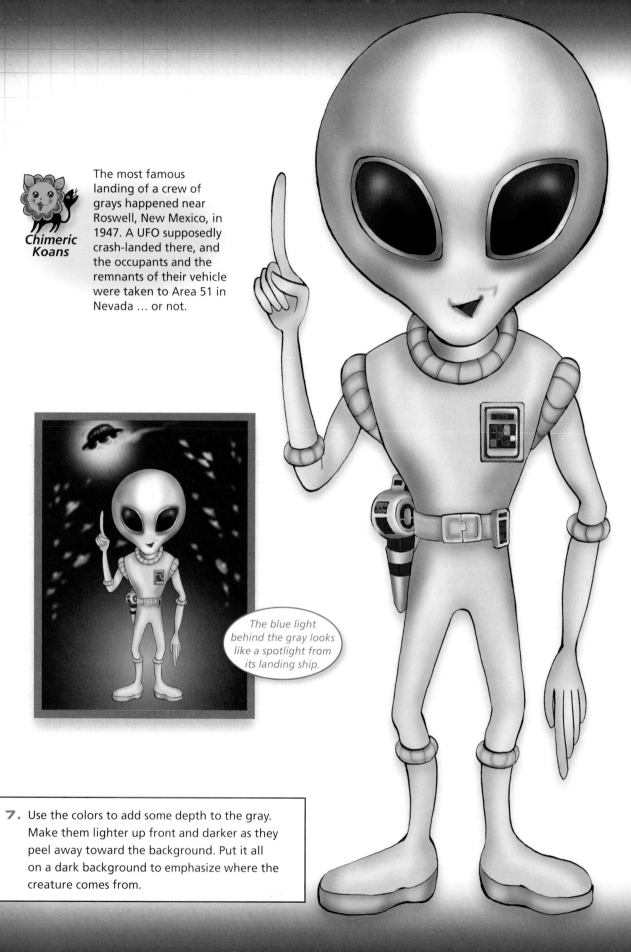

Chimeric Koans

The most famous landing of a crew of grays happened near Roswell, New Mexico, in 1947. A UFO supposedly crash-landed there, and the occupants and the remnants of their vehicle were taken to Area 51 in Nevada … or not.

The blue light behind the gray looks like a spotlight from its landing ship.

7. Use the colors to add some depth to the gray. Make them lighter up front and darker as they peel away toward the background. Put it all on a dark background to emphasize where the creature comes from.

Killer

Killers are aliens who exist for only one reason: to kill—and sometimes eat—everything in their path. They're not here to meet your leaders. They want to tear them apart instead, and you, too, while they're at it.

Pearls of Wisdom

Most aliens have some sort of higher motivation that humans can come to understand: exploration, greed, curiosity, and so on. Killers, though, are only organic machines of death. The only way to deal with them is to kill them before they kill you.

This is one crustacean you're not likely to find boiling in a pot.

1. For this killer, we're going to go with a crablike shape. Notice that the creature has four legs and two arms which terminate in claws.

Most things in nature are symmetrical, and this killer's no exception, alien or not.

2. Flesh out those limbs, especially the claws at the ends of the arms. Add a horny crest to the top of its body. Give it a bunch of eyes.

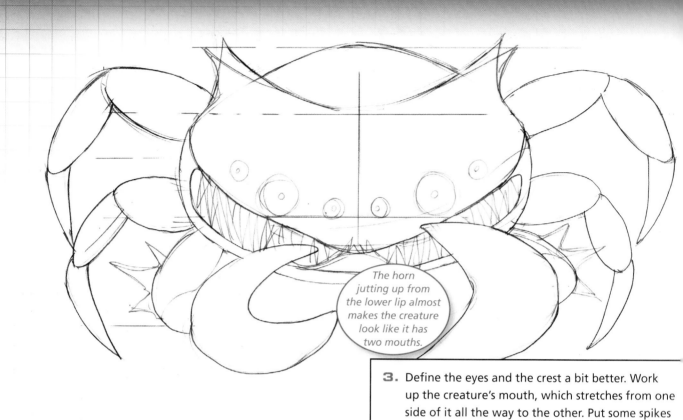

The horn jutting up from the lower lip almost makes the creature look like it has two mouths.

3. Define the eyes and the crest a bit better. Work up the creature's mouth, which stretches from one side of it all the way to the other. Put some spikes along those arms to make it even more dangerous.

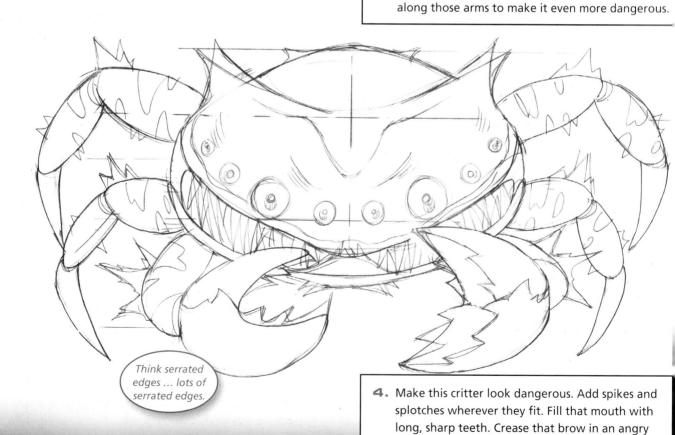

Think serrated edges ... lots of serrated edges.

4. Make this critter look dangerous. Add spikes and splotches wherever they fit. Fill that mouth with long, sharp teeth. Crease that brow in an angry manner. Open the claws.

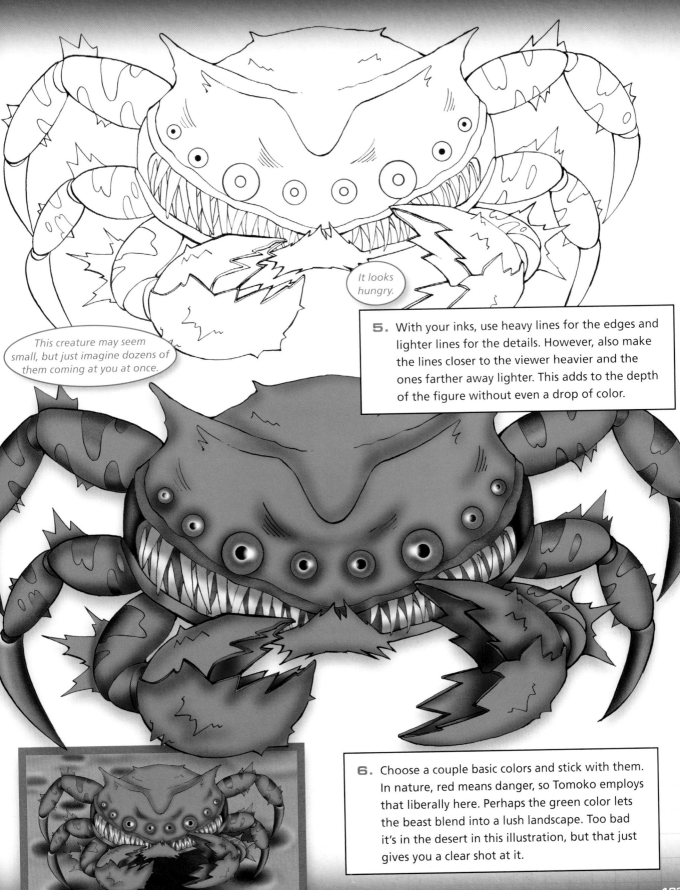

It looks hungry.

This creature may seem small, but just imagine dozens of them coming at you at once.

5. With your inks, use heavy lines for the edges and lighter lines for the details. However, also make the lines closer to the viewer heavier and the ones farther away lighter. This adds to the depth of the figure without even a drop of color.

6. Choose a couple basic colors and stick with them. In nature, red means danger, so Tomoko employs that liberally here. Perhaps the green color lets the beast blend into a lush landscape. Too bad it's in the desert in this illustration, but that just gives you a clear shot at it.

Robot

Robots are one of those essentials of early science fiction that has become real, as you'd see if you visited any automobile factory. To punch things up t the next level, let's think about robots with real personalities, creatures tha are common enough that you might find them in a home—like a robot maic

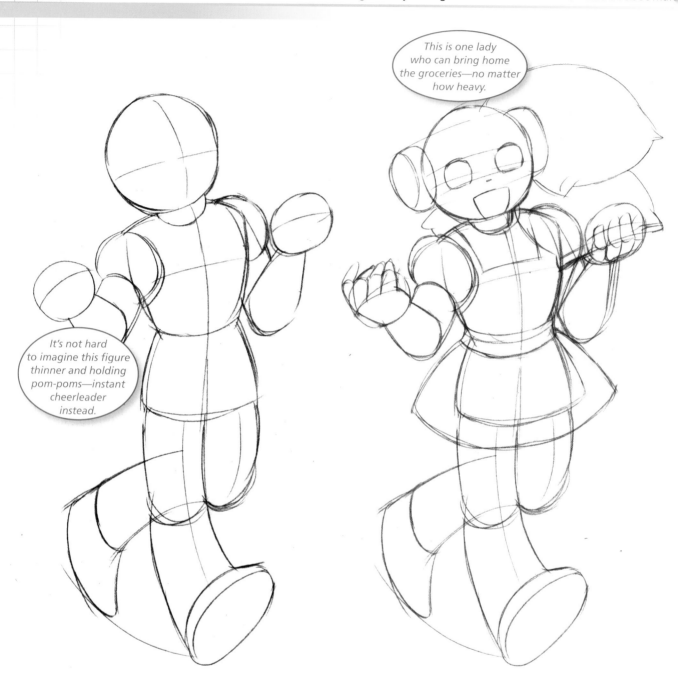

This is one lady who can bring home the groceries—no matter how heavy.

It's not hard to imagine this figure thinner and holding pom-poms—instant cheerleader instead.

1. Use a standard human skeleton for this creature, but make it thicker. This denotes the robot's weight and solidity.

2. Add in bits of the robot's uniform, like the skirt. To make it clearer that this isn't a human, put a cylinder through its head to represent its ears—or buns of hair. Put some sacks of rice on its shoulder, too.

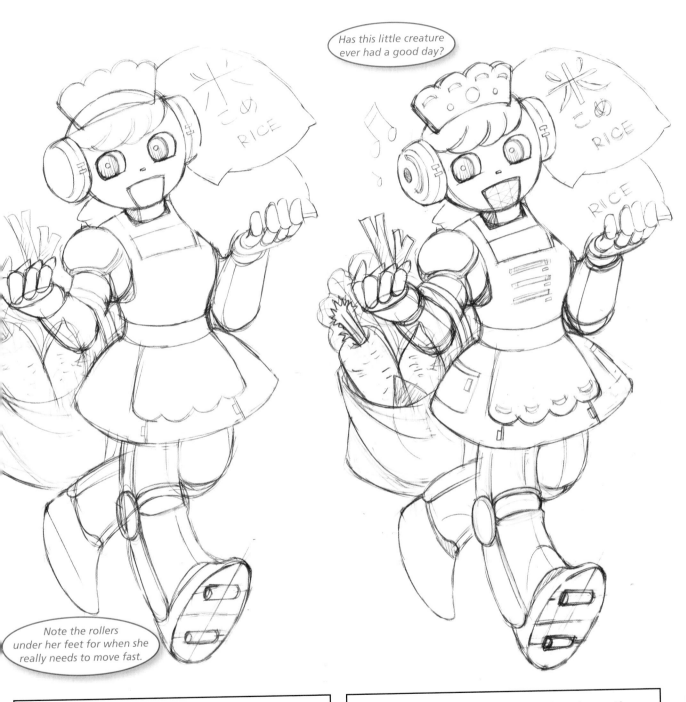

Has this little creature ever had a good day?

Note the rollers under her feet for when she really needs to move fast.

3. Add in more elements of the uniform, like the maid's cap atop the fake sweep of hair. Put more groceries in her other hand. Add in obvious joints, too, and fill in those eyes.

4. Work in all the rest of the details on her uniform and limbs. Fill in the mouth with a speaker grill. Pay attention to the contents of her grocery sack.

AIIEEE!!!

It's easy to make a robot look scary. A different cast to the eyes, and the robot goes from servant to slayer. If that's what you're going for, fine, but take care to make sure you achieve the effect you want.

The lines in her eyes make them look like headlights, which fits perfectly.

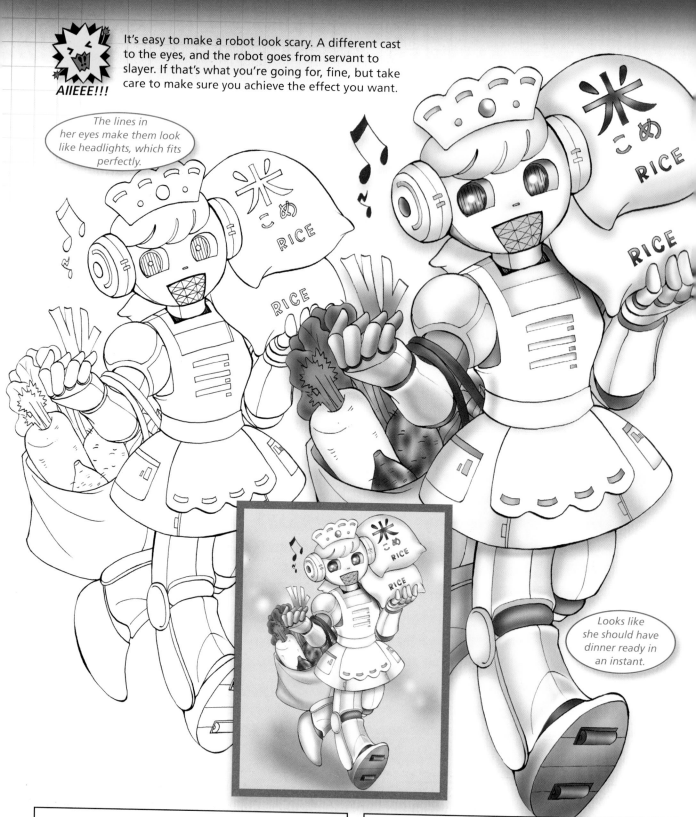

Looks like she should have dinner ready in an instant.

5. Ink the drawing. Use harder lines for the robot herself and softer lines for her uniform and the things she carries.

6. You could paint a robot in any color, of course, but we're going to go with steely colors to emphasize her nature. We can use brighter colors with the groceries, which frame her nicely.

Mecha

Mecha—giant robots—come in two flavors: those driven by humans like gigantic walking tanks, and those driven by computers like gigantic walking tanks. The only real difference is who or what is at the controls, especially since most of the computer-driven mecha are artificial intelligences smart enough to manifest their own personalities. For an artist, the only real difference is whether or not the mecha has a cockpit. For our drawing, we'll assume that it does.

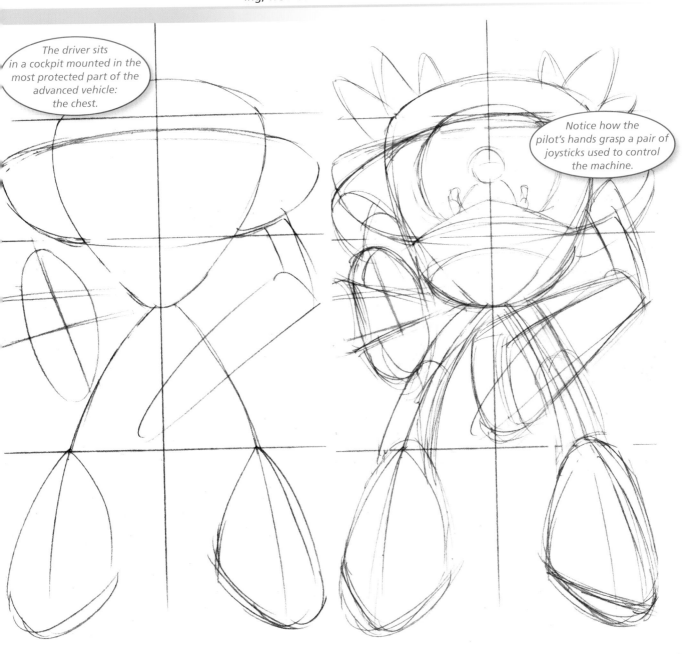

The driver sits in a cockpit mounted in the most protected part of the advanced vehicle: the chest.

Notice how the pilot's hands grasp a pair of joysticks used to control the machine.

1. Mecha generally have a human shape, but often without a headlike structure atop them. The ends of the arms are fitted with heavy weapons, and the feet are usually large and weighty enough to provide a counterbalance for the rest of the machine.

2. Place the cockpit and the pilot inside of it. Add some bulk to the limbs. This is a machine, so we'll have clean lines eventually, but feel free to work with rough curves at this stage. Add some heat vents to the back if you like. These things run hot.

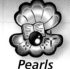
Often the mecha in the same unit, squad, platoon, battalion, etc., have similar color schemes. If you plan to draw lots of them together, you should come up with unique insignia or nameplates for each of them. Otherwise, the viewer may find it impossible to tell them apart.

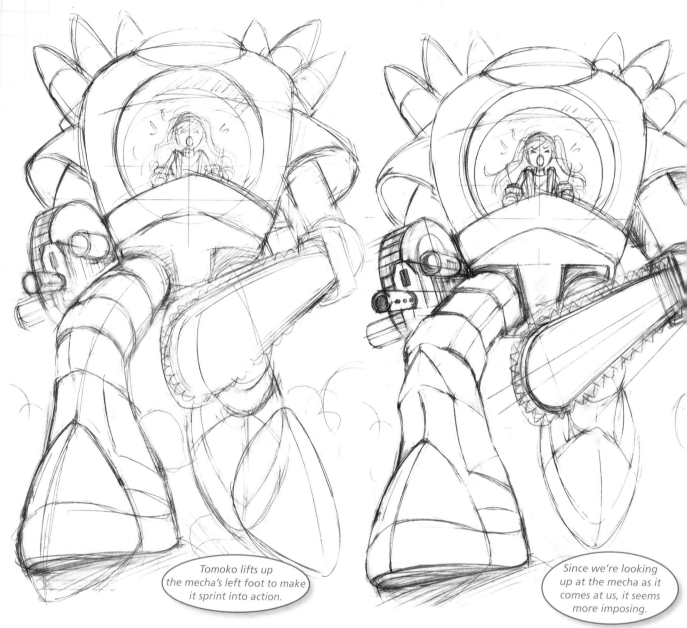

Tomoko lifts up the mecha's left foot to make it sprint into action.

Since we're looking up at the mecha as it comes at us, it seems more imposing.

3. Attach a huge chainsaw to the mecha's left arm. Put a machine gun with a massive drum of ammunition on the right. Make things a bit more angular, but remember you can use curved lines to give limbs and the like an illusion of depth.

4. Polish the lines of the robot. Curves along the body are just fine, but they should be smooth and clean, like those on an expensive car. Use motion lines along the chainsaw to show it buzzing along. Show the pilot shouting at the top of her lungs as she charges into battle.

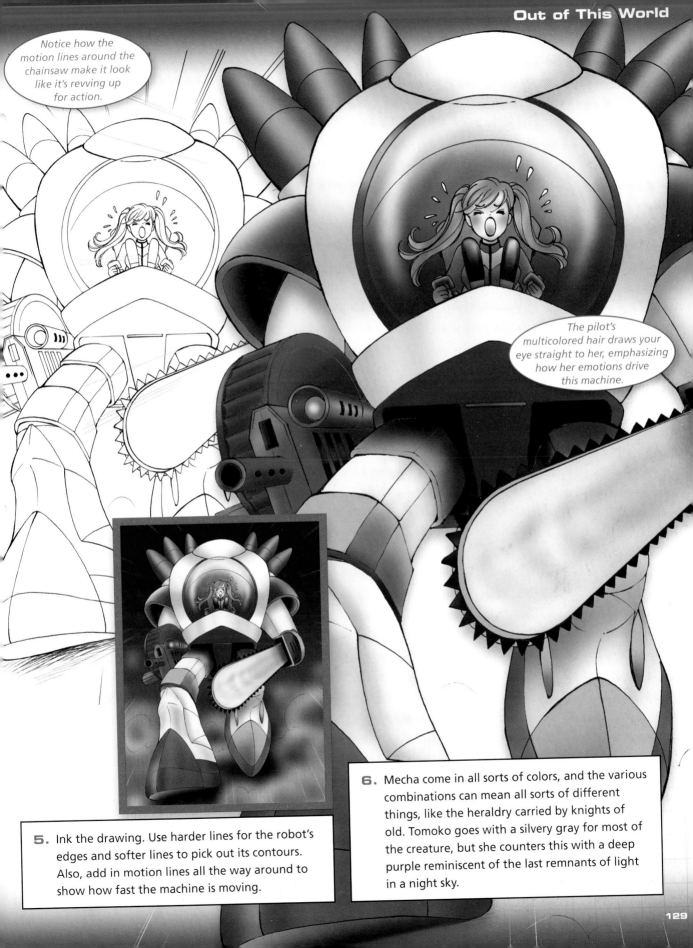

Notice how the motion lines around the chainsaw make it look like it's revving up for action.

The pilot's multicolored hair draws your eye straight to her, emphasizing how her emotions drive this machine.

5. Ink the drawing. Use harder lines for the robot's edges and softer lines to pick out its contours. Also, add in motion lines all the way around to show how fast the machine is moving.

6. Mecha come in all sorts of colors, and the various combinations can mean all sorts of different things, like the heraldry carried by knights of old. Tomoko goes with a silvery gray for most of the creature, but she counters this with a deep purple reminiscent of the last remnants of light in a night sky.

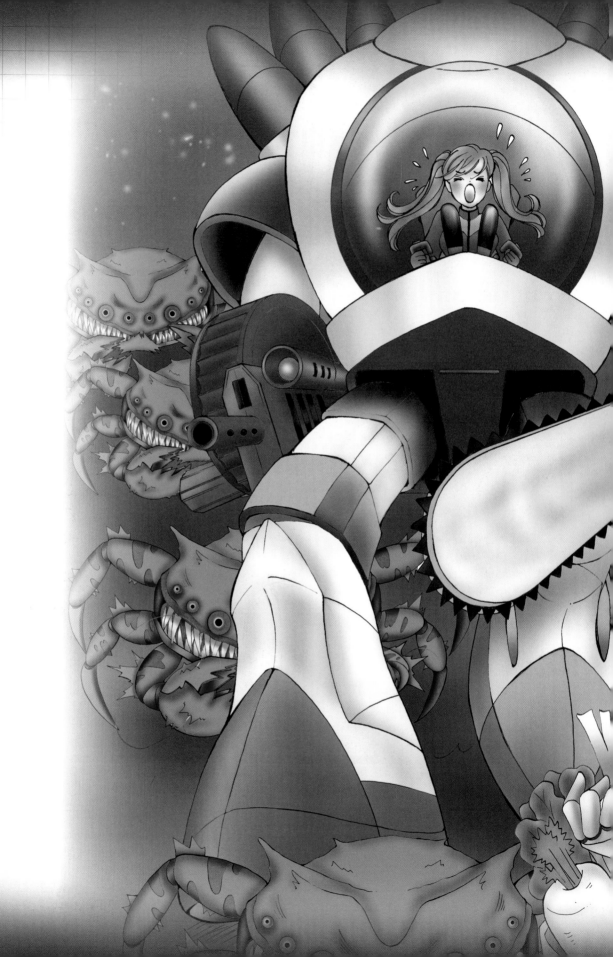

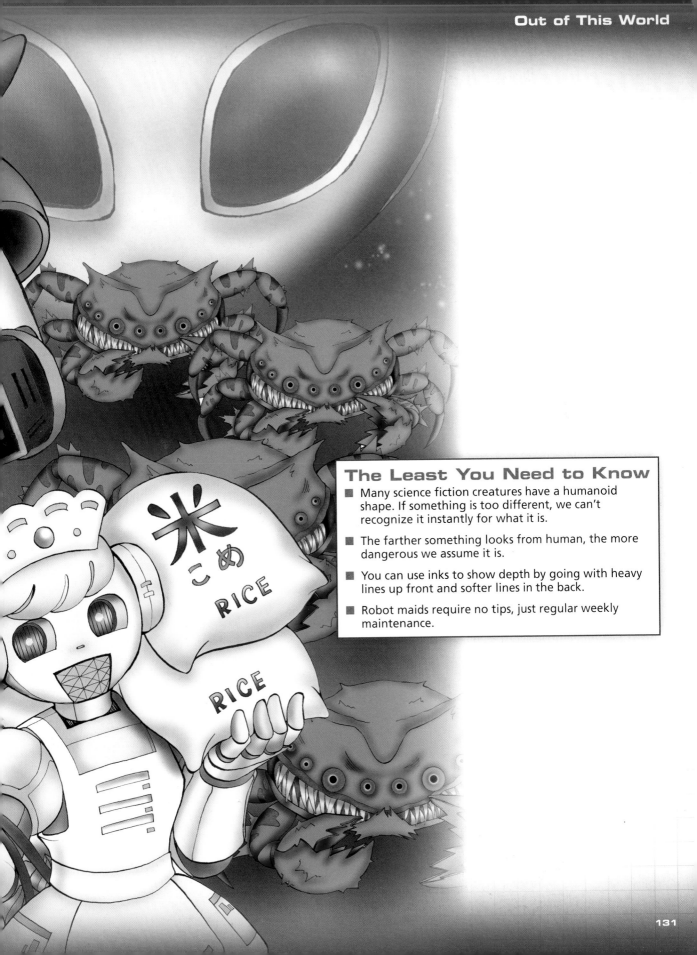

The Least You Need to Know

- Many science fiction creatures have a humanoid shape. If something is too different, we can't recognize it instantly for what it is.

- The farther something looks from human, the more dangerous we assume it is.

- You can use inks to show depth by going with heavy lines up front and softer lines in the back.

- Robot maids require no tips, just regular weekly maintenance.

Part 3
Creating Your Own Creatures

Learning to draw the human figures and classic monsters is fine and good, but most artists eventually feel the itch to stretch their creative wings. When you're ready to come up with creatures of your own, we're here to help you soar.

We cover the basics of finding a theme. Then we explore riffing hard and fast on those basic notions.

When you think you've exhausted those techniques, we point you in directions both stranger and subtler than before.

To cap it all off, we introduce an entirely new style of manga drawing to try your hand at. With that under your belt, you can give every other chapter in this book a fresh look. The fun never ends.

Think Theme: 9
Start with the End in Mind

In This Chapter

- A cat sparking far more than static
- A metallic mutt with a sharp tongue
- A winged creature of the dusk

With all that under our belts, we should be ready to think about coming up with creatures of our own. If you're like many artists, you may already have sketchbooks filled with doodles of your own creations. Be sure to play around with those until you're happy with them. In the meantime, here are some ideas about how to come up with creatures from scratch.

Start with a particular theme and then riff on it like a jazz musician. Apply your own likes and dislikes to it, and see what you come up with. Allow your mind and pencil to range wide and free.

Don't fear mistakes. There are no wrong answers here. The only way to fail is to never start, so get drawing.

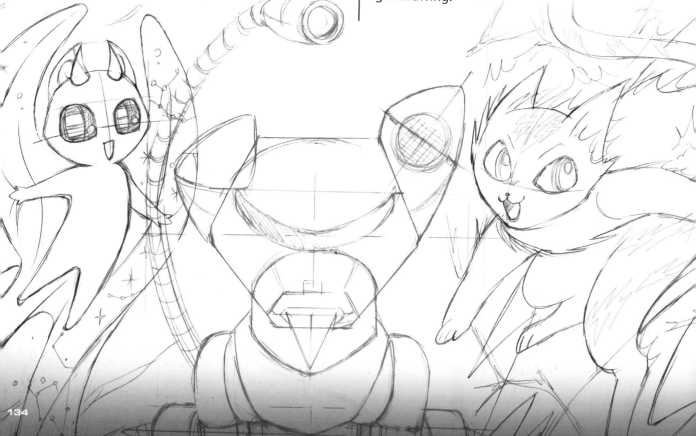

Lightning Cat

To start, we'll take two iconic ideas and cross them. Let's start with lightning and a cat. Imagine the sort of static discharge a cat generates while rubbing itself on a carpet on a dry, winter day, and then pump that up a million percent. Let's see where that takes us.

AIIEEE!!!

There's a long tradition in the arts of taking something other people have done and then riffing on it, making it your own. "There is nothing new under the sun," as they say. Still, you have to take care to make sure you're not just outright copying someone else's efforts. That sort of intellectual theft is called plagiarism.

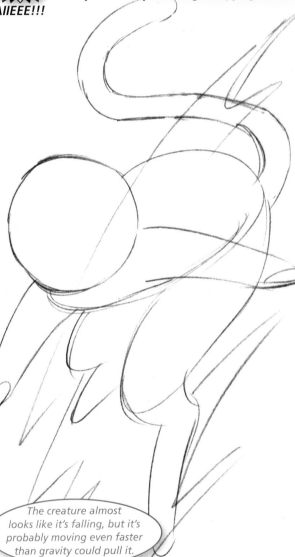

The creature almost looks like it's falling, but it's probably moving even faster than gravity could pull it.

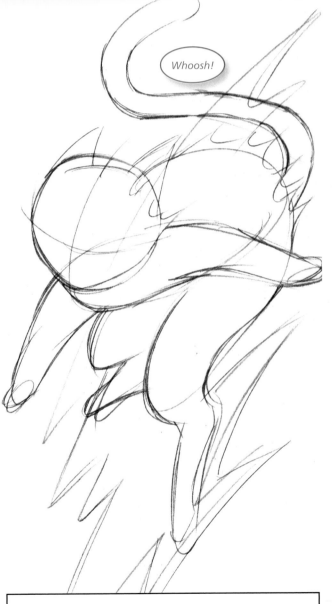

Whoosh!

1. Break the figure down. Tomoko puts the cat up on its hind legs so that it rides a lightning bolt like a surfer on a board. This adds a lot of action to the drawing and emphasizes what the creature's all about: power and speed.

2. Add in some of the creature's fur and its ears. Show motion through the way its fur moves. With such electricity about, the cat's hair would stand on end, and its movement would sweep it backward at the same time.

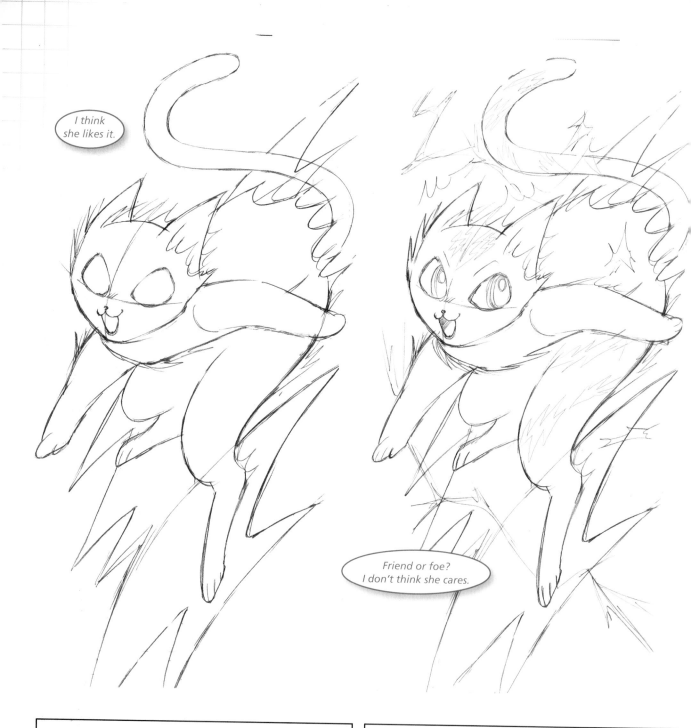

3. Focus on the face here. This cat is having the time of her life. Add in more motion to the fur to show how the wind rips through her as she moves.

4. Think crackles and sparkles here. Add all the little bits that make such a picture come to life. Focus on the eyes, too, as those will set the tone for the entire image.

Chimeric Koans

Don't get hung up on naming your creature before you start. As you create, you're going to come up with new ideas anyhow. If you lock yourself into a name too early, that can trap you in a single line of thinking. Let yourself roam free in those early stages and nail everything down later.

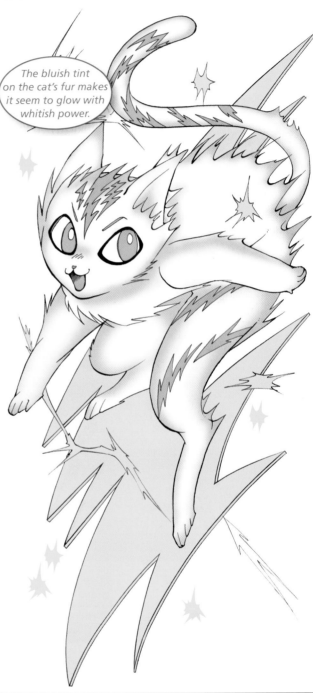

The bluish tint on the cat's fur makes it seem to glow with whitish power.

She looks like she could give you one big zap.

5. With something as insubstantial and fleeting as lightning, use lighter ink lines. Do the same for the cat's fur to emphasize her link to the elements in which she finds herself. Go especially heavy on the eyes to anchor her around her personality.

6. Pick a single, bright color for the lightning and go with a bright color and a complementary darker color for the cat. Tomoko chooses yellow for the energy and white and orange for the cat.

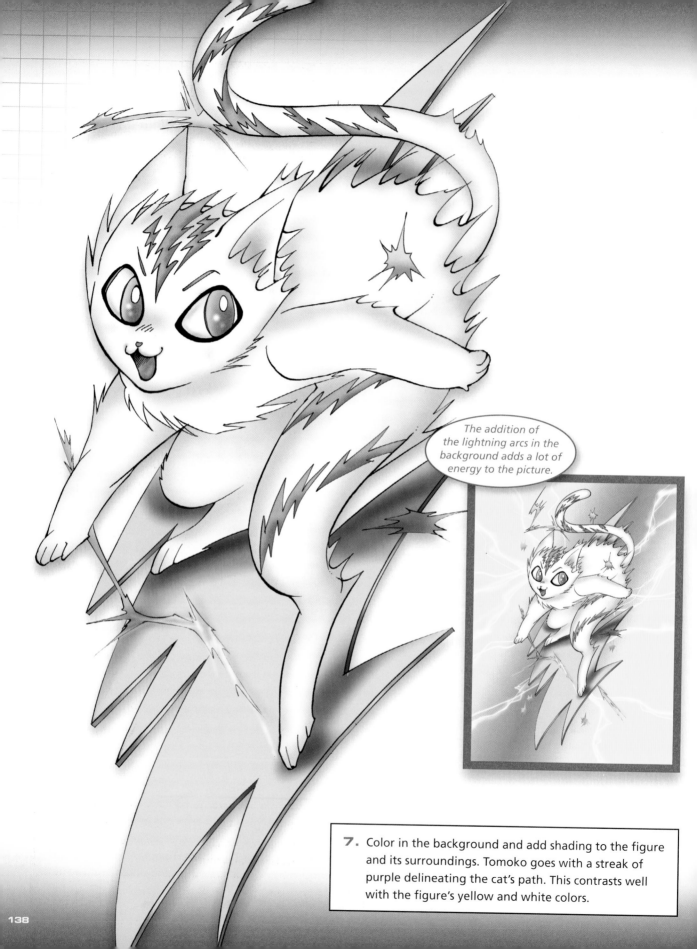

The addition of the lightning arcs in the background adds a lot of energy to the picture.

7. Color in the background and add shading to the figure and its surroundings. Tomoko goes with a streak of purple delineating the cat's path. This contrasts well with the figure's yellow and white colors.

Robodog

Next up, we'll combine another household pet—a dog—with a robot. How dangerous do you think we can make a harmless puppy seem? Let's give it a shot.

One reason for basing your figures on well-known creatures like house pets is that both you and your viewers already know the anatomy of such beasts. That makes it easier for you to draw them, and for the viewer to instantly understand them.

How much is that doggy in the window? More than you have.

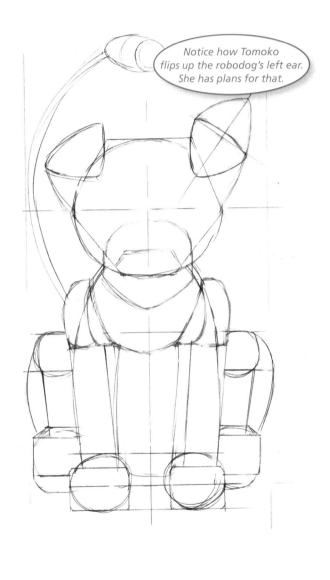

Notice how Tomoko flips up the robodog's left ear. She has plans for that.

1. Let's start with a basic dog shape. This pooch sits right in front of us like a happy puppy awaiting its master's orders. The only clue that something isn't quite right is that long tail with what looks like a high-tech lampshade on the end of it.

2. With the basic shape down, start making the angles sharper and more metallic. Make the joints larger and rounder.

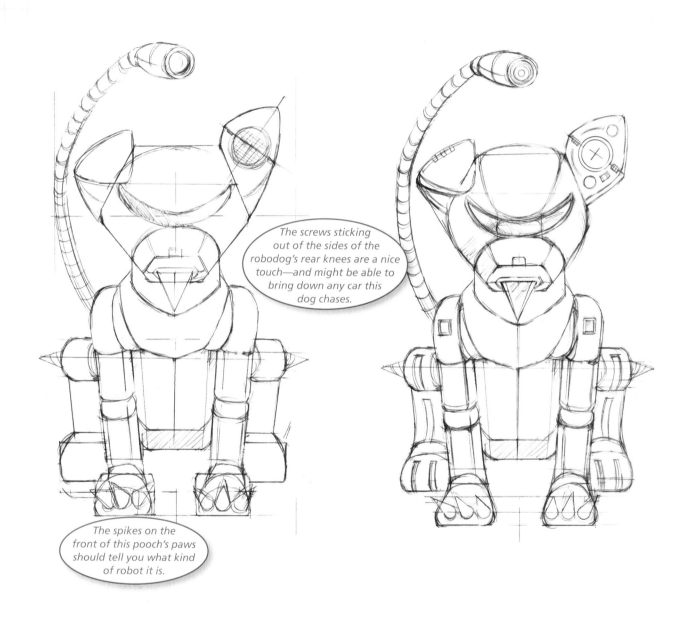

The screws sticking out of the sides of the robodog's rear knees are a nice touch—and might be able to bring down any car this dog chases.

The spikes on the front of this pooch's paws should tell you what kind of robot it is.

3. Make everything sharper, more angular, and more metallic. Put articulated joints in the tail, making it look even more like a modern desk lamp. Go with one wide eye—more of a visor—instead of a pair of eyes.

4. Add in more details, making the creature look more like the product of an engineer's CAD modeling program rather than a living mutt.

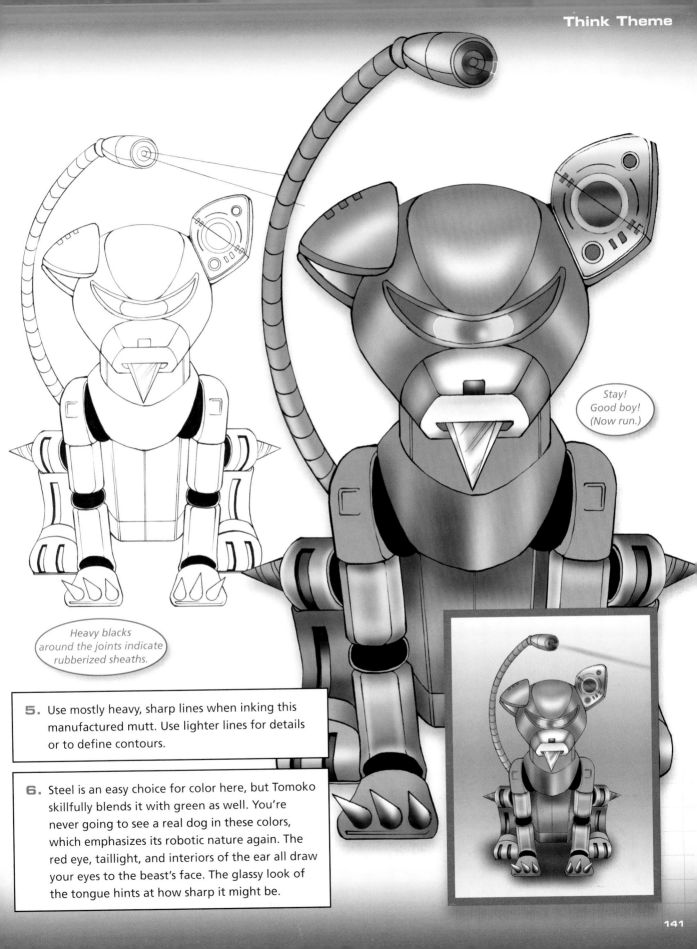

Stay!
Good boy!
(Now run.)

Heavy blacks around the joints indicate rubberized sheaths.

5. Use mostly heavy, sharp lines when inking this manufactured mutt. Use lighter lines for details or to define contours.

6. Steel is an easy choice for color here, but Tomoko skillfully blends it with green as well. You're never going to see a real dog in these colors, which emphasizes its robotic nature again. The red eye, taillight, and interiors of the ear all draw your eyes to the beast's face. The glassy look of the tongue hints at how sharp it might be.

Night Creature

It can be fun, even illuminating, to cross things that don't line up well. But it's worthwhile to try lining up two things that match, just to see how far you can take them. This time, we're matching night with the creature most associated with it: the bat.

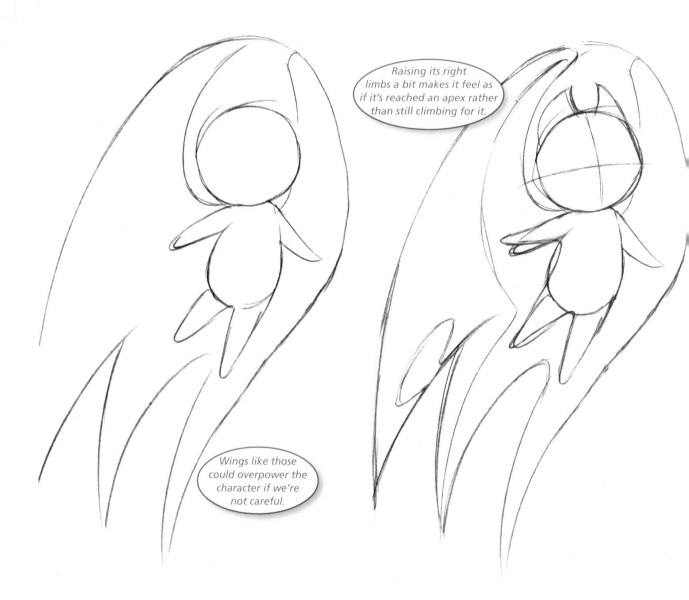

Raising its right limbs a bit makes it feel as if it's reached an apex rather than still climbing for it.

Wings like those could overpower the character if we're not careful.

1. Tomoko goes with a humanoid figure here. This denotes a friendlier creature rather than an all-out monster. The large, sweeping wings play against that, though, so we'll have to see where this takes us.

2. Pull the edges of the wings around, enveloping the creature's body like a protective cloak. Add some horns to the head to give it a bit more edge.

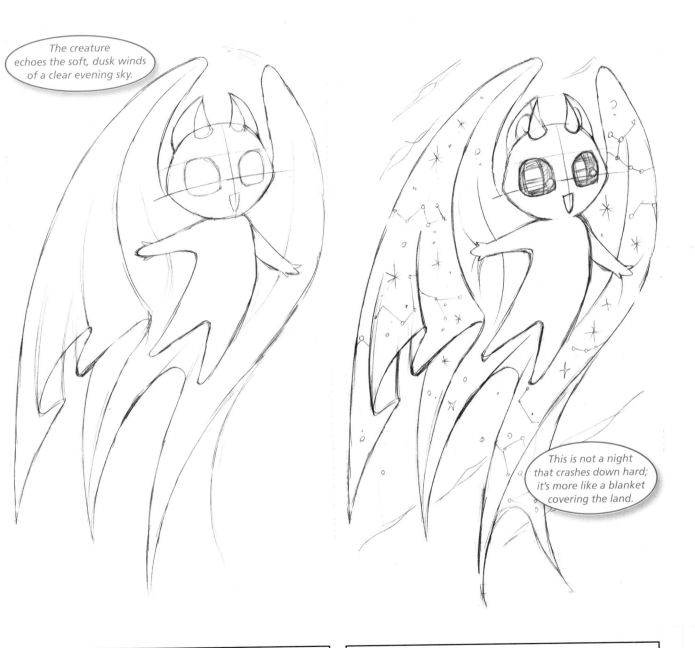

The creature echoes the soft, dusk winds of a clear evening sky.

This is not a night that crashes down hard; it's more like a blanket covering the land.

3. Add some sweeping lines to the wings, making them feel more sheer. Place the eyes and mouth. Note that the new "horns" atop the creature's head aren't any such thing. They're part of the bat's large, curved ears.

4. Night's not all about blackness, so stitch those wings with stars. The way the creature grabs at her wings with her fingers makes the wings seem even softer. Fill in the eyes and mouth and define the ears better.

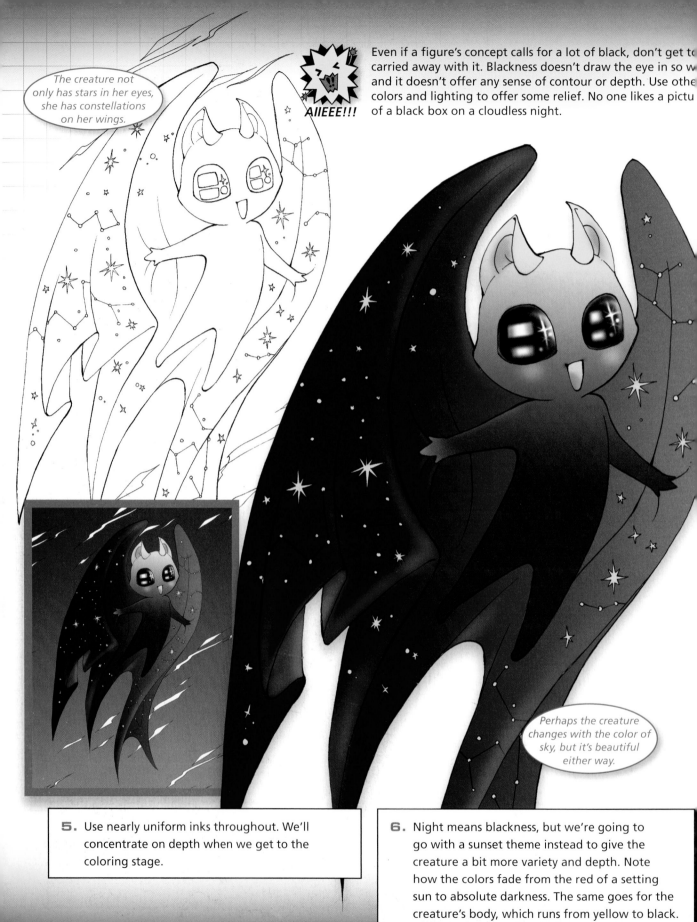

The creature not only has stars in her eyes, she has constellations on her wings.

AIIEEE!!!

Even if a figure's concept calls for a lot of black, don't get too carried away with it. Blackness doesn't draw the eye in so well and it doesn't offer any sense of contour or depth. Use other colors and lighting to offer some relief. No one likes a picture of a black box on a cloudless night.

Perhaps the creature changes with the color of sky, but it's beautiful either way.

5. Use nearly uniform inks throughout. We'll concentrate on depth when we get to the coloring stage.

6. Night means blackness, but we're going to go with a sunset theme instead to give the creature a bit more variety and depth. Note how the colors fade from the red of a setting sun to absolute darkness. The same goes for the creature's body, which runs from yellow to black.

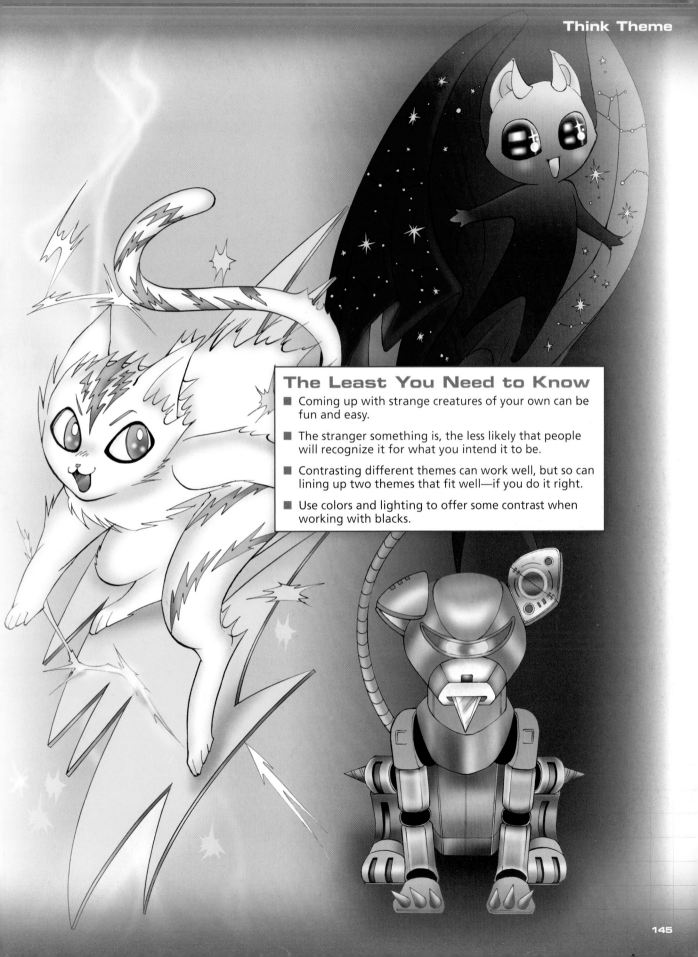

The Least You Need to Know

■ Coming up with strange creatures of your own can be fun and easy.

■ The stranger something is, the less likely that people will recognize it for what you intend it to be.

■ Contrasting different themes can work well, but so can lining up two themes that fit well—if you do it right.

■ Use colors and lighting to offer some contrast when working with blacks.

Variations:
Spice Up Your Creature's Life

10

In This Chapter

■ Balls of rice and other things

■ Fire-breathing apes in love

■ The dragon of the future

■ Undead vermin looking for more than cheese

■ A royal fairy fit to be crowned

Now that we've got the basics down for how to create fantasy monsters or animals of your own, let's try a few more variations. Some of these are outlandish (like the living rice ball), but others are just riffs on a theme we've already visited (like zombie rats).

You can get a lot of mileage out of small tweaks to creature types you're already familiar with. Sometimes they come out fantastic, and other times they're just silly. Fortunately, manga has room for all types.

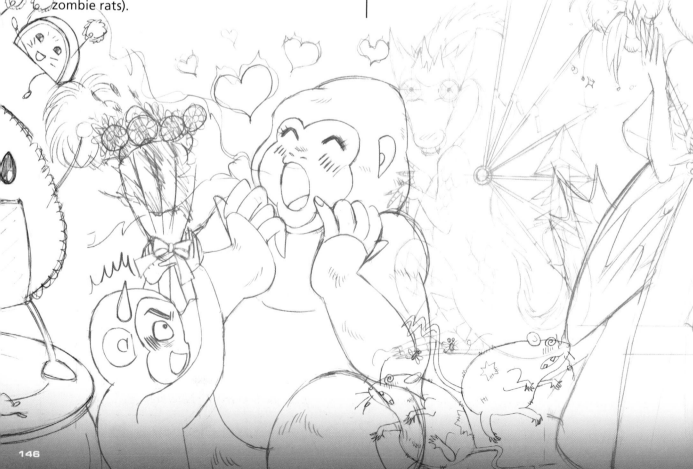

Rice Ball

A rice ball is a traditional Japanese food. It usually comes filled with some sort of tasty meat or fish, and wrapped in a sheet of dried seaweed. They're more popular in Japan than sandwiches, and nearly everyone eats them. At least, until they get up and talk.

Chimeric Koans

What's silly and what's not is mostly a matter of taste, but it also depends somewhat on the context. A living rice ball that gets up from your plate and yells at you for trying to eat it may seem trippy. But if you show that same rice ball crawl out of a refrigerator, grab a knife from the kitchen, and slip into a bedroom, it's suddenly a lot less funny. It's absurd either way though.

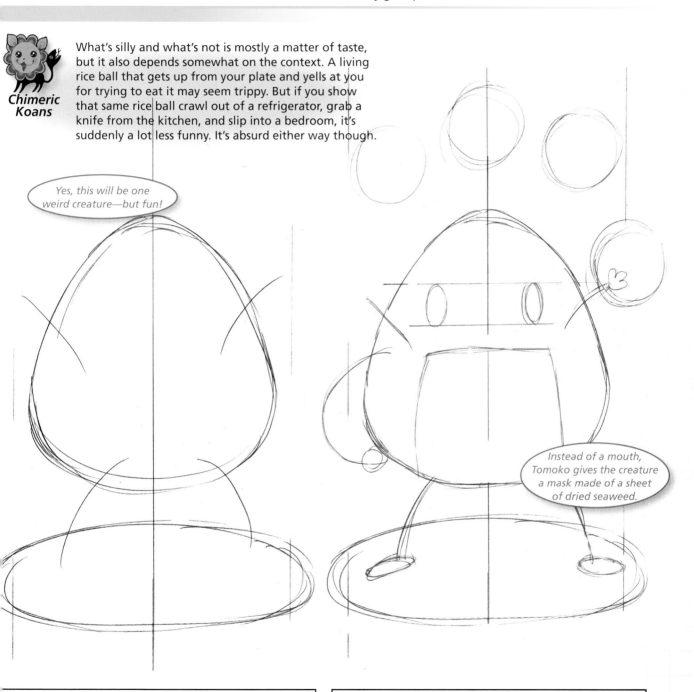

Yes, this will be one weird creature—but fun!

Instead of a mouth, Tomoko gives the creature a mask made of a sheet of dried seaweed.

1. If you have no idea what a talking rice ball might look like, skip ahead to the end and come back here. Rice balls come in a wide variety. Tomoko decides to go with the popular triangular form. She puts it on a plate and gives it arms and legs.

2. Put a pom-pom in the creature's left hand, and sketch in the eyes. Put a few circles above it for placement of some alternative food monsters, which you'll show in smaller sizes.

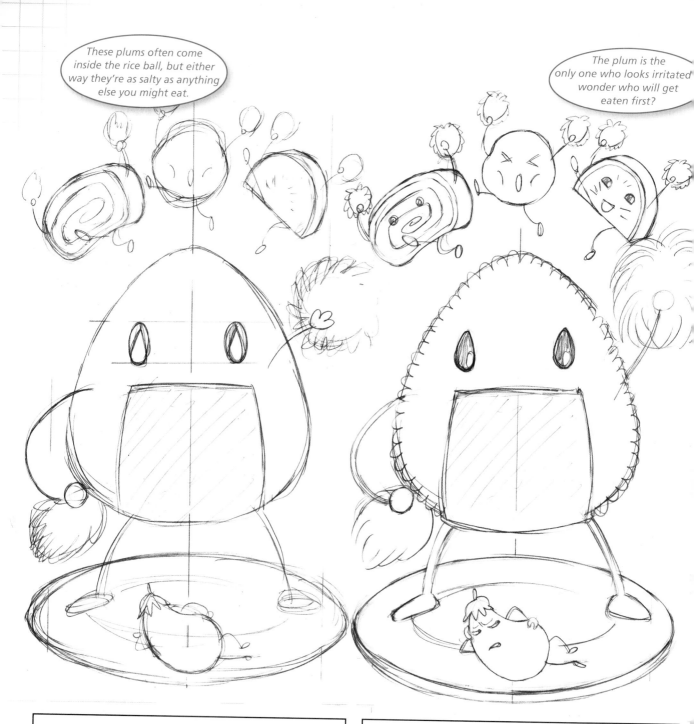

3. Put in some details on the other food creatures. They'll each have pom-poms, making for a full line of cheerleaders. Define the rice ball's eyes a bit better and put a salty plum on the plate at its feet.

4. Put faces on the other food creatures. Add a ruffled ridge all the way around the outside of the rice ball to show what it's really made of. Give the plum a face, too.

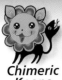

Chimeric Koans

A talking rice ball may seem strange to Americans, but you can find things like this in manga if you look. The *Monster Rancher* anime, for instance, has a monster named Mochi, who is so named for his resemblance to a sweetened Japanese version of the Chinese rice cake.

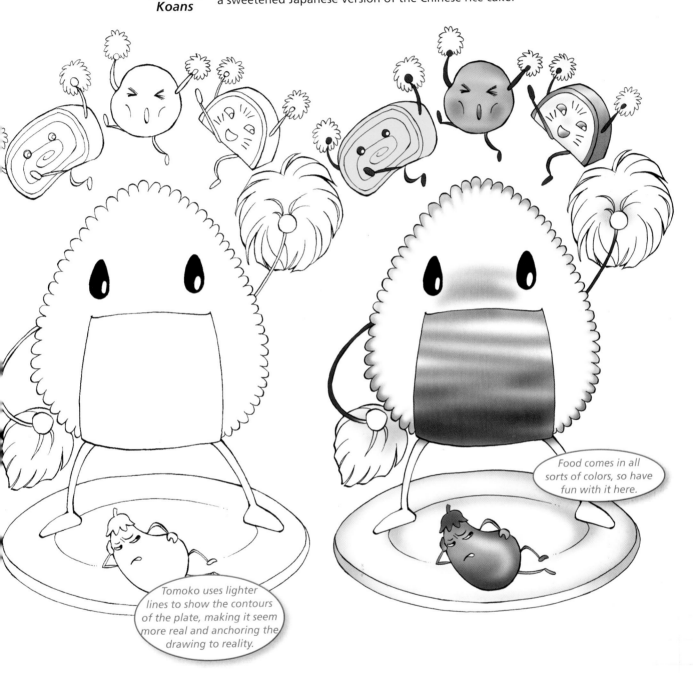

Tomoko uses lighter lines to show the contours of the plate, making it seem more real and anchoring the drawing to reality.

Food comes in all sorts of colors, so have fun with it here.

5. As this creature is more of a cartoon than a serious work, you can use uniform lines throughout.

6. Choose some basic colors for each of the creatures. These should be based on their ingredients. The rice ball, for instance, is mostly white, with a bit of brown for the soy sauce. The plum is as purple as you would expect.

It all looks good enough to eat.

7. Add all sorts of bright colors to give the final piece some life. Tomoko puts splashes of color below each of the creatures, showing which direction is straight down for them.

Fiery Gorilla

Here we have a gorilla with a dragon's ability to breathe fire. Just for fun, Tomoko decides to make this part of a romance story in which the love-struck gorilla is so excited by the presentation of a bouquet of flowers that she burns it to a crisp. It's all part of the evil plot of the horned monkey who shows her the flowers, of course.

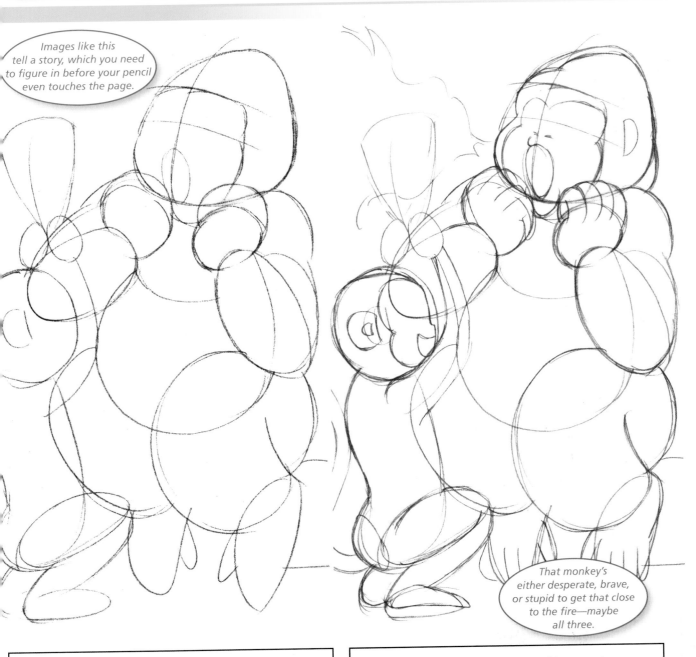

Images like this tell a story, which you need to figure in before your pencil even touches the page.

That monkey's either desperate, brave, or stupid to get that close to the fire—maybe all three.

1. Since the gorilla and the monkey are primates, you can use humanoid skeletons for them. Just make the gorilla burlier than your average person, and both of the creatures a lot more flexible. Don't forget to put that bouquet up there in the line of fire of the gorilla's scorching breath.

2. Work in the faces and the markings on the primates. Note how the monkey smiles and the gorilla seems surprised. Also add in the fringes of the flames.

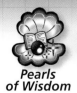

**Pearls
of Wisdom**

Use sticks of art charcoal to draw the burning flowers. This gives them a naturally burnt look.

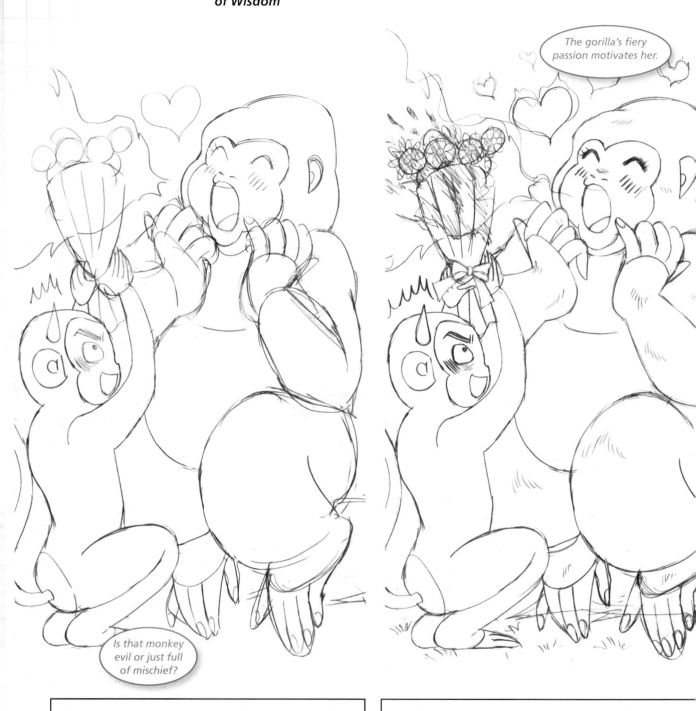

The gorilla's fiery passion motivates her.

Is that monkey evil or just full of mischief?

3. Add the primates' features. Elongate the gorilla's fingers and toes. Complete their faces, and add horns to the monkey. Tomoko adds in a heart to show what the gorilla's feeling.

4. Put a few more hearts around the gorilla. Use furry contours to show the gorilla's bulk. Put petals on the flowers. Add flames to the hearts, too.

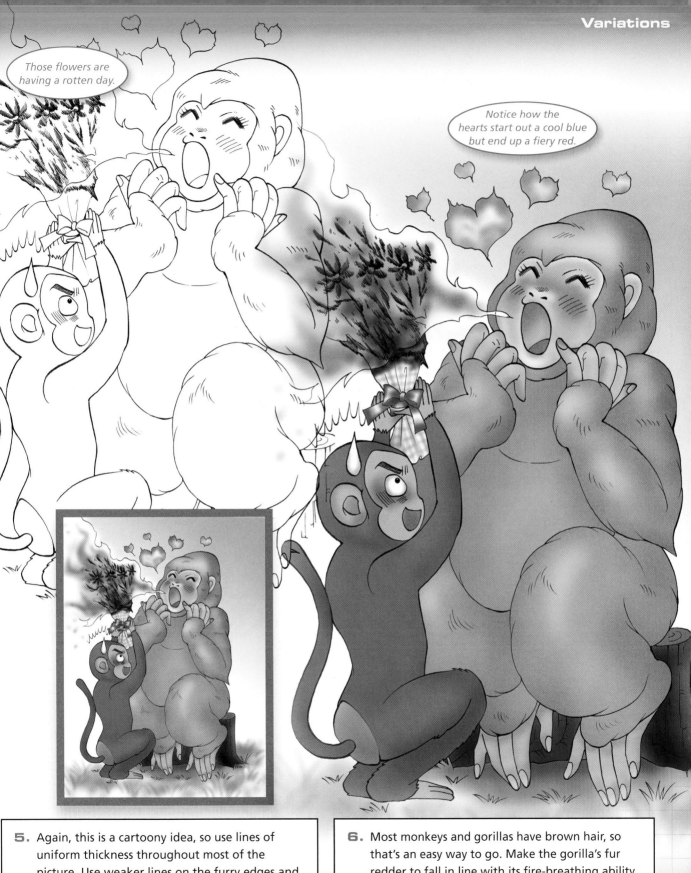

5. Again, this is a cartoony idea, so use lines of uniform thickness throughout most of the picture. Use weaker lines on the furry edges and on the edges of the flames.

6. Most monkeys and gorillas have brown hair, so that's an easy way to go. Make the gorilla's fur redder to fall in line with its fire-breathing ability.

Bionic Dragon

Dragons are dangerous enough, but when you outfit them with bionic weaponry and senses, they become a force able to take out even the strongest soldiers of the future. New knights may come equipped with laser swords, but the cyberdragon is ready for them!

1. Start out with a standard Western dragon shape. We'll end up replacing some of his natural parts with cybernetics, but don't worry about that right now.

2. Add in some more details to the creature's head. Pay attention to the shape of the body. Try to make it seem more natural and muscled. Again, don't worry about the cybernetics yet.

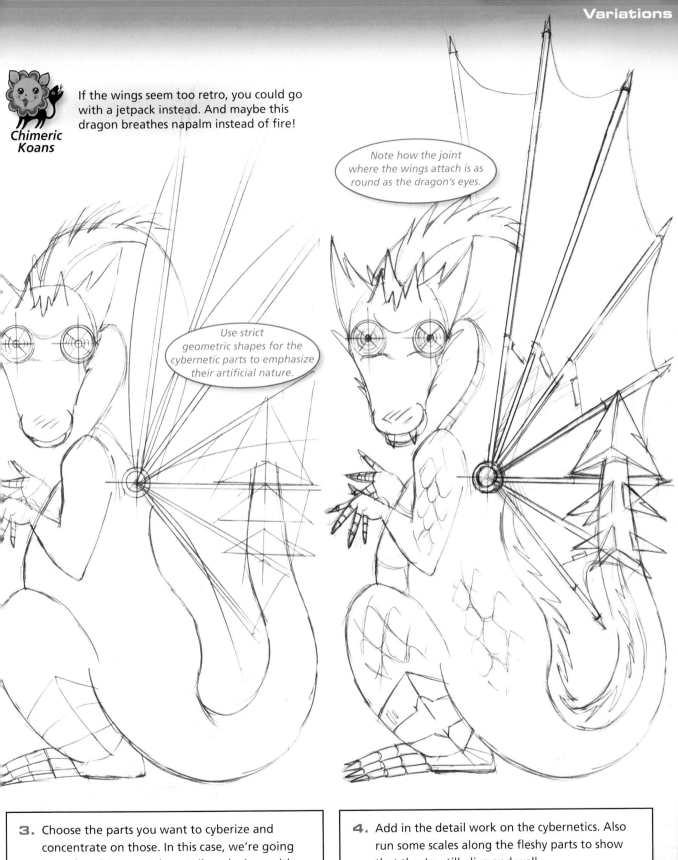

Chimeric Koans

If the wings seem too retro, you could go with a jetpack instead. And maybe this dragon breathes napalm instead of fire!

Note how the joint where the wings attach is as round as the dragon's eyes.

Use strict geometric shapes for the cybernetic parts to emphasize their artificial nature.

3. Choose the parts you want to cyberize and concentrate on those. In this case, we're going to replace his eyes, talons, tail, and wings with cybernetic parts.

4. Add in the detail work on the cybernetics. Also run some scales along the fleshy parts to show that they're still alive and well.

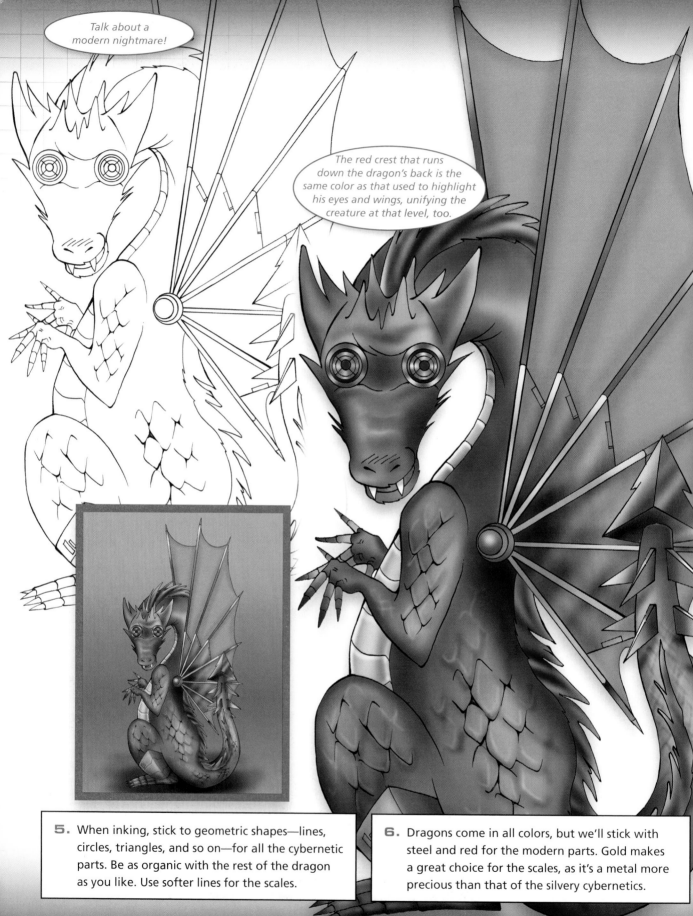

Talk about a modern nightmare!

The red crest that runs down the dragon's back is the same color as that used to highlight his eyes and wings, unifying the creature at that level, too.

5. When inking, stick to geometric shapes—lines, circles, triangles, and so on—for all the cybernetic parts. Be as organic with the rest of the dragon as you like. Use softer lines for the scales.

6. Dragons come in all colors, but we'll stick with steel and red for the modern parts. Gold makes a great choice for the scales, as it's a metal more precious than that of the silvery cybernetics.

Zombie Rats

We covered zombies way back in Chapter 2, but those were the human kind. There's nothing that says that zombie-hood can't be inflicted on other species like, say, rats. Imagine a horde of these undead vermin worming their way into your home, and you have the fodder for a real nightmare.

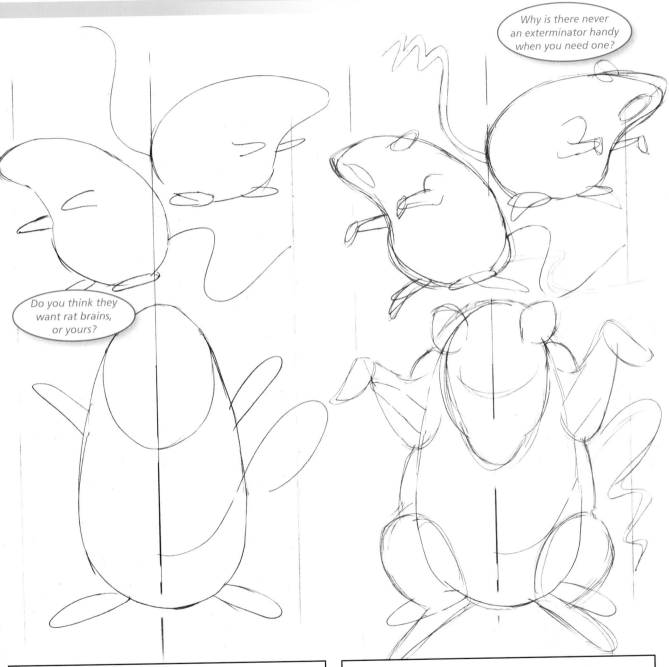

Why is there never an exterminator handy when you need one?

Do you think they want rat brains, or yours?

1. Because a single rat—even a zombie rat—is pretty small, Tomoko decided to go with three rats instead. Each of them has a different pose, but the one up front is coming right at you!

2. Move beyond shapes into the fleshier forms. Since these are evil, meat-eating vermin, make their poses as aggressive as you can. Note how the front rat's head is bowed low so it can glare at you from under its brow.

When it comes to zombies, there's a fine line between fun and gore, and you need to know on which side you want any one of your pictures to sit. Each has its own fans, but it's not fair to tease a viewer with one and then deliver the other—unless you want people mad at you, in which case, go for it. In most cases, though, it's best to choose a path for your work and then stick with it.

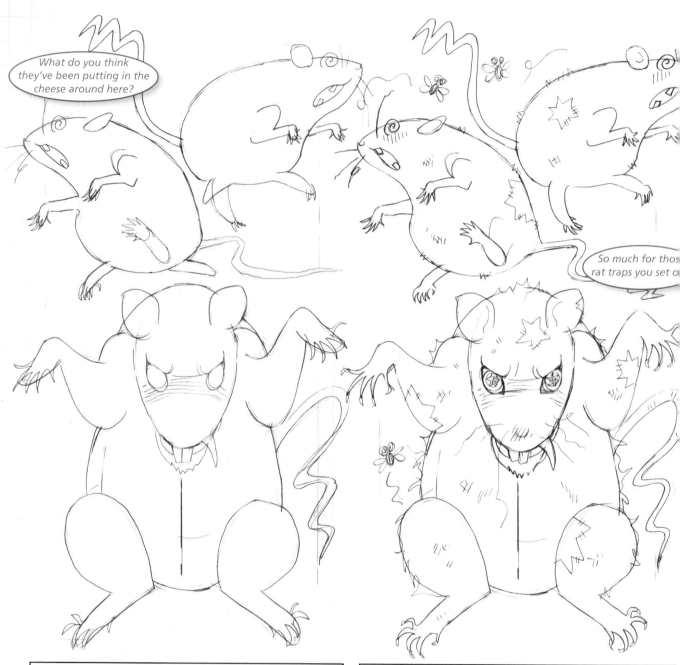

3. Add in faces and fangs. You can use crazed swirls in place of the eyes if you like, especially in the rats in the background. Leave room for the one up front to glare right at you instead.

4. Now that you have your vicious little rats ready to go, tear them up. These are undead rats, and they need to show a lot of wear. You could let bones show through if you wanted to, although Tomoko's stopped shy of that here.

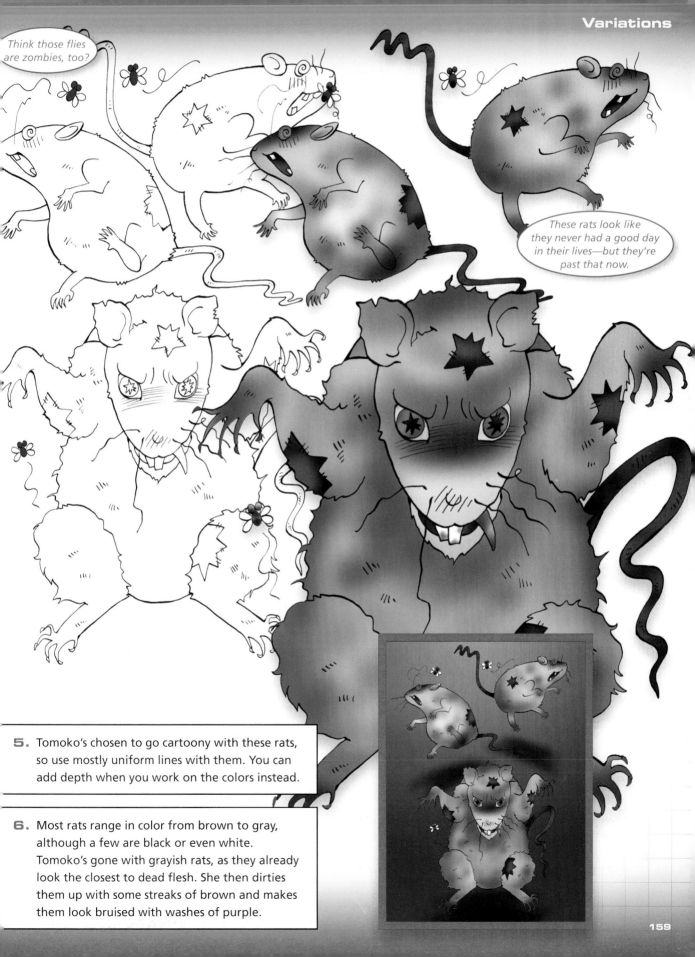

Think those flies are zombies, too?

These rats look like they never had a good day in their lives—but they're past that now.

5. Tomoko's chosen to go cartoony with these rats, so use mostly uniform lines with them. You can add depth when you work on the colors instead.

6. Most rats range in color from brown to gray, although a few are black or even white. Tomoko's gone with grayish rats, as they already look the closest to dead flesh. She then dirties them up with some streaks of brown and makes them look bruised with washes of purple.

Pixie Queen

We tackled pixies back in Chapter 3. Let's try to see what the queen of the pixies might look like. Combining perkiness with posh royalty can be tricky, but with some thought we can pull it off.

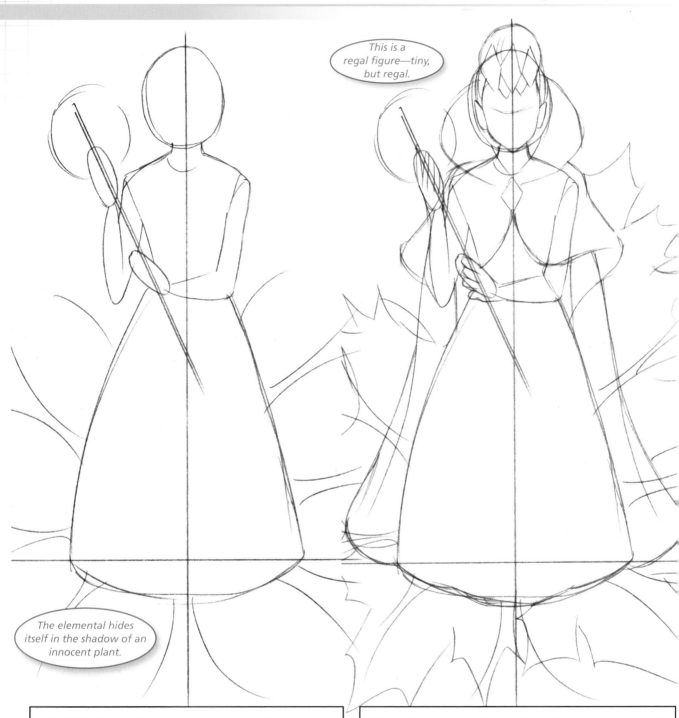

This is a regal figure—tiny, but regal.

The elemental hides itself in the shadow of an innocent plant.

1. Pixies have a humanoid shape, so that's easy enough to pull off by this point. Put her on some kind of plant to help show scale, and give her a scepter as a symbol of her power.

2. Add some material to the pixie queen's dress and give her a crown. A high collar on a warm stole works well, too. Sketch out the leaf that's under her feet.

Pearls of Wisdom

If a better idea strikes you in the middle of a drawing, that's okay. That's why you have an eraser in your art kit. Notice how Tomoko started out with the pixie queen on a flower and changed it into a leaf. This fits better with the queen's dress and gives the picture an autumnal flavor that a flower wouldn't have suggested. When your gut tells you to change your picture and try something else, do it. If it doesn't work out the first time, you can always try it again.

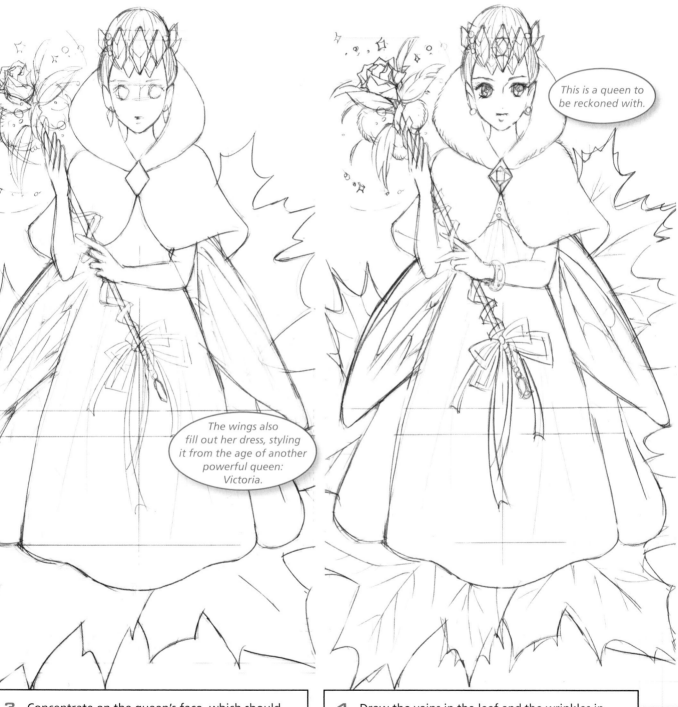

The wings also fill out her dress, styling it from the age of another powerful queen: Victoria.

This is a queen to be reckoned with.

3. Concentrate on the queen's face, which should show the serenity of a creature confident in its power. Go wild on the scepter. Make it as elaborate as you like. Add in some wings folded low, ready to be unfurled when needed.

4. Draw the veins in the leaf and the wrinkles in the material of the dress. Pick out the flowers at the end of the scepter. Finish off the face, paying particular attention to her eyes.

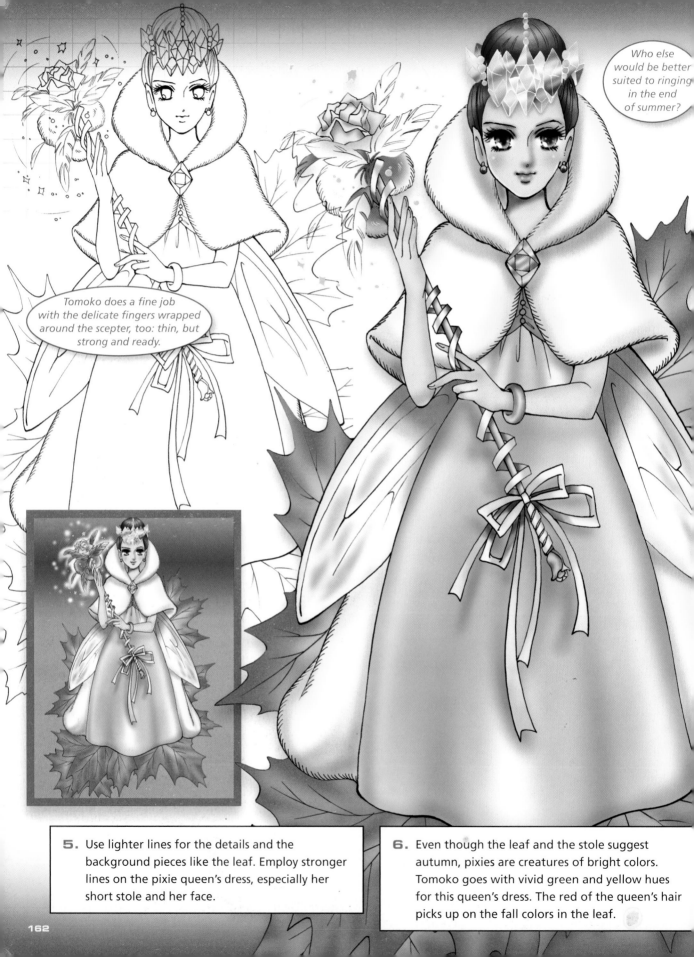

Who else would be better suited to ringing in the end of summer?

Tomoko does a fine job with the delicate fingers wrapped around the scepter, too: thin, but strong and ready.

5. Use lighter lines for the details and the background pieces like the leaf. Employ stronger lines on the pixie queen's dress, especially her short stole and her face.

6. Even though the leaf and the stole suggest autumn, pixies are creatures of bright colors. Tomoko goes with vivid green and yellow hues for this queen's dress. The red of the queen's hair picks up on the fall colors in the leaf.

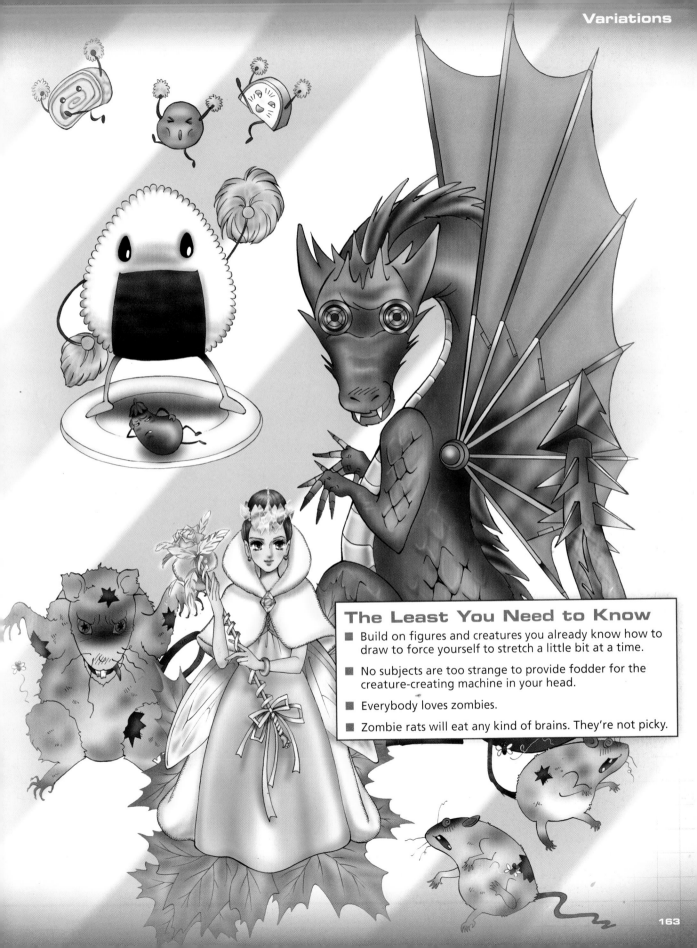

The Least You Need to Know

■ Build on figures and creatures you already know how to draw to force yourself to stretch a little bit at a time.

■ No subjects are too strange to provide fodder for the creature-creating machine in your head.

■ Everybody loves zombies.

■ Zombie rats will eat any kind of brains. They're not picky.

Surprises:
Monsters More than They Seem

11

In This Chapter

- Creatures of the night who worship the sun
- Octopus-headed snakemen wizards casting spells
- Books that take a big bite from their readers

It's time to take the weirdness meter and crank it up to 11. We're going to play with expectations and twist things around a bit.

We'll start with a vampire princess that enjoys the California beaches. From there, we'll move on to

a serpentman shaman, who looks like Cthulhu's (the greatest of author H. P. Lovecraft's elder gods) distant uncle. Then we'll finish up with a monster book that's more monster than book.

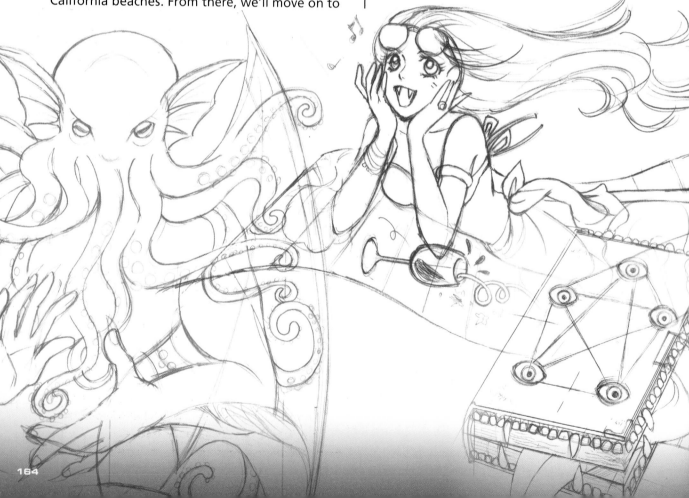

Vampire Princess

Vampire princesses are the sort of monsters who sneak up on you right to your face. They seem like carefree and happy, even beautiful, young women … until they get hungry and decide to snack on your blood to take the edge off. Fortunately, they always seem to be watching their figures, so if you're lucky they'll leave you with something to live on.

Pearls of Wisdom

As an artist, you can try to affect what people look at first in your drawings. If you're successful with a little misdirection, you can cause your viewers to miss something at first glance that can sneak up on them like a high-speed blender of a plot twist.

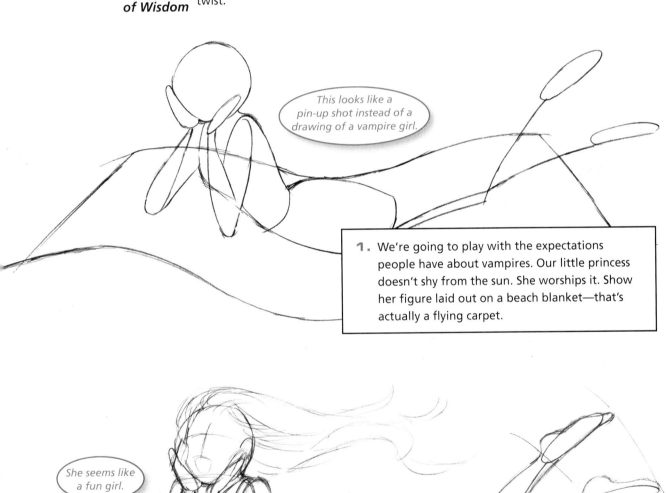

This looks like a pin-up shot instead of a drawing of a vampire girl.

1. We're going to play with the expectations people have about vampires. Our little princess doesn't shy from the sun. She worships it. Show her figure laid out on a beach blanket—that's actually a flying carpet.

She seems like a fun girl.

2. Add a bit more flesh to the creature. Sketch out the edges of her swimsuit, which features a skirt. Add in her flowing hair, which helps impart the feeling of movement to the picture.

Chimeric Koans

In the most famous vampire novel, Bram Stoker's *Dracula*, the vampire lord Dracula walks around in broad daylight. He can't use his vampiric powers then, but the sunshine doesn't do anything worse than make him shade his eyes.

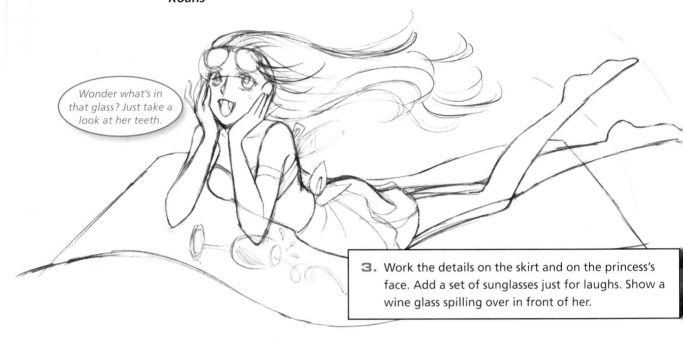

Wonder what's in that glass? Just take a look at her teeth.

3. Work the details on the skirt and on the princess's face. Add a set of sunglasses just for laughs. Show a wine glass spilling over in front of her.

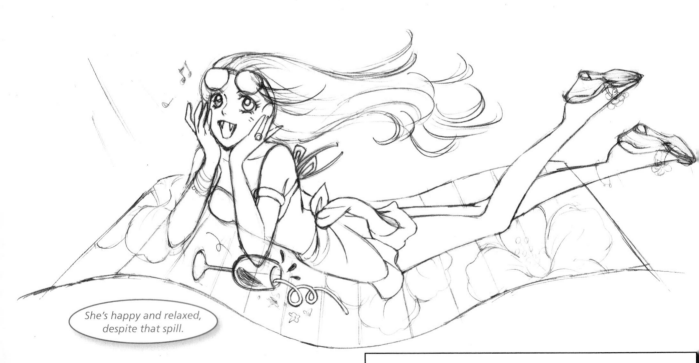

She's happy and relaxed, despite that spill.

4. Put a floral pattern on the flying carpet. Give her some funky shoes and an anklet. Put a couple music notes next to her and show the sun shining down.

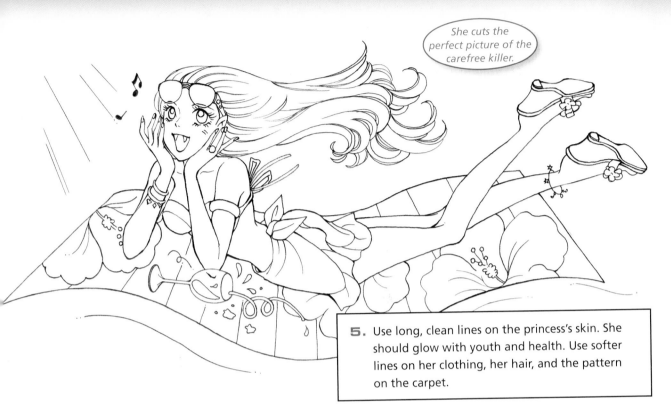

She cuts the perfect picture of the carefree killer.

5. Use long, clean lines on the princess's skin. She should glow with youth and health. Use softer lines on her clothing, her hair, and the pattern on the carpet.

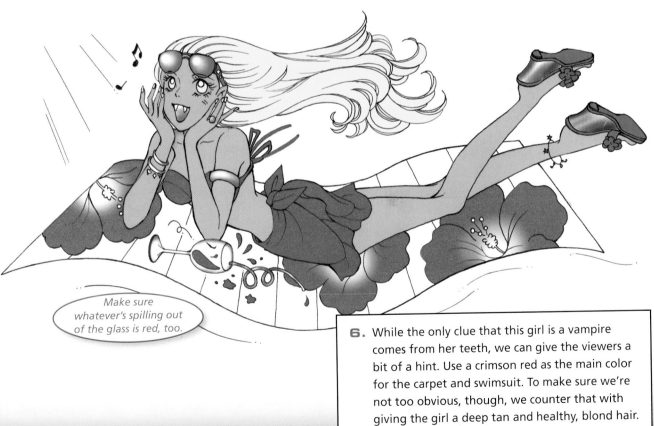

Make sure whatever's spilling out of the glass is red, too.

6. While the only clue that this girl is a vampire comes from her teeth, we can give the viewers a bit of a hint. Use a crimson red as the main color for the carpet and swimsuit. To make sure we're not too obvious, though, we counter that with giving the girl a deep tan and healthy, blond hair.

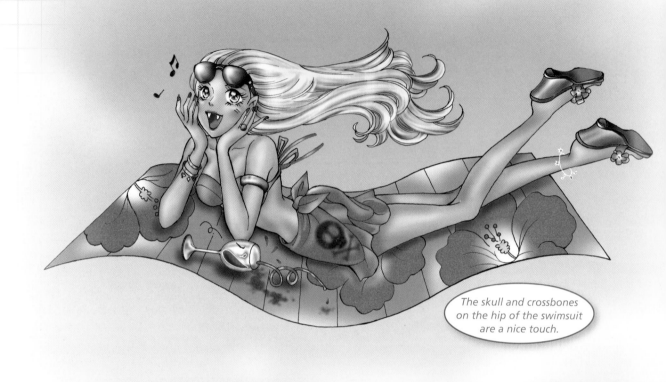

The skull and crossbones on the hip of the swimsuit are a nice touch.

7. Polish the colors. Add some green to the carpet to contrast with the red. Placing a shadow far below the carpet shows that she's flying high in the clouds.

Snakeman

This creature is as over the top as you can get. It has the lower half of a snake propping up the upper torso and arms of a man, all topped off with a head of an octopus, complete with tentacles. Cthulhu, meet your nephew.

Chimeric Koans

Cephalopods are a class of marine mollusks that includes octopuses, squids, and nautiluses. Note that all of these soft-skinned beasts have loads of tentacles to wrap around their victims before they drag them into the briny deep.

See, nothing to worry about; nothing you wouldn't find in your average Sinbad movie.

Now we're tripping into the weird.

1. This is a serpentman with a funny head, so we can use a standard humanoid shape for the upper part, including the head for now. The lower part looks like a coiled snake.

2. Here's where we start to get a little stranger—okay, a lot stranger. Add in the tentacles dripping down from the face, and place a set of batlike wings on the creature's back. A set of batlike ears completes the image.

3. Pin down the creature a bit harder here. Follow the curls of those tentacles. Show the eyes. Raise the top of the head.

4. Work in all the details here. Add scales to the snake part and suckers to the tentacles. Give the wings an underlying framework.

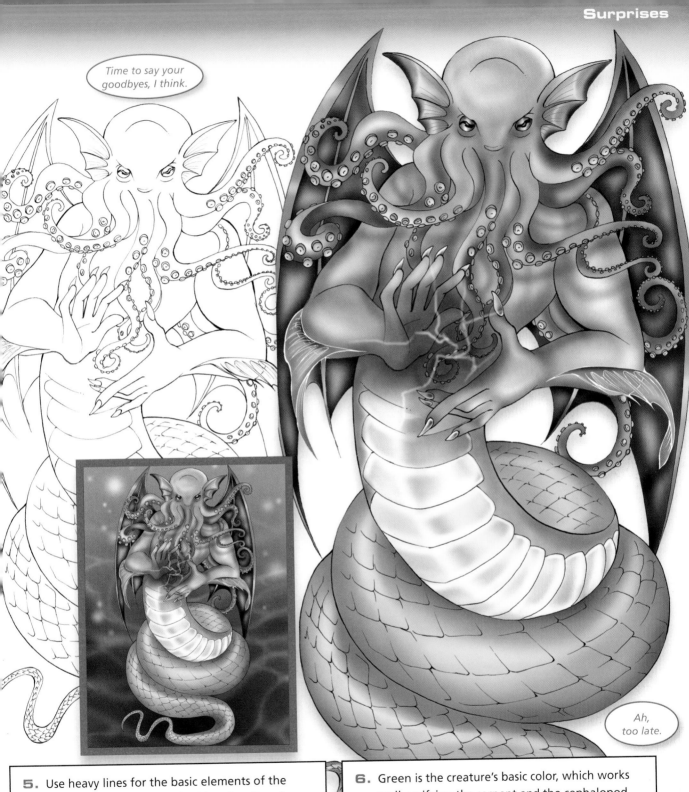

Time to say your goodbyes, I think.

Ah, too late.

5. Use heavy lines for the basic elements of the creature's shape, but stick with softer lines for details like the scales. This creature has a lot of detail, and putting strong lines everywhere would muddle the picture so much you wouldn't be able to pick anything out.

6. Green is the creature's basic color, which works well, unifying the serpent and the cephalopod parts. The addition of rainbow-tinted bits on the ears and along the arms makes the creature seem even stranger. The final touch, though, is the glowing ball of crackling, crimson energy hovering between the creature's hands.

Monster Book

Some books contain words that bite, but this creature actually has teeth and a tongue between its covers. It may look like an innocent book at first, but if you get close enough, it might lick its binding. If that doesn't let you know that something's wrong, then you're already too far gone.

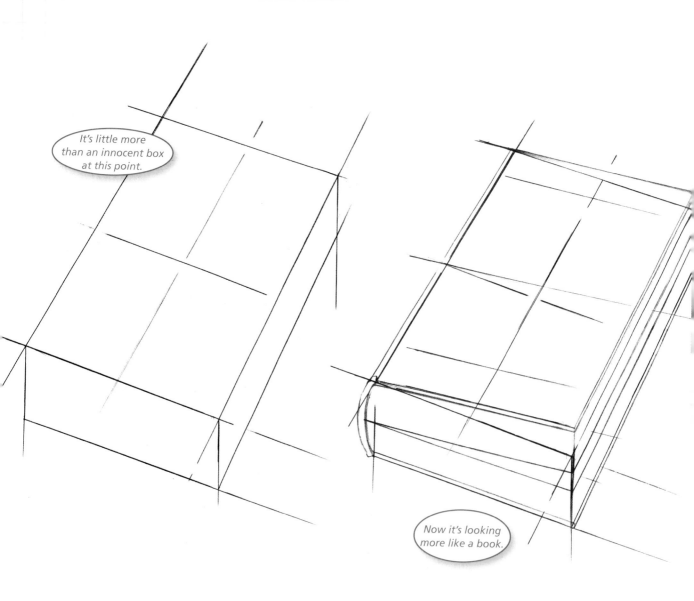

It's little more than an innocent box at this point.

Now it's looking more like a book.

1. Books are rectangular, and this creature is no exception.

2. Show the book opening up a bit here. Leave the bottom of the book where it is, but set up the top slab at a different angle. Curve the binding while you're at it.

**Pearls
of Wisdom**

The most famous of evil books, the
Necronomicon, never existed. H. P. Lovecraft
made it up for the stories in his Cthulhu mythos.

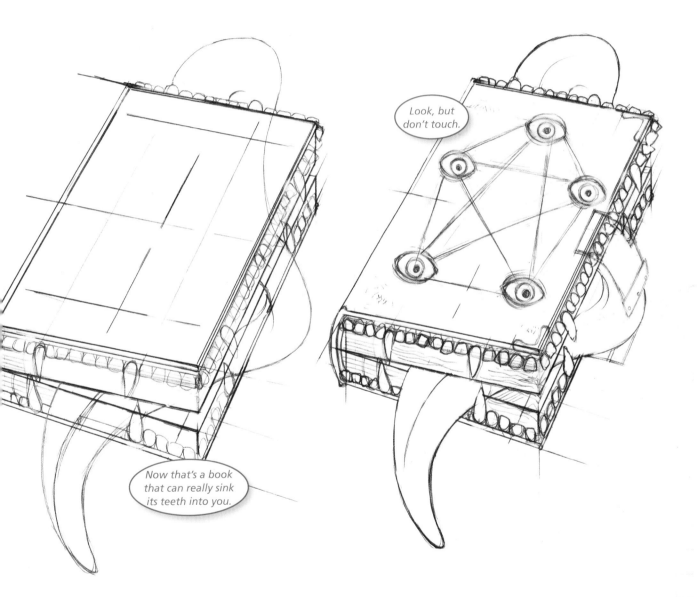

*Look, but
don't touch.*

*Now that's a book
that can really sink
its teeth into you.*

3. Add a single, long tongue snaking through the
edges of the book and back. Line the edges of
the pages with teeth, including a few sets of
fangs.

4. Add a pentacle on the cover, with open eyes at
each of the outer vertexes. Place an undone lock
along the open edge. Fill in those page edges
and the details on the teeth.

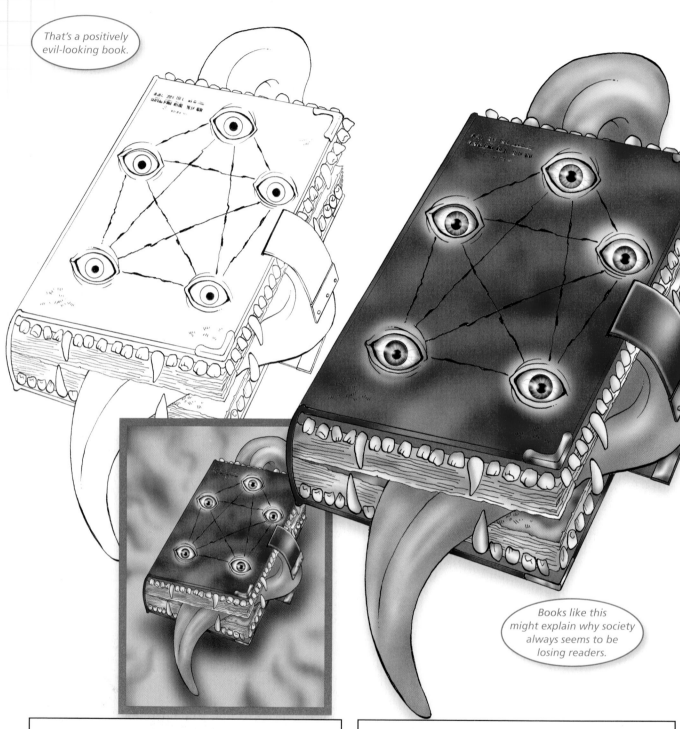

That's a positively evil-looking book.

Books like this might explain why society always seems to be losing readers.

5. When inking this, use unsteady lines in many places, especially the pentacle atop the book. This makes the thing appear hand-tooled rather than manufactured.

6. A dark red reinforces the book's unwholesome appearance. Coloring the tongue pink and the gums red makes the thing's mouth uncomfortably human.

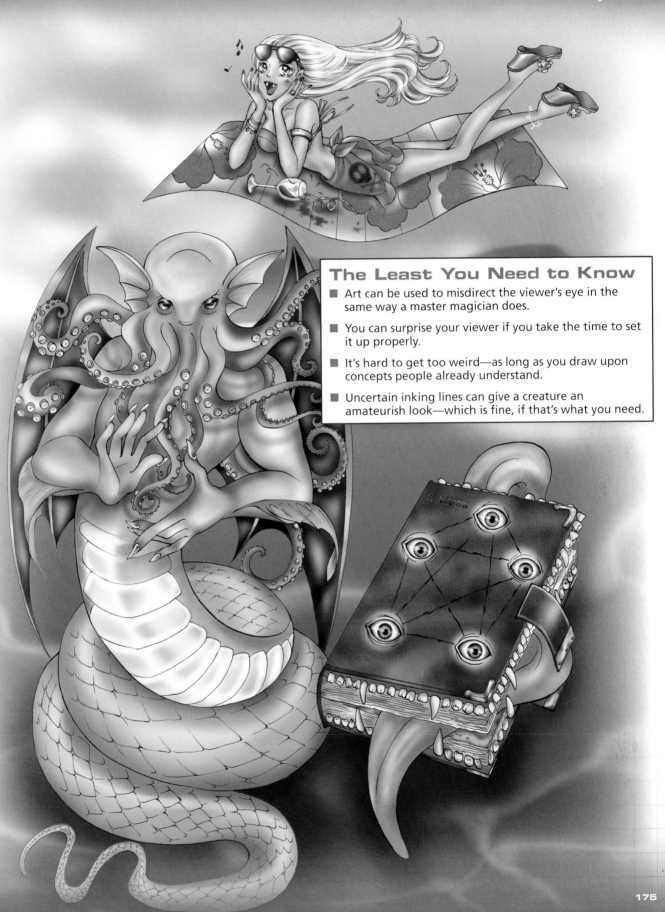

The Least You Need to Know

■ Art can be used to misdirect the viewer's eye in the same way a master magician does.

■ You can surprise your viewer if you take the time to set it up properly.

■ It's hard to get too weird—as long as you draw upon concepts people already understand.

■ Uncertain inking lines can give a creature an amateurish look—which is fine, if that's what you need.

Chibi:
Too Darn Cute

In This Chapter

- The sweetest little assassin ever

- The cutest little devil

Chibi isn't a type of creature. It's a drawing style in which the artist creates superdeformed characters and monsters. You can pick out a chibi character by its super-large head, humongous eyes, tiny mouth, and small body.

In American culture, chibi are the equivalent of baby versions of popular characters—like Baby Muppets or Baby Looney Tunes. Their features are exaggerated and drawn with clear, strong lines. More than anything else, they are cute. Too cute.

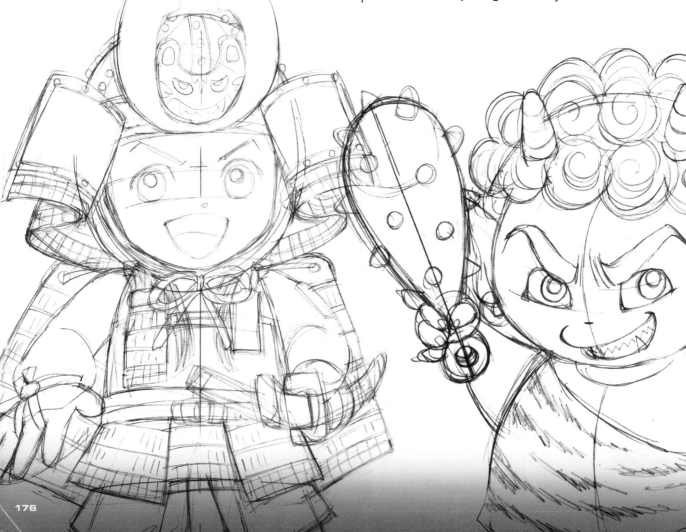

Chibi Samurai

Chibi are usually friendly in any form, although some are more full of mischief than others. Here, we'll concentrate on one of the good ones. By way of contrast, we're going to make a chibi from the samurai found in Chapter 1.

A **chibi** is a child or little person. Similar connotations include words like "shrimp" or "runt."

Manga-nese

If this reminds you of a character from a daily comic strip, then you're on the right path.

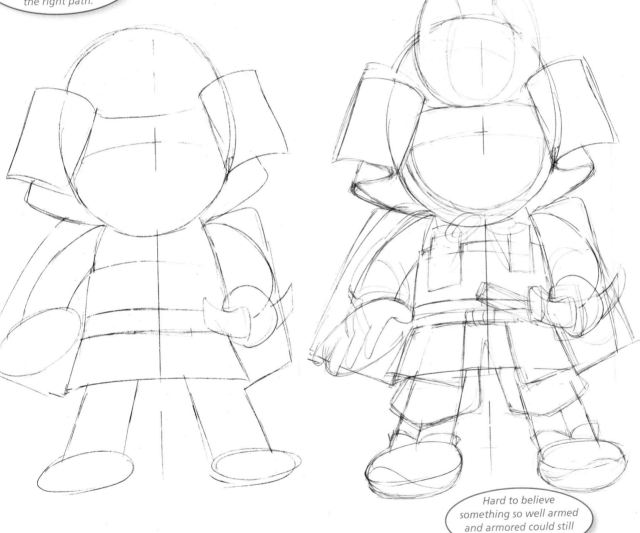

Hard to believe something so well armed and armored could still seem innocent.

1. Start with a basic human form, chibi style. Note that the chibi's head is as large as—or even larger than—its entire torso.

2. Elaborate on the armor and the rest of the samurai's belongings. Even his sword should look cute.

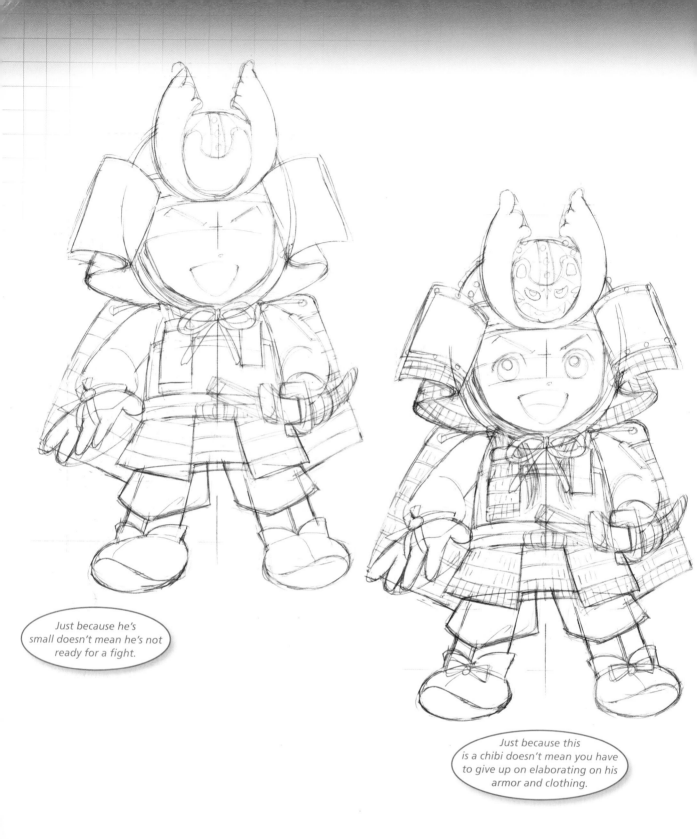

Just because he's small doesn't mean he's not ready for a fight.

Just because this is a chibi doesn't mean you have to give up on elaborating on his armor and clothing.

3. Add more details to the samurai's armor and face. Exaggerate the eyebrows and mouth for effect.

4. Work in the details on the samurai's armor and face. Make his boots look more like booties.

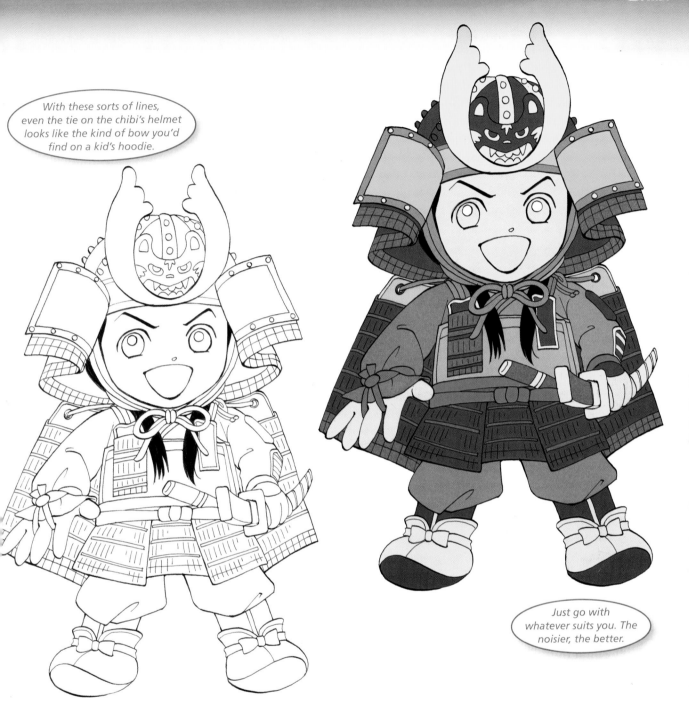

With these sorts of lines, even the tie on the chibi's helmet looks like the kind of bow you'd find on a kid's hoodie.

Just go with whatever suits you. The noisier, the better.

5. Lay down your inks. Notice that there are details on the samurai's clothes but little to none on his body or hands.

6. Chibi samurai come in all kinds of colors, but they're often seen in reds, golds, and silvers.

Chibi not only look childlike, they act childlike. A chibi samurai would likely be a source of comic relief in a story. He would take himself far too seriously and often let that take him into ridiculous situations.

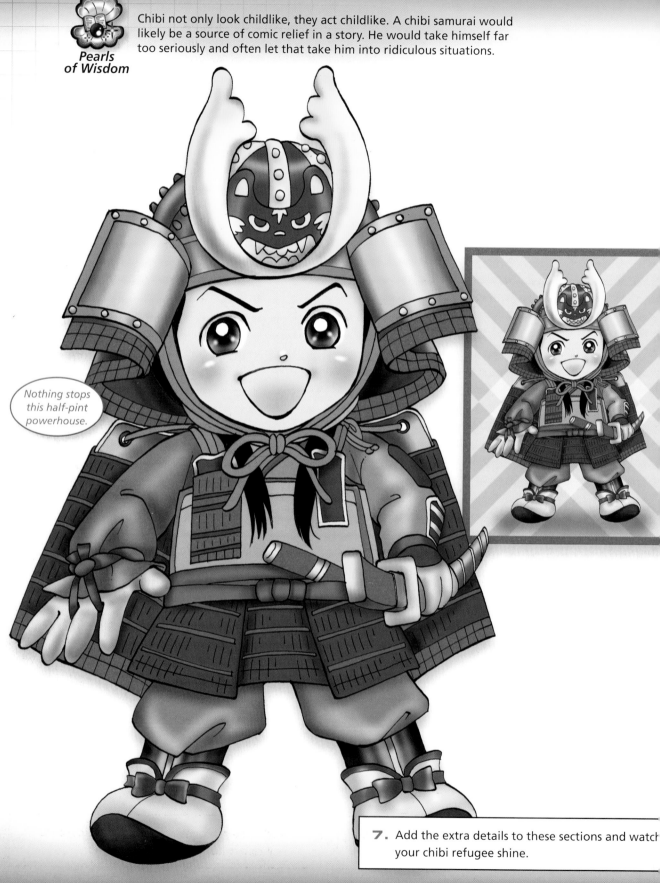

Nothing stops this half-pint powerhouse.

7. Add the extra details to these sections and watch your chibi refugee shine.

Chibi Demon

Since the oni is a monster of the worst sort, it seems appropriate to make a chibi version of it. After all, that sort of contrast shows you just how far you can superdeform a creature—and what that process does to it.

AIIEEE!!!

Remember, chibi are meant to be cute. That doesn't mean they can't be dangerous. Most chibi are mischievous at worst, but that doesn't mean you can't make yours a bit meaner—or more murderous—than that.

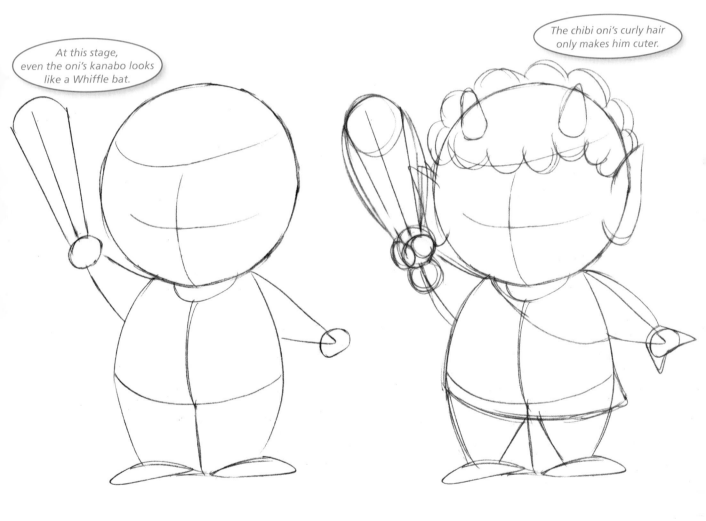

At this stage, even the oni's kanabo looks like a Whiffle bat.

The chibi oni's curly hair only makes him cuter.

1. Think circles here. We're going to make ourselves a tiny, chubby oni.

2. Add some more details: curly hair, pointy ears, and simple hands.

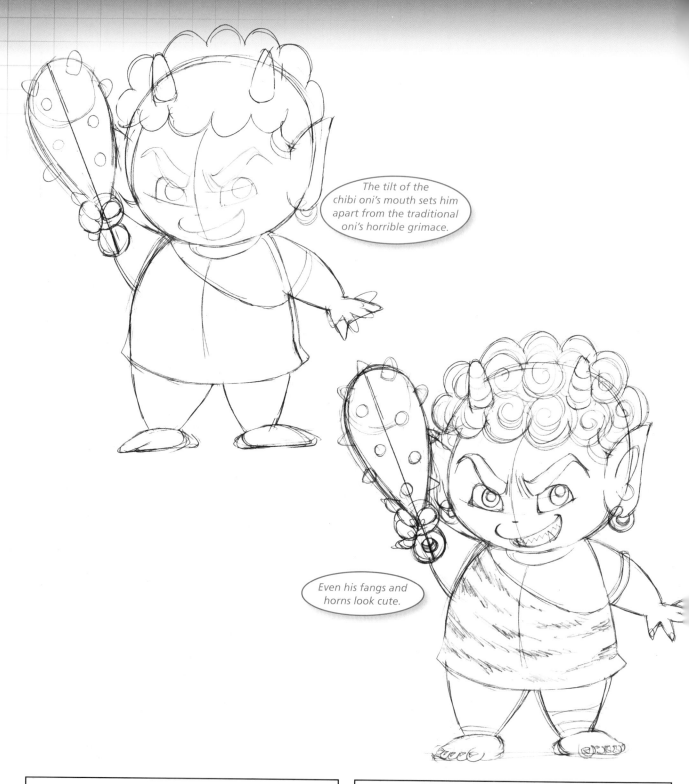

The tilt of the chibi oni's mouth sets him apart from the traditional oni's horrible grimace.

Even his fangs and horns look cute.

3. Concentrate on the oni's features here. The eyebrows are much the same as ever, but his tilted eyes speak of mischief over murder. Even the nubs on his kanabo look relatively harmless.

4. Add the stripes to the oni's tiger-skin toga. Show the figure's babylike fingers and toes.

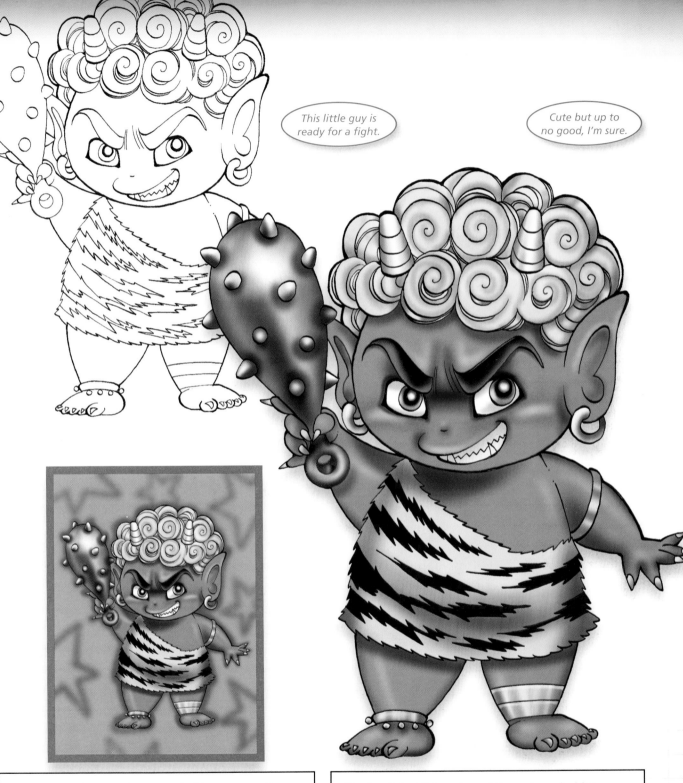

This little guy is ready for a fight.

Cute but up to no good, I'm sure.

5. Use simple, even lines to ink this creature. Go heavy whenever you like. This should give the figure a more uniform feel.

6. For this chibi version of the oni, use bolder, flatter colors. You can still add highlights and shadows, but don't work too much at it. This is supposed to be an idealized, childlike version of the original, right down to the style of its colors.

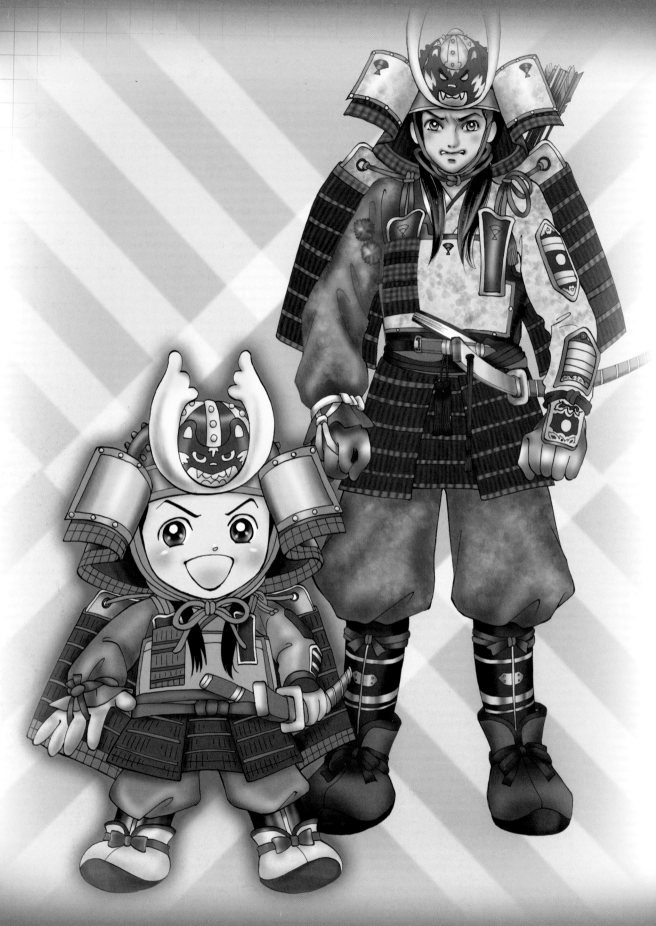

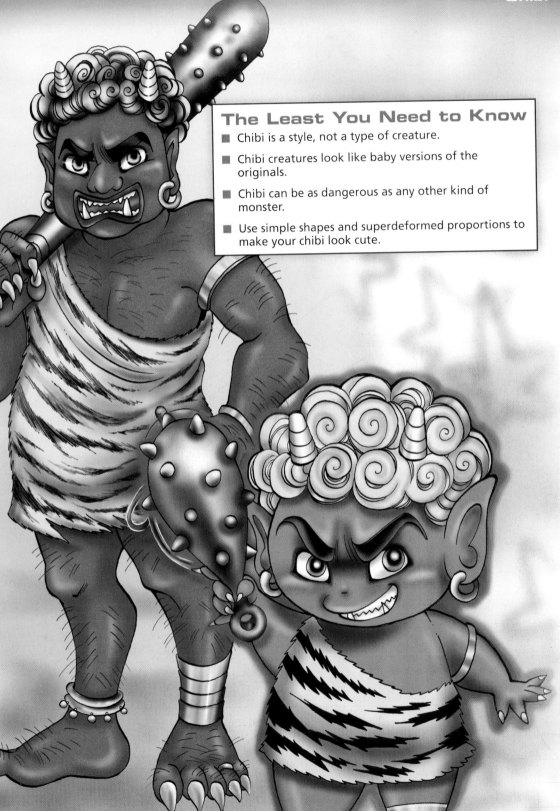

The Least You Need to Know

- Chibi is a style, not a type of creature.
- Chibi creatures look like baby versions of the originals.
- Chibi can be as dangerous as any other kind of monster.
- Use simple shapes and superdeformed proportions to make your chibi look cute.

Appendix A
Glossary

anime

Japanese animation. This generally shares the style and the archetypes of printed manga.

Bee Train

The Japanese anime studio most famous for creating the .hack//SIGN and Noir animated television series.

bokor

An evil voodoo priest.

breakdown

The roughest stage of a drawing. Here, you put down simple shapes in pencil, figure out the poses of the creatures and items involved, and determine the angle at which the viewer sees the contents of the picture.

beastman

Any creature that is part animal and part human.

bushido

The way of the warrior that samurai follow.

cephalopod

A class of marine mollusks that includes octopuses, squids, and nautiluses.

chibi

A style of manga in which the figures are infantilized by giving them large heads and features atop tiny bodies.

coloring

After a drawing is inked, it is often colored. Originally, this was done with paints, markers, or colored pencils. Today, most comics are colored on a computer.

comic (or comic book)

A pamphlet or book that tells a story using sequential art and often words.

Cthulhu

The greatest of the elder gods in the Mythos pantheon created by H. P. Lovecraft.

daisho

The set of two swords a *Samurai* carries, including a *katana* and a *wakazashi*.

elemental

A creature composed entirely of one of the four or five ancient elements of the universe: earth, wind, fire, water, and (sometimes) void.

finished pencils

A pencil drawing that is as complete as you can make it. Often such drawings are then inked and colored.

foreshortening

The forced use of perspective to make things closer to you appear larger.

Fu Manchu moustache

A long, thin moustache that hangs off the edge of the face, named for an evil, Asian mastermind in Sax Rohmer's pulp novels. Also seen on Chinese dragons for centuries before Rohmer was born.

ganbatte

Japanese for "good luck."

graphic novel

A comic book published in book form, usually containing either a complete story or a substantial arc of a larger story.

hentai manga

Sexually explicit manga made for adults only.

hopping vampire

A Chinese vampire that leaps after its prey, tracking it by sound rather than sight.

inking

Going over finished pencils with ink to make the art permanent and sharp.

kanabo

A studded iron club, carried by an oni.

katana

A long, curved, Japanese sword with a single sharp edge.

manga

Originally, comics published in Japan, but the term now encompasses any comics work that uses the artistic styles and archetypes that originated in Japan.

mecha

Giant robots or human-piloted power armor, a staple of Japanese science fiction.

ninja

A Japanese assassin.

oni

A Japanese demon, often seen carrying a kanabo.

penciling

Drawing a picture with a pencil. Artists often start with breakdowns and work their way up to finished pencils, which are then inked and colored.

perspective

The fact that things farther from the eye look smaller than those that are closer. Artists mimic this in two-dimensional drawings to give their work the perception of depth.

rice ball

A traditional Japanese food that usually comes filled with some sort of tasty meat or fish and is wrapped in a sheet of dried seaweed.

rough
A drawing in a preliminary stage that contains the breakdown and the skeleton but has not been finished with pencil.

samurai
Honorable warriors from feudal Japan.

sayonora
Japanese for "goodbye."

shojo manga
Japanese for "girl's comics." These tend to focus more on characters and their relationships.

shonen manga
Japanese for "boy's comics." These tend to be filled with action and adventure.

skeleton
The underlying framework of any creature, whether it has bones or not.

undead
Any creature that ignores the fact that it's already dead.

velociraptor
A small, carnivorous dinosaur that likes to hunt larger prey in packs.

wakazashi
A short, curved, Japanese blade, sharp on one edge.

Appendix B
Visual Glossary

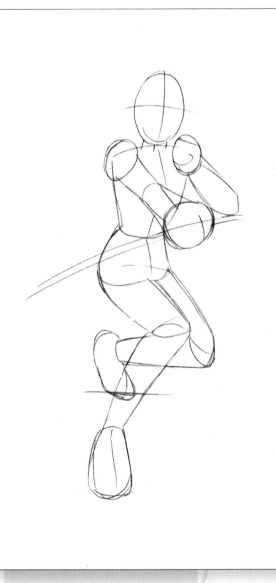

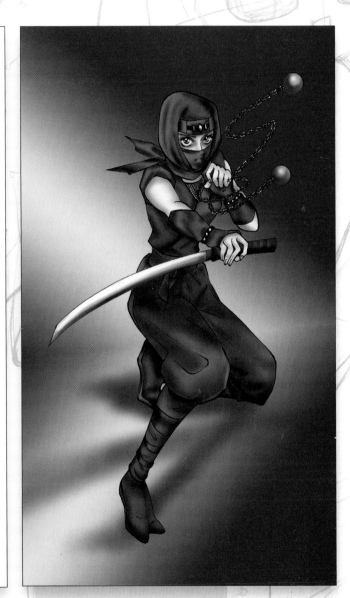

breakdown
The roughest stage of
a pencil drawing.

colors
The final stage of a drawing,
in which you color it in
whatever fashion you like.
Much manga is produced
without colors.

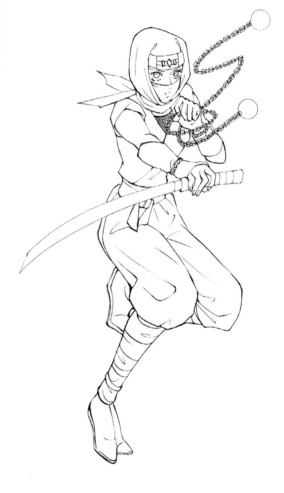

finished pencils

A pencil drawing that is as complete as you can make it. Often such drawings are then inked and colored.

inks

The stage of a drawing at which you go over your pencils with ink to make them more permanent. Some artists skip this step, preferring the look of the finished pencils instead.

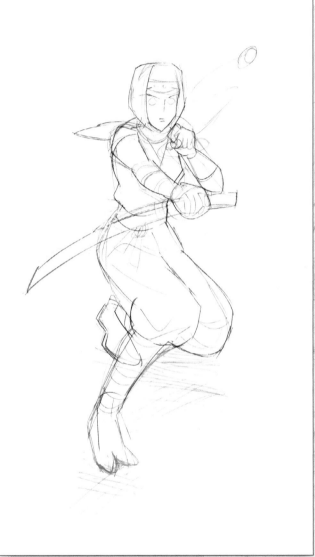

perspective
The fact that things farther from the eye look smaller than those that are closer. Artists mimic this in two-dimensional drawings to give their work the appearance of depth.

rough
A drawing in a preliminary stage, after you've got down the breakdown and the skeleton but before the finished pencils.

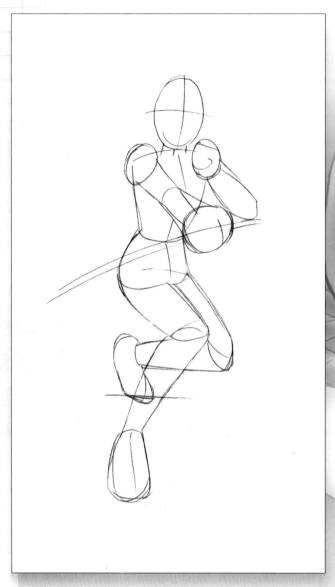

skeleton

Once you have a breakdown of your drawing, you move to the skeleton. This is the character's underlying framework. While it's based upon the character's bones, you don't have to actually draw them. Just show the basic, anatomical frame upon which you can base the rest of your drawing.

Appendix C
Further Reading

The Original

This book stands squarely on the shoulders of another, the first book in the series: *The Complete Idiot's Guide to Drawing Manga, Illustrated*, by John Layman and David Hutchinson. If you haven't read that book and you're truly a newbie when it comes to manga, rush out and get it right away. I'm surprised you made it this far into this book without reading it. Grab that book, read it, and come back here for the advanced course.

Just to make this all official:

Layman, John, and David Hutchinson. *The Complete Idiot's Guide to Drawing Manga, Illustrated*. Indianapolis: Alpha Books, 2005.

A couple other guides in *The Complete Idiot's* series should prove useful, too. These are:

Gertler, Nat, and Steve Lieber. *The Complete Idiot's Guide to Creating a Graphic Novel*. Indianapolis: Alpha Books, 2004.

Hoddinott, Brenda. *The Complete Idiot's Guide to Drawing People, Illustrated*. Indianapolis: Alpha Books, 2004.

Jarrett, Lauren, and Lisa Lenard. *The Complete Idiot's Guide to Drawing, Second Edition*. Indianapolis: Alpha Books, 2003.

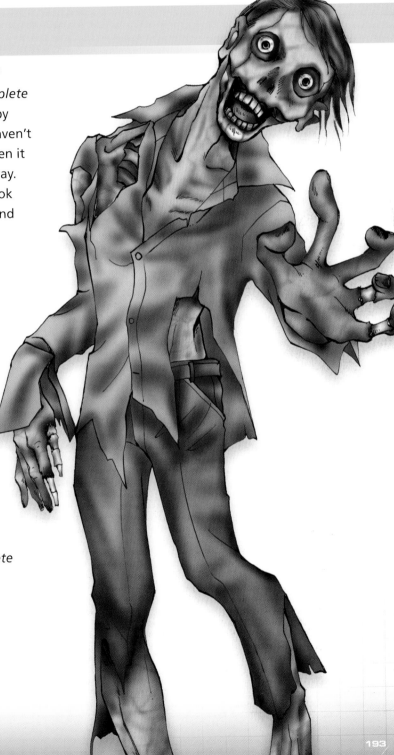

Other Drawing Books

Now that you've plumbed *The Complete Idiot's Guides,* here are a number of other books you might find useful. They range from books that cover the same subject as this work to intellectual examinations of exactly how comics work. Dip in deeply, and enjoy liberally.

Casaus, Fernando, and Estudio Joso. *The Monster Book of Manga: Draw Like the Experts.* New York: Collins Design, 2006.

Edwards, Betty. *The New Drawing on the Right Side of the Brain.* New York: Tarcher, 1999.

Eisner, Will. *Comics and Sequential Art, Expanded Edition.* Tamarac, FL: Poorhouse Press, 1985.

———. *Graphic Storytelling and Visual Narrative.* Tamarac, FL: Poorhouse Press, 1996.

Hart, Christopher. *Draw Manga Monsters!* New York: Watson-Guptill Publications, 2005.

———. *Manga Mania Fantasy Worlds: How to Draw the Amazing Worlds of Japanese Comics.* New York: Watson-Guptill Publications, 2003.

Hernandez, Lea. *Manga Secrets.* Cincinnati, OH: Impact Books, 2005.

Hogarth, Burne. *Dynamic Figure Drawing.* New York: Watson-Guptill Publications, 1996.

Martin, Gary. *The Art of Comic Book Inking.* Milwaukie, OR: Dark Horse Comics, 1997.

McCloud, Scott. *Making Comics: Storytelling Secrets of Comics, Manga and Graphic Novels.* New York: Harper Paperbacks, 2006.

———. *Reinventing Comics: How Imagination and Technology Are Revolutionizing an Art Form.* New York: Harper Paperbacks, 2000.

———. *Understanding Comics: The Invisible Art.* New York: Harper Paperbacks, 1994.

Okum, David. *Manga Fantasy Madness.* Cincinnati, OH: Impact Books, 2006.

———. *Manga Monster Madness.* Cincinnati, OH: Writers Digest Books, 2005.

Plex, Inc. *Let's Draw Manga: Monsters.* Gardena, CA: Digital Manga Publishing, 2004.

Tsubota, Noriko, and Big Mouth Factory. *Let's Draw Manga: Fantasy.* Gardena, CA: Digital Manga Publishing, 2005.

Recommended Websites

All Done with Machines

In today's world, books may seem quaint. They're static, which means changing anything in them requires a reprint or a whole new edition. You can't index them with a search engine. They don't consume electricity.

Of course, instant classics like this book are exceptions to the rule. Lessons like those you find in here never go out of style. And if you're trying to reproduce something on a page, there's no substitute for actually seeing it on a page first.

Still, the World Wide Web complements any other source of wisdom well. While you're surfing around, point your favorite browser to the following places for some further enlightenment.

Anime Expo
www.anime-expo.org
A large convention centered on anime, manga, gaming, J-culture, and fan culture.

CMX
www.dccomics.com/cmx
DC Comics division devoted to publishing manga.

Comic Book Resources
www.comicbookresources.com
A great site for news about comics of all sorts.

Comipress
www.comipress.com
A manga-centric news site.

The Drawing Board
www.sketchbooksessions.com/shanesboard
An artists' community.

Forbeck.com
www.forbeck.com
The official website of the writer of this book.

Manga Tutorials
www.mangatutorials.com
Free tutorials on how to draw manga.

Manganews.net
www.manganews.net
A news site devoted to manga.

Newsarama
www.newsarama.com
An excellent general-comics news site.

The Pulse
www.comicon.com/pulse
Up-to-the-minute comics news.

System Apex
http://apex.syste.ms
A site filled with links to Japanese artists' websites.

Tokyopop
www.tokyopop.com
A top manga publisher.

Viz
www.viz.com
A top manga publisher.